My
GURU IN DISGUISE

MY
GURU IN DISGUISE

PRIYA MOOKERJEE

wisdom
tree

Cosmic Man
As above, so below.
cosmic consciousness penetrating the being
and dissolving it into oneness.

Pages 3-4 "Know this atman.......*forever and ever." Courtesy: Bhagavad Gita Swami Prabhavananda and Christopher Isherwood. A Mentour Religious Classic. The New American Library.*
Page 17 The Speech of Jawahar Lal Nehru. Courtesy: Sources of Indian Tradition. Columbia University Press, New York 1958.
Pages 38-39, 153-155 Songs of Krishna. Courtesy: Deben Bhattacharya Samuel Weiser, New York.

ISBN: 978-81-8328-116-4

Published by
Wisdom Tree
4779/23 Ansari Road
Darya Ganj
New Delhi-110002
Ph.: 23247966/67/68

Published by Shobit Arya for Wisdom Tree; *edited by* Manju Gupta; *designed by* Kamal P. Jammual; *typeset at* Marks & Strokes, New Delhi-110002 and *printed at* Print Perfect, New Delhi-110064

Contents

Acknowledgements *vii*

1. No Longer Mother's Child 1

2. Entry into an Alien World 9

3. Reawakening of the Soul 30

4. The Ever Deepening Gap 42

5. The Path to Self-discovery 61

6. A Divine Experience 72

7. A Drastic Upheaval 90

8. A Christmas Gift 106

9. The Last Journey 122

10. My Inner Calling 145

11. A Strange Premonition 152

12. The Last Moments of Life 177

13. The Silent Departure 193

14. The Irreversible End 201

Acknowledgments

No words can ever express my depth of gratitude to my late friend Mangla Sharda, who first encouraged me to write this book.

To my friend Ptah, for her invaluable help and suggestions with my manuscript without which this book would not have taken its present form. I thank you.

My sister Para Hamilton, for standing beside me during very difficult times and for reaching out with her great spirit of generosity. I thank you.

I am grateful to my friend Francoise Gilot, for all that she has done for me over the years; and to my friend Sherry Silverman, for guiding me in the right direction.

1

No Longer Mother's Child

Pain, deep, unbearable, intense and tender. An invisible hand kneaded, twisted and turned my heart. My throat contracted; no breath could pass. I was suspended in great despair. Rootless, without definition, without boundaries, like water on a flat surface, I was suddenly free, not defined by the past.

Mother, Mother, where are you? Can you hear me? Feel my pain? Do you still love me? My heart cried out. I felt alone and lost. I wanted to shout, but silent screams echoed, surging and engulfing my being like a huge tidal wave. Then, in total silence, I cried. Tears streamed down my cheeks and gently dampened my shirt.

My palms covered her hand, and I could still feel the warmth that had been her life. Her face was pale, her eyes closed, and she seemed to be soundly asleep. *Mother, are you drifting blissfully into the world of your dreams? Am I in it? Or have you already forgotten? For you, am I now the past?*

I leaned over to kiss her for the last time; my lips were warm against her smooth, cool face. Touching her forehead, I pushed back her hair with utmost care and tenderness, so as not to cause her any more pain.

"There is no pain in death, only freedom from the body cage," she had once told me.

Still, my love for her made me irrational. I mourned the loss of someone who gave me life; one who had made my very existence possible. I mourned the loss of the passing of an era when I was her child. I mourned the loss of shared moments, of laughter, of sadness, of anger, of everything.

Somewhere deep within my soul I knew she felt my love, not clinging, not demanding, not expecting, just there.

Death, the great teacher, arrived at my door, not in the shape of a hooded grim reaper, but as an acute awareness of unconditional love — a love that defied boundaries and was now beyond the physical form of this lifeless body. My tears reminded me that life is but a fleeting moment that cannot be held captive, not even with love. At some point in time we have to let go of everyone and everything, but there was such deep hurt in being ripped away from the source that gave me life.

Her body was so frail, so small. She hardly resembled the beautiful person of my childhood. Badly burned — 65 per cent of her body had been ravaged by a fire — all that was left were the charred remains, raw flesh held together with yards of white bandage. Miraculously, her feet, hands, chest, neck, face and head had remained untouched by the raging flames.

As I gazed at her face, I saw no agony, no suffering, only a calm and gentle peace. With a sharp jolt, I was reminded again of the fleeting, transitory nature of everything. Is this what the ancient sages called *maya* — images that move like shadows across a screen, where figures briefly meet and then pass on?

The time was 4:00 a.m., July 16, 1990. I was intensely aware of every passing moment. My beating heart made me feel that I, too, would pass some day, entering the realm where my mother now dwelt. I was certain that we would see each other then. I felt the spiritual essence of Mother envelop me, reassuring me of her presence and holding me in her arms of light.

Night faded, merging with and embracing the approaching dawn, the magic hour when the mystic awakens to communicate with the divine. Somewhere, from a distance, the sound of a beautiful voice drifted through:

"Allah ho Akbar, Allah ho Akbar, Allah ho Akbar."

A Muslim worshipped, remembering divine greatness in his daily prayers. Bringing my palms together, I closed my eyes and prayed. Now the words from the *Bhagavad Gita* became a poignant reality.

Know this atman
unborn, undying.
Never ceasing,
never beginning,
deathless, birthless,
unchanging forever.
How can it die
the death of the body?
Worn-out garments
are shed by the body;
worn-out bodies
are shed by the dweller
within the body
New bodies are donned
by the dweller, like garments.
Not wounded by weapons,
not burned by fire,
not dried by the wind,
not wetted by water:
such is the atman.
Not dried, not wetted,
not burned, not wounded,
innermost element,
everywhere, always

being of beings.
Changeless, eternal,
forever and ever.

The atmosphere in the room felt different. The fragrance of flowers and incense filled the dimly lit space. To me, nothing felt morbid or melancholic, but rather, like being in a dark inner sanctum of some ancient temple.

I sensed I was witnessing an event that would transform me forever.

Two women stood by her bedside, softly chanting a *mantra* that was close to Mother's heart. Meeting Mother had had such a profound effect on their lives that they became her disciples years ago. They were with her from the first moment she was hospitalised, forgetting their own families and their own comfort. They remained with her until the very end, singing, chanting and reciting from the sacred scriptures. Slowly, we all gathered around Mother, chanting in unison the divine name of Krishna she so dearly loved.

I could see all the tubes that had been attached to save her life were disconnected, freeing her forever from her earthly existence. She was now truly in the realm of the spirit. I experienced a strange but deep sense of relief at her release.

The doctor entered, followed by the nurse. He examined her for the last time. Suddenly, I felt angry. *Can't you see she is dead? Yes, that is my mother, my own flesh, a part of me that just died. What can you do, Doctor?* I choked, unable to utter the words that were in my heart. He handed me a piece of paper.

"She was a very brave person, your mother. My sincere condolences," he said, leaving the room.

I stared at the large letters, 'Death Certificate'. *Cause of death*: 'Severe burns throughout the body.' The words seemed to leap out and grab me by the throat — brutal, stark, painful and real. There was no escape, no relief; only a stabbing sensation within my heart. How strange that these bits of paper can so often define things that are important and meaningful in life. I resisted the impulse to tear the certificate into pieces.

The nurse leaned over the bed and closed her eyes. Tears trickled down her face. I noticed a tiny cross around her neck. She was a Catholic woman from the southern state of Kerala.

"She was such an extraordinary human being," the nurse said. "What an amazing capacity for pain and endurance she had! I have never in all my years of nursing seen anything like this. She must have suffered excruciating physical pain, but not a sound escaped her lips; not a tear, no groaning, no moaning, nothing. The only time I heard her was when her dressing had to be changed. 'Aaah...aaah...Oh! Lord! Take me.' That is all she said. I can't get her out of my mind. I have been thinking of her all the time. She spoke only of God every waking moment. Nothing else mattered. For me, this was just like the crucifixion of Christ. I am blessed that I had the chance to serve her for these few weeks." Her voice filled with emotion, her deep devotion, astonished and touched me.

No one rushes death in India. Death is not clinical and antiseptic, but rather the most important part of a life experience; much more than birth, or anything else.

Death is the door through which we realise we are not just flesh and bones, muscle and mucous, but rather a pure spirit — unborn, imperishable, infinite and omnipresent. Within this body shell, we all carry a spark of that great eternal light, which is the essence of all life.

Mother made me aware of *lila*, the divine play, which is the joyous exuberance in the art of creation, a freedom of movement and a free flow of energy experienced as sheer delight. Life becomes burdensome and difficult when we forget and begin to identify only with the limitation of our perceptions and consider it to be our permanent state.

I remembered the times when Mother was in a particular mood and would act out different roles. Sometimes she would dress to become a wandering minstrel, sometimes the ascetic detached from the world, and other times, the joyful playmate of Lord Krishna. For her, 'play' was natural, connecting her so fully to the object of her devotion. But the

outside world viewed this as a kind of insanity. To them she was someone who acted and dressed strangely.

She always reminded me that we all come here to play our parts and then leave. We adorn ourselves in so many guises and shapes, playing different roles on the different stages of what we call life.

The first rays of a new dawn appeared over the eastern sky, casting a faint rosy hue that mingled gently with the fading darkness of the night, as nature renewed itself uninterrupted. The time had come for us to prepare to take Mother home. My younger sister Pebs, our family caretaker Prashad, the two women and myself, lifted her body and lowered her carefully on to the stretcher. She felt like a rag doll held together with nothing but yards of gauze. There was little left. Her whole body had been poked, probed, touched and turned, and what remained was bruised, raw, and badly wounded.

I was amazed that there was no odour, no stench of burned flesh. She smelled just as I had always remembered her — of sandalwood, with a hint of rose.

Chanting softly under our breath, we carried her body towards its final destination. The gentle light of early dawn made her face glow. She looked like a small child who was fast asleep. Perhaps she was now in her own mother's arms, held and rocked and soothed after a long journey's end.

Rest now, Mother, rest in peace.

I looked out of the moving vehicle at the shafts of sunlight streaming in through the massive *gulmohar* trees that lined the path. Birds chirped loudly, singing their daily songs. To the faint sound of traffic, the city of New Delhi awoke.

Everything appeared just the same. Nothing had changed. Life went on as usual, but my mother was missing. She was no more. I would never see her face, or hold her hand, or hear her voice. How she would chide me when she called me repeatedly and I didn't get out of bed

"Priya, you are the king of laziness," she would say.

Tears filled my eyes. What a strange thing to remember!

The two women sat in total silence. I heard Prashad as he chanted quietly under his breath, while Pebs and I were lost in our thoughts, remembering and connecting with the one who had just left us.

As children, Pebs and I sometimes had difficulty living daily with a mother for whom this world had become a mere mirage of an inner reality, yet which, for her, was more 'real' than the tangible existence of everyday life.

But, at that instant, when we had lost her forever, I could only remember those rare, fleeting moments from my past when I had somehow stumbled into her world and seen a glimpse of what she saw through her eyes — a realm which took me into the very depths of my own soul, unfolding in me a greater awareness of my inner life and the spiritual journey upon which I would eventually embark. Now, as I stared starkly at the face of death, I struggled with my anger and confusion, my pain and my love, with a sense of grateful remembrance.

Memories of early childhood days when we travelled together, visiting different places of pilgrimage, listening to her sing beautiful songs of devotion, talking about spiritual things — all flashed through my mind like a film on 'fast-forward'. I wanted to capture and engrave in my brain every possible way to remember her. Somehow, by doing this, I felt I would always have a part of her, and she would still be a part of me.

Memories flooded my mind. Following no order of events, they came in waves, rising and ebbing like the tide as I refused to grasp the reality of never seeing her again, at least not in her physical form.

Losing Mother in this turbulent way left my innermost self, my soul, severely wounded, the scars of which would always remain. Perhaps there was a part of me that was confused and angry with God for not protecting her, and then, there was another part that was angry with Mother for putting us through this turmoil and for abandoning us once more, as she had done when we were children. I knew that I would

somehow have to let go of my pain, release my anguish and learn from the bitter lessons that life teaches us. I knew I had to do this with no bitterness, no anger, no resentment, because only then would the shackles of conditional love break, freeing me to find true acceptance.

The body is subject to physical laws. We are born; we live; and we die. I knew this. Yet the feelings of loss, of pain, of sorrow, were so basic, so deeply rooted in human nature that there was no logic, no reasoning with my heart. The turmoil within was like a huge wave that carried me up and down, but always left me at the same starting point.

There was so much of me that had emerged from her; so much that was deeply linked. I suddenly felt like a picture with an important part missing, a part that could never be filled with anything else.

I would now have to learn to see myself in a new way, to draw a different portrait of a familiar face from an unfamiliar point of view. More than any other loss, losing Mother cut off the very basis of my origin. Rootless, without ground, I entered a world of ambiguity, not knowing who or what I was.

From now on, I would have to redefine myself, now that I had ceased to be my mother's child.

My Guru In Disguise

2

Entry into an Alien World

Mother's life, and now her death, always remained a bit of a mystery to me. I was never sure of what had actually happened on that fatal day of the fire, and since Mother would not talk about the tragedy, all I got was her caregiver, Meena's version. That morning, when she brought Mother her usual cup of tea, all was well. Mother had just showered and changed. Everything was like any other normal day when, suddenly, the smell of smoke filled the air. The few seconds that Meena took to run back upstairs to the bedroom were too many, because by then Mother was already engulfed in flames.

The lower half of her body was completely surrounded by a furious raging fire. In a desperate effort to muffle the fire, Meena wrapped the bedcover around the flames. At that point, Mother stood up and started to walk towards the bathroom. In a panic, Meena pushed her under a running shower. As the fire subsided, she realised how badly burned Mother was. Meena then removed what was left of Mother's old clothes and wrapped a sari, the long piece of fabric, around her. She helped Mother back into the bedroom when Mother surprised her by combing her own hair!

Later she told me how amazed she was because Mother had not made a single sound. Had she done so, Meena might have rushed to her sooner than she did.

"Take me to the hospital," Mother had stated calmly.

* * *

A few weeks after Mother was no more, I found myself sitting alone in her room, trying to adjust to the new reality of not having her around. The dim light of dusk washed everything in a shade of dark ultramarine blue. I sat beside the light of a small table-lamp on the floor of her sparse room, going through all her books and journals. I discovered old letters and cards, all neatly tied together in a bundle. I was surprised, because I had no idea that she found family letters and cards important enough to keep. Looking through her journal, I found loose scraps of paper, where she talked about her own childhood.

"I remember as a child," she wrote, "that I was very fond of my paternal grandmother. I would follow her around everywhere, as she went about her daily routine. I simply would not eat until she fed me with her own hands, after which, we would both take long afternoon naps together. I would amuse her for hours with my singing, of which she was rather fond. She would, in turn, tell me stories of flying horses and fantastic lands, and this delighted and enchanted me enormously. Grandmother and I loved each other in a very special way.

"Both my father and my mother were very fond of music, and sensing my natural inclination, would always encourage me to sing. I loved music with such a passion that I could pick up and sing whatever song I heard for the very first time.

"My father was one of those exceptional human beings, whose kindness and generosity were legendary. He was one of the most gentle and sensitive souls that I have ever known. I was the apple of his eye and he tended to spoil me a little. I remember he once bought me a beautiful paint-box, and a large drawing book. I had a habit of scribbling everywhere — on my bedroom walls and on the walls of the veranda of

My Guru In Disguise

our house. I would find special little corners around the house that were especially to my liking. My mother did not find this habit acceptable, but much to her dismay, all her scolding had no visible effect on me. However, sometimes, much to my surprise, my parents would watch me with great interest, as I painted vigorously on the walls.

"We were four sisters and one brother, with me the oldest. We were a very noisy bunch and always up to some mischief. One day, to keep us quiet, Father brought home two very thick books. He told us that from that day on, every evening when he got back from work he would read stories to us, provided we sat in silence! We all gathered around him and that was the first time I heard stories from the great Hindu epics, the *Mahabharata* and the *Ramayana*. I would wait eagerly for Father to come home, so he could continue where he had left off the previous evening.

"Our home was an open house. Father and Mother were very hospitable and there was always a constant flow of guests and visitors. Many of them were artists, writers, poets and musicians. Mother would sometimes ask me to sing at these gatherings. As I grew older, my passion for music led me to believe that this was what I wanted to do for the rest of my life. But somehow that was not to be. Unfortunately, many unforeseen circumstances came between my music and me, and I was unable to follow what my heart desired. I brooded over this for a very long time.

"My father died in 1950 and left me with so much sorrow that I withdrew myself from everything. Somewhere during those moments of solitude, I decided to paint and began doing so in December of 1952.

"I was born on May 5, 1923; I am now 31-years old."

As I sat reading, I began to see Mother in a different light. She was not only a person of deep insight and wisdom, but she was also vulnerable with human desires and conflicts — one who felt the pain of losing someone she loved. She was nostalgic, remembering the happy times, and she struggled like everyone else with life's trials.

Mother belonged to a privileged and well-known family. Their great

wealth, power and influence made them one of the most dynamic families of India — the Tagores. They were philanthropists and visionaries who, through social reforms, transformed and changed the existing norms of the day and helped usher India towards a new and more progressive direction. They contributed greatly in promoting the cultural life of the country, as they were enthusiastic connoisseurs of the arts. The family produced many painters, poets and writers, among whom was the great Rabindranath Tagore. In 1913, he became a Nobel laureate for his famous book of poetry, *Gitanjali*. One could say that Rabindranath Tagore is to India what Shakespeare is to England. Both my grandparents descended from the Tagore line.

Rabindranath himself visited the home of my grandparents several times. During those visits he would ask Mother to sing one of his many compositions. She sang in her clear voice with such feeling that often he would be moved to tears. He told my grandmother that he had not heard anyone sing his songs so beautifully as his grand-niece, and that she should never stop singing because her voice was truly a God-given gift.

Mother grew up in the city of Hyderabad in the Deccan plains of Central India. Her childhood was perhaps the happiest time of her life — 'carefree and wonderful', in her words. When she spoke of those days, a smile would invariably spread over her face.

Her parents named her Sudha, a Sanskrit word that means 'pure' and 'free from error'. She was a delicate child, prone to catching colds easily. That made the family even more cautious and her existence very sheltered. Even as a child, she had a kind heart that was easily moved at the sight of the poor, the needy, and those less fortunate than herself.

I remember a story my aunt told about the time when Mother was eight- or nine- years old. One day, as she played in the garden of her house, she noticed the guard outside the front gate shiver a little in the early morning chill. The house was a large, sprawling building on a hill

My Guru In Disguise

surrounded by large trees. He would walk around the boundary several times, keeping an eye on things. That distressed Mother terribly, and she decided she had to do something. Hurrying straight into her parents' room, she pulled off the camel-hair blanket from their bed. Then, taking a pair of scissors, she cut a large hole in the middle and ran back to the guard, insisting that he wear the 'poncho' she had made for him! Poor man, he was in a great fix! But she stubbornly stood her ground and refused to leave until he had put the poncho on.

Like all proper, upper-class children of her time, who were supposed to get a well-rounded education, she was sent off at the age of six to a convent school named Saint Ann's, run by Irish Catholic nuns, a few miles away from their home. She was a fairly good student who excelled in art and music. Seeing this aptitude, one of the nuns encouraged her to take up the violin. Mother's love of Western classical music made her plunge into this endeavour rather seriously and she would spend hours each day practicing diligently. Eventually, she became quite a good player and received a graduating diploma directly from London. At that time, India was still a part of the British Empire.

As a youngster, Mother was a daydreamer. She would get lost for hours in her own private world, playing all kinds of imaginary games. Her father doted on her, indulging her by bringing her toys and dolls from his trips abroad and around the country. She had accumulated such a large collection that her father had a separate playroom built especially for her, where she would get completely engrossed for hours, playing with her dolls and toys.

Growing up in such a protected atmosphere, where a houseful of servants took care of every conceivable need, there was little surprise in the fact that she had no concept of life's practical aspects. Many times she would take her sisters and her brother to see a movie, or on a shopping trip, but would invariably forget to take any money with her, much to their annoyance.

Although Mother grew up in a Hindu and a Brahmin household,

they were by no means orthodox or typically traditional. Open to all kinds of influence, they were cosmopolitan and modern, highly individualistic free-thinkers who were interested in both Eastern and Western cultures.

Therefore, when the time came for Mother to marry, she made her own choice, which was unheard of in those days. That man was her first husband but not my father. My mother was only 18 at that time, young and inexperienced, and filled with youthful romantic notions. Within a year of her marriage, she was expecting a child. The childbirth was very difficult for her and, much to her distress, after long hours of excruciating labour pains, a decision was made to remove the baby with forceps. That course of action had a disastrous effect on the child. Although he appeared normal, something in his brain had been permanently damaged.

A brain-damaged child put such a huge strain on Mother's relationship that the marriage broke apart, once she and her husband discovered that they had very little in common and were quite incompatible. The stress of looking after a child with special needs, coupled with the realisation that her husband and she had nothing left that could hold them together, created a great upheaval in her young life. Ill equipped and inexperienced, she simply could not cope with a situation that was rapidly spinning out of control.

That was when my father entered the picture. He had come to Hyderabad on a vacation with a mutual friend. At his friend's insistence, he went along to meet Mother's family. My aunt described Father as a lanky young man who was a bit shy, but endearing. His boundless energy and his great sense of curiosity and adventure made him unusual and interesting. He was a country boy, whose simple ways charmed Mother and drew her to him. Mother, on the other hand, was beautiful and gifted with a generous and open heart that he found irresistible. The moment he met my mother, he instantly fell madly in love with her and she with him! The attraction between them was a force that

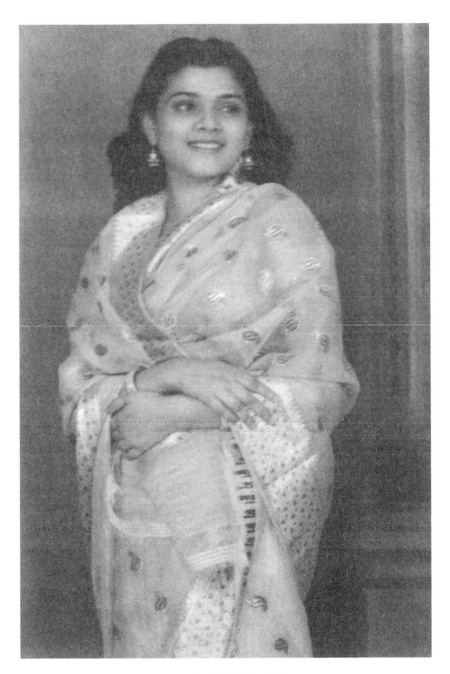

Mother in Hyderabad

was unstoppable. That was the start of a passionate love affair that took place in secret. Since Mother was still married, they would meet in secret at the home of a mutual friend, who became a go-between and would sometimes carry love letters for them.

Soon they had to decide on the outcome of this mad love affair. Faced with a difficult situation, Mother decided to file for divorce. Although the decision distressed her parents a great deal, they gave in for the sake of their daughter's happiness, accepting the unavoidable course of events. That must have been hard on them, because in those days, there was such a stigma attached to any one who divorced. To make matters worse, a woman taking such a step on her own was unheard of.

Feeling rejected and humiliated, her husband made sure he got full custody of their son, denying Mother any rights whatsoever. The boy was cruelly removed from his mother, never to see her again — a huge blow for both of them. The loss of her son wounded her deeply, causing her extreme pain, from which she never fully recovered. I heard rumours that her son died at the age of 13, but I could never be sure if that was true since I never dared to ask Mother.

Father returned to Hyderabad to ask for her hand in marriage. When he met his future mother-in-law, she told him bluntly that anyone who wanted to marry her daughter had to be well educated, preferably from a university in England. That declaration hit Father's pride, and he became determined to prove his worthiness.

For Father that was a very big leap, because even though he came from a family of landowners (which is how wealth was measured in those days), they were humble and did not possess the kind of wealth and sophistication that Mother's family had. If her background was cosmopolitan and modern, then Father's was that of old India of joint families and ancient traditions.

His adventurous spirit made him leave home at an early age and he travelled across the country, mingling with artists and craftsmen, gathering objects and paintings that interested him. Ultimately, this grew

My Guru In Disguise

into a significant collection of *tantra* art, for which he later became a well-known authority. However, at that time, his burning passion for Mother compelled him to prove his worthiness to his future mother-in-law. With very little money and just a suitcase, he got on a ship and sailed half way round the world to England. He had already received his post-graduate degree in Ancient Indian History and Culture from Calcutta University, but he subsequently received his M.A in History of Art and Anthropology at the University of London. He even spent some time as an announcer for the BBC's Overseas Service.

During his stay in London, World War II took a decided turn for the worse, but he continued with his studies and remained there throughout the blitz. He would often tell us stories of his wartime experiences, of how he endured the siege as London turned into a fireball, bombarded day and night by German planes. Many times I would tease him, saying, "I think you suddenly became very heroic to impress Mother and to woo her family! You were so much in love that your rational mind took flight!"

He returned to India as a model of what a good son-in-law should be. My grandmother was rather impressed with Father's tenacity and achievements. With the blessings of my grandparents, they were married in a simple wedding ceremony on March 9, 1945.

They were what could aptly be described as 'the ideal couple'. Young, good-looking, intelligent and well-educated, they epitomised a new, modern breed which was the future of the soon-to-be-liberated, independent India.

They settled in Calcutta, moving next door to my maternal aunt and uncle, where they quickly became a foursome, participating actively in the social and cultural life of the city.

Meanwhile, a tidal wave of great change was sweeping through India. Years of struggle to free India from British rule were coming to a climax, the outcome of which would forever change the course of India's history. Most families at that time had at least one or more active members who dedicated their lives to the freedom of India. Both of my parents'

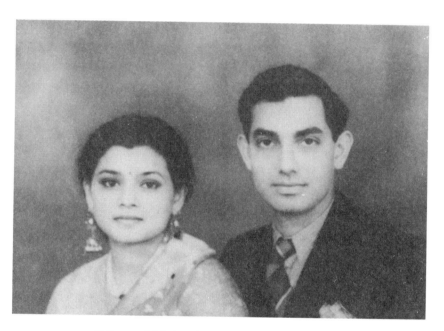

Father and Mother shortly after they were married

families were so deeply entrenched in the movement that some family members had been thrown into jail by the British for their political activities.

The partition of India, which divided the country into East and West Pakistan, threw the country into terrible chaos. Riots broke out and the nation became a blazing inferno. After moments of great strife, at last, on the midnight of August 15, 1947, a new flag was raised and India became an independent nation.

Standing at the threshold of a new era, a new nation awakened. Nehru, who became the first Prime Minister, articulated the mood of the times when he said in his speech to the Constituent Assembly in 1947: "As I stand here, I feel the weight of all manner of things crowding upon me. We are at the end of an era and possibly very soon we shall embark upon a new age; and my mind goes back to the great past of India, to the 5,000 years of India's history, from the very dawn of that history which might be considered almost the dawn of human history, till today. All that past crowds upon me and exhilarates me and, at the same time, somewhat oppresses me. Am I worthy of that past? When I think also of the future, the greater future I hope, standing on this sword's edge of the present between the mighty past and the mightier future, I tremble a little and feel overwhelmed by this mighty task. We have come here at a strange moment in India's history. I do not know, but I do feel, that there is some magic in this moment of transition from the old to the new, something of that magic which one sees when the night turns into day, and even though the day may be a cloudy one, it is day after all, for when the clouds move away, we can see the sun again."

As the sense of nationhood became established, voices were raised in unison for the first time as the national anthem was sung with the words and music composed by Rabindranath Tagore.

Those events, I am sure, profoundly affected the lives of both Father and Mother. Their families were driven out of their ancestral homes in the east, which later became Bangladesh. Bloody partition riots broke

out in Calcutta and the city went up in flames. Later, they described that as the most brutal and barbaric experience they had ever witnessed. Although they were still living in the same country, their homeland no longer seemed like the same place. Out of the chaos came a great turning point in India's history — from having been colonial subjects, they now found themselves citizens of a newly independent nation.

While outer changes took a definite direction, the personal lives of Father and Mother reached a critical turning point, which they probably did not fully realise at the time. Although not visibly apparent, Mother's internal changes had already begun, and she was gradually turning inward. Three years into their marriage, when Mother was 25, I was born. Father and Mother, like any other happy couple, were experiencing the joys of parenthood, enjoying their first-born child by pampering and indulging their baby.

At the same time, Father was becoming extremely successful and was now getting invitations from countries all over the world to lecture on archaeology, art and related subjects. He decided to include Mother on one such tour that would take them to several countries around the world. They left in January 1949. I was eight-months old. They were gone for four months, leaving me in the care of my aunt.

They returned home after a very successful world tour wherein they made new friends and visited different places. In fact, they became a very popular couple, especially in America where several newspapers printed articles about them.

But those happy times were about to change drastically, rapidly taking them both in unforeseen directions, which would eventually tear them apart.

Mother received the shocking news that some stranger had stabbed her father to death as he sat alone in his study one evening. Mother's relationship with her father had been extremely close. She adored and admired him and he loved her in a very special way. She was still only a young woman of 27 when she was suddenly forced to face the tragic loss

Mother in New York, 1949

of her beloved father at the age of 55. His death remained shrouded in mystery and nobody knew why or who was responsible for his murder. They never found the perpetrator of that dreadful crime.

The unresolved nature of her father's death made endurance of his loss extremely unbearable for her. The severing of two very important personal links — that of her father and her son, both at such a young age — left an indelible impact on her. Her intense pain had left her with deep inner scars that, I don't believe, ever healed. I always felt that she carried a deep sense of guilt for having left her young son in order to marry the man she loved, and now that the second marriage also seemed to be on the verge of a breakdown, she seemed to have withdrawn herself from the material world.

The painful events became the propelling force that pushed her towards a spiritual path. Perhaps she realised the frail, transient nature of life around her and turned inward for solace and comfort where she would not be touched by anyone, thus internalising her pain to the point of numbness.

Unexpectedly all of our lives changed. Father, who was still relatively young and inexperienced, did not know how to cope with her anguish. He wanted things to return to normal as soon as possible. Mother's nature was highly sensitive, requiring patience and gentle understanding. Father was totally unprepared and unable to cope with a situation that he could not fully grasp. Neither was he able to give her the kind of support she needed from him. The tragedy of their lives was that their great passion was ripped apart by my Mother's compulsion to follow her spiritual calling, which was for her, equally compelling and which she was utterly powerless to stop.

Although I was too young to have understood the seriousness of the events, I sensed that something had changed between them. Our home had become a strange and sad place, and their attitudes towards me became distant. I was puzzled and could not understand why I was no longer the centre of my parents' attention. I felt Father had grown distant

My Guru In Disguise

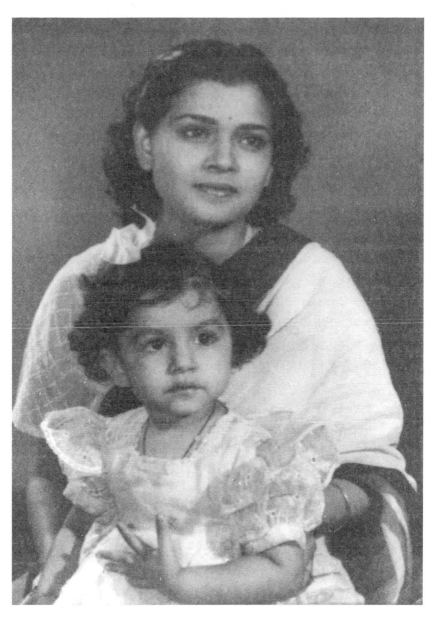

Mother and myself

and Mother had cut me off. All of my physical needs were well taken care of. There were maids and caretakers and a houseful of servants, but the emotional aspect remained without support. That made me turn to my aunt, who had become like a second mother to me.

Slowly, Father started to drift away, leaving home for long periods of time. I think the only way he knew how to cope with the situation was to throw himself wholeheartedly into his work. He frequently went away on tours abroad, causing Mother to feel even more isolated. They tried once more to hold their marriage together by having another child but by then it was too late. Mother was 33 when my sister arrived on the last day of the year. I think both my parents knew their marriage was over, despite the joy of that occasion.

My sister was a beautiful baby, who was healthy in every way, except that she was prone to all kinds of allergies. The slightest cold would turn into something that would drag on for weeks. I watched Mother holding her night after night, rocking her gently to sleep. Mother would do that often, because any attempt to put her back in her crib would result in her crying with discomfort as she had difficulty in breathing. Sometimes Mother would hold her and softly sing a lullaby. That would soothe her and she would instantly fall asleep.

Life with my mother was never what one would call 'normal'. I don't ever remember her cooking, dropping us off at school, or doing any of the usual motherly things. But in spite of what others perceived as being indifference on her part, I always felt that she cared for us in her own unusual way. Her way may not have been the accepted norm, but that would have been impossible, because she was in the process of breaking out of a mould that defined a role she was supposed to play. Mother was too much of an individual to follow any expectations, or any rigid norms. She had found her own way of expressing her feelings for us in very unpredictable ways.

Ironically, despite her aversion to domestic chores, she enjoyed sewing our clothes and knitting colourful sweaters for us. Everyone

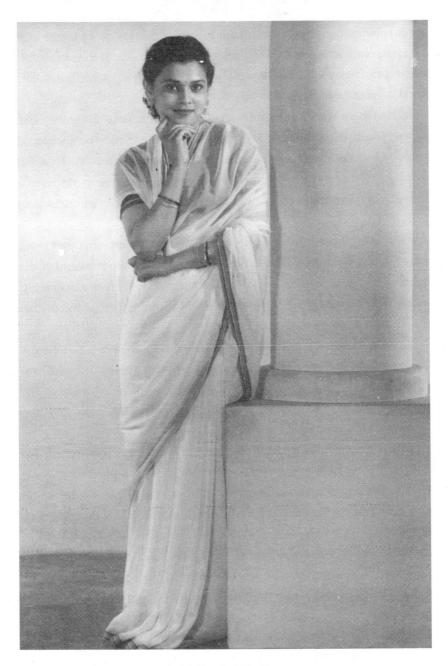

Mother in Calcutta

would always compliment us on our beautiful clothes, and Mother took great pleasure in seeing us well dressed and groomed. At the same time, she was not fussy when she saw our grubby faces or muddy clothes after we'd been outside, playing.

Then there were those rare occasions that I vaguely remember, like when I was five-years old and we were still living in Calcutta. She would sometimes take me to see a cartoon or a children's film, such as *The Wizard of Oz*. She once accompanied my aunt to see me perform in a school play. I don't ever recall her participating in any of our school activities as other parents did; for that matter, neither did my father.

But even those rare moments of interaction ended when her inner changes started to move her in other directions. As we grew older, her spiritual trances became more intense, occurring with greater frequency, taking her away from the outside world and slipping further and further into the deep recesses of her own being.

I think that was the time when we really missed having a mother in the usual sense. Even though she was physically around, she was emotionally and mentally absent. She would become oblivious to us and to everything else that surrounded her, except for those rare occasions when she would interact with us.

These powerful changes affected not only her inner spiritual life but also her physical well-being. Her body and mind had stopped functioning in a normal manner. Something strange began to happen — she would go into a trance-like state where her body seemed like an inanimate object and ceased to have any normal bodily functions. Sometimes this state lasted for a few days or a few weeks, and the condition was completely beyond her control. She had absolutely no idea how she could create a balance that integrated both her spiritual and physical worlds.

The condition is a symptom of what in *yogic* terms is known as *kundalini shakti*, where the brain cells and the nerve centres react differently. A person can remain in a state of suspended animation for

My Guru In Disguise

long periods, with all normal reactions and functions of the body coming to an end. Usually, intense *yogic* practices are required to awaken this energy. In the advanced stages of meditation, the body's normal functions can be suspended by the *yogic* technique of stilling the breath completely. However, in some rare instances, this happens spontaneously, as was the case with Mother.

Each occurrence took a toll on Mother physically, weakening her already fragile constitution. She would look drawn and weak. Unfortunately, during that time, there was no one who could guide her through this process, and none of us, including herself had any idea of how to practically deal with the mysterious condition.

Meantime, my younger sister, whom I affectionately called Pebs, came as a welcome addition to me because I now had a playmate and a companion to keep me occupied, taking my mind off the difficult family situation. In spite of everything, after Pebs was born, our home was by no means a sad or a gloomy place. Both she and I grew up surrounded by a wonderful support structure of other members of the family and a large circle of friends who would constantly drop in.

Our house was an easy-going place where friends gathered and had fun. With Father away on tour, or at work, Mother would lock herself in her room, removed from the world. This gave us much more freedom than we would have had in a conventional household. There was a lot of laughter and an abundant supply of food, which kept all our friends and us feeling carefree and happy. Both Pebs and I often look back on those times with fondness.

Just after Pebs was born, Mother decided that she wanted to paint again. She would lose herself for hours painting, shutting herself away in her room — perhaps, her way of keeping her mind focused on a normal level of consciousness.

Father encouraged her art and even arranged some exhibitions of her work, for which she received favourable responses. Perhaps he, too, was trying to engage her mind in more earthly realities.

The three fish

This must have been a very bleak period in her life, as she had no idea where her destiny would ultimately lead her. She was forced to function in a world from which she felt alienated; she was in a spiritual world that was elusive and out of reach, and still a great mystery.

A power far greater than herself was pulling her away from us and everything else she loved into unknown depths, which she felt compelled to follow.

3

Reawakening of the Soul

Childhood now seems like a faded dream mixed with vivid memories. Certain events I will never forget — such as the time when one afternoon I sat listening to Mother while she sang beautiful songs of devotion. Her clear bell-like voice filled the room. I loved her voice and would sit for hours listening to her.

That afternoon like every other, a flower-seller came to our door. Bringing Mother a bunch of flowers had become his mission, and no matter what the weather, he would be there without fail. As usual, he arrived that afternoon carrying his basket filled with all kinds of flowers. Some days he would linger, listening to her talk of spiritual matters. But that day he looked distressed and worried.

"What is the matter? Don't you feel well?" Mother inquired.

"Mother," he said with folded hands, "my wife is seriously ill. I need to take her to a doctor but I am a poor man. I don't have that much money. I don't know what to do. My children are still young and they need their mother. If anything should happen to her…" his voice trailed off and he broke down, sobbing, his body shaking with emotion. "She will die, Mother, if I don't get her to the hospital," he said, in a choking voice.

I turned to look at Mother — her eyes were filled with tears.

"With the grace of God, all will be well, don't worry...don't worry at all," she told him, and without any hesitation, she undid the clasp of her necklace and placed it in his hands. "Take this! Go quickly before anyone sees us. This is a very expensive piece of jewellery and should fetch you a very good price. Now, go quickly, hurry," she urged him.

"But, Mother I can't take this," he insisted, trying to return the piece to her. He looked terrified and his hands trembled nervously. Never in his life had he seen or touched such an expensive piece of jewellery. The necklace was a 22-carat gold piece, studded with rubies and emeralds.

"If anyone gives you any trouble, just send them to me. Now hurry, go quickly!" Mother prodded him in a hurried tone of voice.

"What will you tell your family? They will find out and throw me in jail," the man replied, desperately.

"That is my problem. You don't worry about that. Nobody will take you to jail; don't be foolish. Now go," she told him firmly.

"I will not be able to bring you flowers for some time Mother and that makes me very sad," he said, reluctantly getting up. "Mother, you are not an ordinary being; you are a living goddess!" he murmured, suddenly falling at her feet.

"God bless you. Your deep faith will carry you through this," she replied, touching his head in a gesture of blessing.

The man did not return for some time. Then one day, he suddenly arrived with a beautiful bouquet of flowers for Mother.

"My wife is much better now and I also have some extra money. Mother, it is all due to you. I had no trouble at all. This was all due to you," he kept repeating again and again.

"No, no, it was all due to the grace of God and your own faith. I am glad your wife is well," she replied, smiling back at him.

I remember clearly, three years later when we were moving from Calcutta to New Delhi, the man came to see her for the last time. He wept as if his world was coming to an end.

"Bless me, Mother, that I may remember you, only you, in my dying hours and with my last breath," he wept, clinging to her feet.

"You are blessed. Your faith and your devotion will carry you to the Light," she told him gently.

Mother's generous gesture caused quite a stir in the household. Father was furious and my aunt was shocked. Both reprimanded Mother angrily, but they knew there was absolutely nothing anyone could do once she had made up her mind.

As far back as I can remember, Mother was always introspective. Many times I would catch her looking distantly, totally absorbed in her thoughts. As time went by, these moods deepened to a point where there were days when she became oblivious to her surroundings.

At times we would try and force her to swallow some liquid, fearing for her health. She seemed to be suspended in time and space where all outer perceptions were put on hold. That took a great toll on her body. She looked thin, drawn and terribly frail; but once the trance-like state had passed, her mind would become acutely sharp and aware again, infused with extraordinary clarity. At times I felt as if she could see into another dimension of reality that was beyond the normal. On coming out of these states, she would be bubbling with joy and her face would radiate with an inner glow.

I recall that during those moments she would say and do extraordinary things. Once, during such a moment, she painted one of her most unusual paintings depicting the goddess in her manifestation as Kali.

Although Mother's first love was music, she loved painting as well. I clearly remember her painting in the traditional Indian manner. She would sit on a sisal floor-mat with a low wooden table before her, over which she would lay a large sheet of handmade paper. Surrounding the table were clear glass jars filled with a beautiful range of pigment colours. There was an altar on which she kept a small drawing that she had made, depicting Krishna and his consort Radha. She always kept her

The cowherd boy

bamboo paintbrushes in a wooden jar, next to the altar. Under the table was a stack of thick, white, handmade paper.

Mother was greatly inspired by the folk traditions of India. She loved the directness and spontaneity of the folk painters and the way in which they portrayed folklore, mythology, and stories from the great epics of India.

As a child I was fascinated to see the paintings she was working on. I could relate to them easily because they were mostly based on stories and myths every Hindu child grows up with. Sometimes she would hand me a piece of paper and a pencil and ask me to draw or paint whatever came to my mind. At times, she would show me the correct way to hold a brush and apply colour to the textured surface of the paper. Looking back, I can now see that those early influences must have been the basis for inspiring me to become an artist.

Mother had just turned 30 in the summer of 1953, when she painted 'The Goddess Kali'. Kali, the universal mother, is the embodiment of feminine energy, the primal creative principle underlying the entire cosmos. She is worshipped in her many forms and is depicted in many different ways. The goddess in the form of Kali is one of the most powerful of all forms.

I remember I was six-years old, when suddenly one afternoon, Mother went into her room and locked herself inside. She did not come out for three days, much to Father's dismay. He tried knocking on the door and calling out her name but there was no response. Fearing something terrible may have happened to her, he decided to break the door down. But my paternal grandmother, who was a woman of great insight, intervened."Don't disturb, Sudha. She is in deep meditation and should not be bothered at this moment. Leave her; she is just fine," she urged him.

Father trusted his mother's instincts on such matters and left Mother undisturbed.

After three days, Mother emerged, looking a little dishevelled and

pale but otherwise normal. Her clothes were covered with patches of colour, and she looked as though she had been painting feverishly.

I remember following Father into her room. The shades were drawn and there was very little light. Father and I stumbled over the furniture while adjusting to the darkness. The room had been completely turned upside down — colours, brushes, paper, rags were strewn all over. The walls were covered with splashes of paint, and brushes and containers full of colour lay scattered on the bed and the floor. Suddenly, Father spotted something under the table — a painting, a watercolour tempera on paper. Pulling aside the window shades, he held the painting up in the daylight. We both stared in disbelief at the strange and unusual piece. Although, I was too young to have truly understood the significance of that image, I knew instinctively that something was different about the painting.

Kali symbolises eternal time, i.e. whatever is born is subject to decay and death. She is the dynamic power, the moving force behind all creation. She is usually shown with four arms, indicating the different aspects of her form. With one arm raised, she gestures fearlessness and with the other she bestows her blessings on all.In Mother's depiction, Kali holds a sickle in her third hand instead of a traditional sword. Perhaps she painted a sickle because that symbolises reaping, gathering and, therefore, sustaining life. The fourth hand holds a severed head, symbolising death and indicating that there is no escape from the passage of time. Her tongue extends out as she absorbs within her form all negative forces, restoring the cosmic balance. Her body is naked and dark, symbolising the stripping of illusion and revealing of our original state, devoid of any outer covering or external layer. Her body is like a black void into which all creation ultimately dissolves. The colours were basic black, red and white drawn over a midnight blue background.

The figure of Kali seemed to leap out of the painting and appeared powerfully alive. The lines were bold and clear and the colours pure and flat, very deftly applied. Mother's interpretation was individualistic and

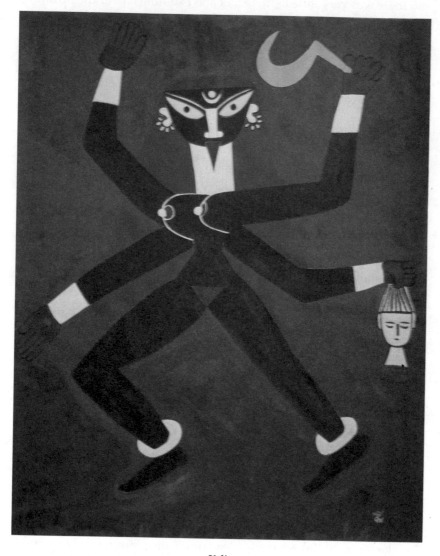

Kali

highly original; very different from the usual mode of representation. It was more abstract and simple and devoid of all details. Years later, Father used that painting on the cover of his book, *Kali, the Feminine Force*.

Soon after Mother painted the image of Kali, a series of mysterious events began to occur — one of which now comes to my mind. A stranger arrived at our door and told us that he had seen Kali in his dream. She appeared before him and told him that if he wanted to see her, he should go to a particular house in our vicinity. By now, some of our neighbours had become aware of Mother's strange behaviour and the trances that she fell into. After inquiring for days, the man was directed by our neighbour to our house. Since he was a great devotee of Kali, for him that experience was like a miracle. After that day, he came often to our house to meditate before Mother's painting. He respected Mother greatly and felt that Kali had chosen to manifest herself through Mother, because she was a highly evolved and spiritual being. Soon he became a close friend of our family and remained so, until his death a few years later.

A special altar was built for this painting of Kali. For Mother, this painting was no longer an inanimate object but had been transformed into something very real: it had become the very personification of *shakti*, the feminine dynamic power behind all creation. Mother started worshipping the image diligently with great devotion. I watched her as she sat before the image, meditating for hours, offering flowers, and burning incense, and reciting her favourite hymns to the goddess.

With a houseful of servants who gossiped, soon the word spread about her falling into a trance and people started visiting our home, bearing offerings. Some even claimed they were healed. This chain of events perplexed Father, and although he was a believer himself, this was beyond his comprehension and he could find no logical explanation for what was happening.

Mother was also perplexed by the intense reaction her painting aroused. Everyone who came saw Mother as a spiritual channel who

could guide them with her spiritual insight. Although she never saw herself in that light, I saw people falling at her feet, weeping, laughing joyfully and dancing in her presence, with an uninhibited spontaneity that was beyond rational understanding.

As word of this spread, more and more people started to arrive at our doorstep. To avoid the rush of people arriving at all odd hours, the painting was moved from its usual location and placed in a private section of the house. Strict instructions were given to the servants by Father not to allow anyone inside. It was invariably a difficult task because many people would refuse to leave without Mother's blessings. Many would travel long distances to reach where we lived, carrying offerings of flowers and fruit, or anything else that they considered suitable.

Mother would get very upset when people were turned away — it became a sore point between my parents and would lead to huge arguments.

The painting of Kali also had a deep impact on me personally. I recall my own experience at the age of six, soon after Mother had created the painting. The temperature outside was probably 102°F — a hot and a humid June day in Calcutta and the height of the kite-flying season. I leaned over the balcony of our house and gazed at the sky, which was like a vast blue dome filled with flying colours. Hundreds of kites in all shapes and sizes danced merrily in the wind. They looked like a colourful fish swimming in the sea.

This is a sport that demands the skill of a master swordsman and the concentration of an expert archer. An accomplished flyer can cut the string of another kite, high in the air. The winner, of course, is the one who can cut the most number of strings and who manages to stay aloft the longest. The strings are specially made with a coating of powdered glass paste that can sometimes cut like a sharp blade. Simultaneously, there was another game in progress on the ground and it was catching the strings of the kites that were cut.

My Guru In Disguise

I was thrilled watching the kites as they floated down in slow motion. I was enthralled by the magnificent dance.

Out of the blue, as if from nowhere, I spotted a giant black kite move across the sky at great speed. Like a large eagle, the kite sometimes swooped down, and then flew up again. I was fascinated. Like a hunter, my eyes were glued to the moving target. I wanted the kite desperately. The desire was so intense that I became breathless.

Suddenly, I lost sight of the kite. I ran as fast as I could, down the long corridor of our house, trying hard to keep up. The kite appeared again outside my bedroom window. I pulled up a high stool and stuck my head through the narrow window, keeping my eyes firmly glued to the kite.

"Ma!.Ma.a..a..a," I called out.

At that time, in the late afternoon, Mother was resting. I was strictly instructed by my nanny not to disturb her, no matter what. However, that day, the lure of the giant, black kite made me forget all the rules. I ran frantically into her room and shook her vigorously.

"Uh! Hum....m...m...n," Mother snapped, opening her eyes.

"Ma! I want that kite. I want it, want it, want it!" I screamed, jumping up and down. I insisted, begged and even grovelled. By now Mother was wide awake, and I am sure, a bit fed up with my antics.

"I will send someone to get you one later this evening," she said, firmly.

"No! I want *that* one!" I shouted, pointing toward the window.

"But how can I?" she interjected.

But I would not listen.

"I want THAT one," I screamed.

I can still remember the look of exasperation that crossed her face."I am only your physical mother. How can I do impossible things? Why don't you plead with your other mother?" she said, softly.

I was not at all sure what she meant, and stared at her quizzically.

"You have another mother, a divine mother. She is the mother of

us all. Nothing is impossible for her. She can do anything. Why not ask her and see what happens?" she said, her eyes sparkling with amusement.

My uncomplicated young mind easily accepted this. I was ready to do anything to get that kite! I ran to the meditation room and, barely able to reach the altar above which hung Mother's painting of Kali, I stared at the image intently. Her eyes seemed to stare back directly at me. I moved a few steps closer to the altar.

"Ma," I prayed with folded hands, "Ma says you are my other mother, and you can do anything. I really want that kite. Will you please give it to me?"

I stood quietly for a moment looking at Kali, and then quickly ran out of the room. Perhaps staring at her had frightened me a little. I gazed longingly at the kite through my window, hoping for something to happen.

The suspense kept building up when the string broke! And the kite began to drift down. My heart pounded with excitement. The descending kite seemed to get larger and larger and when a gust of wind blew it in my direction, the kite slipped swiftly through the narrow window and fell right at my feet!

I jumped with joy. I could not believe my eyes! The kite lay before me, in my bedroom, string and all! I felt I had won the most precious of all the prizes. I ran as fast as I could, back to the meditation room and lifted the kite above my head.

"Ma! Look! Look what I got!" I shouted.

I danced around wildly, showing off the kite to Mother and my nanny.

This incident etched within my soul a feeling of wonder and faith, making me realise that sincere faith and trust can make the impossible possible. From then on, Kali was no longer a concept removed from my own experience but one that became a deep, inner reality; a reality I relied upon for strength and support. For me, Kali was never a terrifying image to be feared but rather my inner guide and source of comfort. That

inner realm became as real to me as my so-called real world. I co-existed in both. Even though I was only a child then, I realised later as an adult, that the incident must have been the start of my spiritual life. I still have a little pencil drawing I made of Kali at that time, perhaps trying to mimic Mother.

That experience made me open to accepting many things in life that could not be logically explained or understood. There were mysterious exceptions beyond the mind's limited capacity to understand. I felt grateful for that — there could be no growth, no discovery, if we knew all the answers.

Years later, in my late twenties, I read a book entitled *Autobiography of a Yogi* by Parmahansa Yogananda. At one point, he narrates a strikingly similar incident with a kite, which he had experienced as a child. I was deeply moved and amazed by that. Somehow, it made my own experience even more meaningful to me.

I remember Mother telling me that a gentle breeze of grace blows constantly and all we have to do is open our sails. She made me understand that divine grace flows like an endless stream and we simply have to open our hearts to that experience. Everything that we search for is, in reality, the most intimate part of our being, but we tend to forget and keep looking outside for answers.

"Dive deep within before looking elsewhere," she always reminded me.

Mother's words had a great influence on me, not only in my life but all during my days as an art student in New Delhi, and later in London. I always tried to paint what was inside the unknown realms of my soul. Sometimes I succeeded when images would emerge effortlessly, and then there were times when I would grope for answers, but no matter what I did, painting for me was a way of delving deep within.

One summer afternoon, thirty years later, as I sat in my New York studio, the kite episode from my childhood came flooding back into my consciousness with such intensity that I was compelled to re-live the moment in a painting I called 'Reawakening'.

4

The Ever Deepening Gap

We moved from Calcutta to New Delhi when I was nine-years old. Father was offered the directorship of a governmental organisation, and since anything to do with the government was based in New Delhi, we all had to move. Although I missed my aunt and her motherly interventions, I felt excited to be in New Delhi.

Unlike Calcutta, which was a crowded and bustling city, New Delhi was open and spread out. We had wide, unenclosed spaces to play in and explore. I took Pebs for long bicycle rides around the wooded ruins and tombs of Mughal kings of a bygone era. Life was pretty normal on the surface. We went to school, played, had friends and did our homework, like other kids of our age, but underneath all that, tension between my parents became apparent.

Disagreements and misunderstandings between them began to get more and more frequent. Father would lose his temper and Mother would recede further and further into her shell. On certain days, the atmosphere would become so unbearable that I would stay away from home with friends for as long as I could, because coming home would only remind me of the total disintegration of our family and the deepening sadness of Mother.

My younger sister

Looking back, I can see now that life must have been far more complex for my parents than was apparent on the surface. Mother was experiencing deep internal changes, which were difficult for her to control. What she was experiencing was, without a doubt, a feeling that was beyond our comprehension. Only someone who had gone through a similar experience could perhaps gauge her personal struggle.

Father was also at a loss. He had no idea how to cope with this rapidly changing situation. He felt exasperated, restless and angry. He wanted a woman who could be his wife, his physical partner and mother to his children, but somewhere along the way, they had ceased to be friends, where each could open their heart and communicate their innermost feelings with each other. Mother's nature was sensitive but highly inconsistent, therefore, no one could easily penetrate the depths of her emotions.

Although they lived in the same house, Father drifted away into his own private life and Mother into her own private world. She became more and more reclusive, locking herself away from everything. Seeing her go through such turmoil disturbed me to the point that I would lash out unfairly at Father, in an attempt to defend and protect Mother. My behaviour angered him even more and made us intolerable with each other. We stopped communicating, and all that we would do was shout at each other.

I think Father and Mother may have seemed, at least on the surface, to be worlds apart, but I believe they had a lot more in common than was apparent. The problem was they never knew how to reach a common ground of understanding in their relationship. I also realised that the force that was pulling my Mother away was so powerful that absolutely no one and nothing could have changed its course.

For Pebs and myself, all the uncertainty around us made us bond even closer together. Children, more than others, have a remarkable capacity to adapt to change, and Pebs and I were no exception. I remember there were times when we were virtually inseparable. We created our

own world of make-believe that we would slip into with great ease. Being seven years older than she was, I had the upper hand and no matter what the game was, I always tended to be the boss and the leader. She was like a little tail that would follow me around. I made her do all the hard tasks from a commanding position, which she endured with a smiling face, as she was always eager to please and participate in the fantastic games that I cooked up.

She was a gentle and very giving child, who picked up stray puppies and took care of them lovingly. Those things would occupy us for days, allowing us to forget our unstable family life. Temperamentally we were miles apart. She was a good student, a sweet child, who was gentle and kind and whom everybody loved. Whereas I was the protector, the clown, the gang leader and the rebel, who constantly got into all kinds of trouble. We would spend hours playing crazy games and I got a great kick out of scaring her and her friends, by suddenly pouncing on them out of nowhere. They would scream with such ear-shattering, full-throated shrieks that Mother would come out of her room, covering her ears and looking utterly distressed.

"Please, please, stop! How can you all scream like that? It really jars my ears," she would plead.

Sometimes, to calm us down, she would ask us both to join her while she chanted or sang her devotional songs. Pebs would keep beat on the drums, which she was fairly good at playing. This way we would spend some afternoons chanting and singing together.

By now, Mother's trances had intensified greatly. She would be lost to the world for days, and we hardly ever saw her, though she was living in the same house as us. Sometimes, when she managed to bring her mind down to reality, she would silently enter our bedroom at night and stand by our bed, just watching the two of us as we slept. She startled me many times and I would wake up. But I always lay very still and just stared back at her in the dark. There were moments when I saw her as this strange and distant figure, whom we could never hug or play with, and who was, at times, a little bit frightening.

I recall Mother telling me once, "Do you know, walking this spiritual path is very difficult, extremely hard? Like walking on the edge of a sharp sword where one false move can hurt. But when a great longing for God, like a deep thirst, overtakes you, all else is forgotten. In the end, all you can do is become silent. Then everyone thinks you are withdrawn or either depressed or insane. Ultimately, there is nowhere left to turn except within."

Nobody could have understood what Mother was experiencing. Even though there were a few who had some insight, her condition remained a mystery to most people because they were on the outside, trying to look in. And if there were others like her, they were very few and far between. What was happening to her was not a usual, everyday experience that could somehow be identified, even in India where a spiritual life is greatly revered and accepted.

Mother not only encountered harsh criticism from strangers, she also faced opposition from members of her own family, especially my aunt, who strongly disapproved of her older sister's ways. I remember once, when she was visiting us at our New Delhi home, she spent hours reprimanding Mother, telling her how she was totally engrossed in her obsession which, in my aunt's view, was a total delusion. She told Mother to make her life meaningful by taking up her rightful position as a good mother and a wife. That was also the general consensus. My aunt simply could not see things from my mother's perspective. She was completely baffled by Mother's strange behaviour and could not understand why, in her opinion, Mother was "throwing it all away". She repeatedly asked her, "For what? Why are you doing this?" Though reiterating that she, too, believed in a spiritual life, she made it clear that she would never have gone to such extreme lengths to prove her commitment. She told Mother that she also said her daily prayers but then got on with the 'business of life'.

"Can't you see that everyone is suffering, especially the children?" she said to Mother, angrily.

I remember watching Mother's still expression as she sat listening to my aunt's disapproving words. Mother believed feelings that were very deep could never be fully articulated but could only be experienced in silence. I knew there was a part of her that was struggling to find words that would make some sense, but she was simply unable to do so.

At last she replied softly, "Please understand that I am not trying to prove anything to anyone, least of all to myself. For me, this inner drive is as important as breathing. I simply cannot exist without it. This is no longer in my hands because I have totally surrendered to the greater will. The power that is compelling me to walk this path is also the power that will watch over my family. I am completely convinced of that. Please don't worry so much. Everything will be just fine, you'll see. Come sit by me and taste the nectar of the divine name." Then she would beckon to her disapproving sister.

With a look of total exasperation, my aunt would invariably give in. Mother would always put an end to these discussions by reading from a book of mystical poetry or by singing some of her favourite devotional songs. I remember the one she sang often:

"Who will then heed the heart,
the tales of my sadness,
if my beloved treats me as alien?
Hoping for coolness
as I open my soul,
the fire redoubles.
And at last I know
that there is none in the worlds
of gods, demons or men
who can be known as one's own.
I shall leave this land alone
for a faraway place.
"My eyes pursued his path
till they were swollen

and yet Krishna never came.
I can no longer bear my life.
My hopes have withered away, my lord.
I wish to fly to that land where Krishna could be found
and love's philosopher's stone
would change my heart to a heart of gold..."

While singing, Mother's spiritual mood would begin to intensify and watching her, my aunt would be moved to tears. I remember similar conversations that took place between both of them many times over the years, and every time the exchange culminated in exactly the same manner.

When I was younger, Mother's attitude of not reacting would irritate me a great deal. I always felt as though she was not confronting the issues; she was escaping from issues that were uncomfortable. I realised much later in my life that it took more strength not to react, because the first impulse is always to retaliate — but to remain silent requires a great deal of inner strength. Mother lived her life by following her inner convictions and did what was truly meaningful to her. For that, she paid a heavy price. Faced with opposition, criticism, isolation and even ridicule, she decided to listen only to her inner calling.

Being a child made it all the more difficult for me to understand Mother's path. There were times when I felt hurt and angry with her, because every afternoon when I returned home from school, I always found the house filled with people, with not even a moment to spend with her. Yet, in spite of everything, there was always a part of me that connected deeply with her. That was something I couldn't grasp or comprehend at the time and even now this remains somewhat of a mystery to me.

I will never forget early one summer morning, as I was preparing to leave for school, I noticed Mother standing in the veranda of our house. She was draped in a hand-spun, coarse, white sari and a cheap pair of rubber slippers on her feet. Under her arm she carried a small bundle

of clothing. She looked as though she was ready to embark on a journey.

I could hear Father's angry voice echoing in the background, while Mother just looked on in stony silence. I never, ever heard her raise her voice, even in the most provocative of circumstances. That day the atmosphere in the house felt thick and heavy and filled with tension.

Soon the time came for me to leave for school, which was a relief, because I could no longer tolerate the tense atmosphere at home. Much to my surprise, Mother followed me out. We got into the car and sat together in total silence. Not daring to utter a word, I kept staring at her face. I could see the pain, the anger, the hurt, and the determination — all emotions intermingled, leaving vivid impressions across her beautiful features. But her eyes were still and cold like glacial ice. Slowly she turned her head and looked straight into my eyes, silently studying me with her gaze. I observed a tiny flicker around her eyes as they glistened with tears. But her nature would rarely permit her to show her emotions and the tears were gone as suddenly as they had appeared.

"Priya, I have something to tell you. I think you are old enough now to understand that I must do this. I feel this is my calling, my path; something I have to do with my life to make it fully worthwhile. I'll be going away for a while. I want you to be brave and strong and look after your little sister for me. Please don't get into arguments with your father, because it is absolutely pointless," she spoke in a voice filled with determination, while trying to convey her message.

"Does this mean you are leaving?" I asked in nervous disbelief.

"Yes, I am leaving," she replied, with the clarity of someone who had already made up her mind.

"But why do you have to go away? Why can't you stay at home with us?" I asked, feeling a sense of panic spread over me like a black sheet of foreboding doom.

"Because I have to be alone for this part of my journey. But I will not be far away," she explained.

"Where?" I inquired.

"To a place called Vrindavan, a place of pilgrimage and prayer, a very sacred and holy spot, only a few hours away from here. I will write often and you can always come and visit me there," she explained.

"But why are you going away? Are you angry with Father?" I persisted.

"No, I am not angry with him. I think he is angry with me. He cannot understand why I am doing this. How can I make anyone understand why I am doing this, when I myself don't know? If I had all the answers, I would not be going. All I know is that this is something I absolutely have to do. Maybe, one day, when you are older, you will understand. There are some things in life we have to do, that we must do, only for ourselves. The choice has to be sharp and clear. In doing so, we can discover who we truly are. This is not selfishness, but a way to learn to become more selfless. Do you understand?" she questioned gently.

I nodded my head in affirmation but without comprehending what she had meant. Not knowing how to respond, I remained silent.

"Will you be my strength, Priya?" she whispered, touching my hand tenderly.

The car moved along the tree-lined driveway. As I approached my school, I could see through the corner of my eye the massive yellow and white structure of the big old building, with rows of solid Corinthian columns that flanked the façade — an obvious reminder of our British legacy. The car stopped outside the high wrought-iron gates.

My heart began to pound as I leaned over to hug Mother. I gave her a quick hug, not daring to linger for a moment longer. The touch of Mother's face against my cheek spoke volumes to me, and in that brief moment, I could sense her anguish, as well as her determination.

"Be careful, darling, look after yourself and your little sister. She is still so young," she said, softly.

I kept staring at her dumbfounded. The whole thing felt strange and unreal. We bid farewell to each other. There were no tears, no gushing emotions, no sentiment, nothing. The only way I could describe the

emotion was that it was a deep-rooted feeling of pain, tinged with love and the sorrow of parting.

Feeling helpless, I stood back, knowing that I would have to let her go. I can still recall vividly the car vanishing out of sight and taking Mother out of our family unit for a long time to come. She did not look back — her eyes stared straight ahead into the distant horizon. Mother was 38-years old when she left home. That was the last I saw of her for five long years.

The year was 1961, and I had just turned 13. My legs felt like lead and my heart pounded like an erratic drum beat, as I dragged myself to face school. Since I was already late for my first class, I decided to quietly slip into the library to seek out a dark corner. Pretending to read, I opened a book and just stared blankly at the page. I felt uneasy and confused at the sudden breakup of my family.

A sharp shudder of pain pierced my heart and before I had a chance to compose myself, I found myself breaking down, sobbing spasmodically but trying hard to control myself. It was a choking sensation of drowning in what felt like a vortex that was carrying me away. I sat hunched over the table with my hands covering my face, trying desperately to hide my flowing tears. I sat in the darkness, struggling hard to gain control, when I sensed someone standing behind me.

She was one of my classmates. She instantly knew something was seriously wrong. I remember struggling to explain to her as simply as I could that Mother had left home and had gone to live on her own for some time. Seeing the expression of disbelief on my friend's face, I quickly added that it was to a place not too far away from Delhi and I could always visit her whenever I desired.

I started to feel claustrophobic, desperately needing some fresh air. We stepped out into the blazing sun, the oppressive heat scorching my face and the harsh glare of noon making my eyes hurt. I felt a deep sense of unease and hopelessness when I heard the school bell ring. All of a sudden, I found myself panicking.

"Oh, no! I don't want anyone to see me like this," I cried.

I could hear the din of class dispersing; soon the corridors would be crowded with the staff and students.

"You can't stay here. Let me take you home," my friend suggested, in a gentle tone.

"No!" I retorted, fiercely.

I needed to first clear my thoughts and calm my nerves, before going home. Across the long hallway, I noticed one of my favourite teachers approaching. She was a kind woman, who had taken a special interest in my welfare by taking me under her wing, and tutoring me every evening with my studies. I addressed her fondly as Mrs. N, an abbreviated version of the word 'nice'. I remember I felt a strange twinge of shame, because not every day did any mother leave her home and her family, especially in India.

Seeing me in such an obvious state of anguish, Mrs. N took me aside, trying as tactfully as she possibly could to find out the cause of my distress. I struggled to explain, but words froze in my throat, leaving me voiceless, unable to utter even a single word. Mercifully, my friend intervened and explained.

"What would you like to do?" Mrs. N asked, putting her arms around my shoulders.

I explained that I needed to sit outside for some time because I did not feel up to attending classes and facing all my classmates in my present shape. By now, I was beginning to feel emotionally drained and physically tired.

She responded with understanding and compassion, providing a sense of inner relief and evoking in me a feeling of deep gratitude. Over the years, whenever I remembered that afternoon, I felt forever indebted to her for her kindness.

When I returned home that evening, the atmosphere was tense and difficult. Father was in a furious mood, and since neither of us had any stamina left to deal with confrontations or explanations, we avoided

My Guru In Disguise

speaking to each other during dinner. I had lost my appetite, but somehow forced myself to eat something, after which I locked myself in my room. I got into bed and closed my eyes, trying to block out everything around me in an attempt to remove myself from the nightmare that I was experiencing, trying desperately to escape into a world that was uncomplicated and simple.

Much to my relief, Pebs had already gone to bed. I knew that explaining everything to her would be very difficult and I would certainly need an extra boost of strength to do so. Every time I closed my eyes, all I could see was Mother's face as I bid her good-bye. I simply could not get her out of my mind. I felt a lump arise in my throat and a deep sense of isolation began to engulf me as I recalled her words, "I am only your physical mother. How can I do impossible things? You have a divine mother, and nothing is impossible for her. She can do anything."

I started to pray softly under my breath:

Divine mother, please help me. I am in pain and I need you to hold me. Please love me, Mother. I pleaded with my whole heart and soul. Soon a wonderful feeling of peace and a gentle calm enveloped me and I distinctly sensed tender, loving warmth surround me in its embrace, as I slowly drifted into sleep.

After Mother's departure, we all tried to cope as best as we could. Pebs, who was only seven-years old, was too young to understand what was going on.

She would directly ask, "Where is Mummy? I want Mummy."

I would try my best to explain to her, in the simplest manner possible, that Mother had gone to a place to learn and experience new things, just as she did in her school. She would sometimes look at me with a perplexed expression in her eyes.

"But I come back home from school. Why doesn't she?" she would insist.

"This is not the kind of school you can leave. You have to be there all the time to learn all the difficult lessons," I would reply, always trying to divert her attention to other happier things.

Being so young she had the unique ability to adapt and she would soon get engrossed in play with her friends. But there were other times when she would remember and begin asking questions, which would start the whole process once again.

Although I was older and understood much more of what was happening, I sometimes found the situation too hard to cope with. I felt I did not want to become a mother-substitute in Pebs life, which, I sometimes found myself becoming. At times, the feeling of being trapped became so overwhelming that I would escape by spending most of my spare time with friends. I had just entered those teenage years, where all emotions were exaggerated and everything was highly dramatic. I became even more rebellious, and that behaviour manifested itself in my interactions with everyone and everything that surrounded me.

Once, at school, I overheard a girl whisper to her friend that my mother had run away and left us. I felt my temper rise, making my face red-hot! I turned to the girl and grabbed her by the collar. Shaking her like a rag doll and snarling under my breath, I shouted at her angrily, "She did not run away, stupid. My mother didn't run anywhere, do you understand? You idiot!"

The poor girl was nearly paralysed with fear. She scurried away as fast as she could, scuttling like a rabbit to save herself from my rage.

As days passed, we realised that Mother's absence had taken its toll on the normal functioning of our household. Even though she never played an active role in the day-to-day running of the household, having her around somehow completed our family unit. We felt a little secure, as much as we possibly could, in a family like ours. Despite her incapacity to cope with the stresses of motherhood, which left her totally exhausted and drained, her absence created a huge gap in our lives, bringing to the surface the dysfunctional nature of our family.

It was especially hard on me, as a young teenager I felt burdened by the responsibility of trying to run a household plus concentrate on my studies. At home, fortunately for us, with Mother gone, we had a loyal

staff, all of whom were like an extended family and some of whom had been with us since I was very young. Even though we had servants who took care of all the practical aspects while Father attended to the finances, somebody still had to be at the helm and I found myself unwittingly in that position. Although I had friends and our house was an open and free-for-all kind of place, behind the facade I felt a great sense of remorse. I covered up my feelings of being abandoned and unloved by putting on a defiant attitude.

That attitude got me into all kinds of trouble in school. I hated the conformity of rigid rules, which to me seemed totally unreasonable. I found everything too boring, tedious and pointless. My mind would wander off and nothing in class was of any interest to me. I enjoyed the fact that I had the power to exasperate the adults around me by constantly doing things that would annoy them and get me into trouble. My behaviour was unacceptable to my teachers and I was frequently ushered off to the Principal's office, only to face a lecture that went in through one ear and out of the other.

To release my tension I became the rebellious clown in my class and hung around with friends, coming home at odd hours, much to the exasperation of Father. I felt happy being out, forgetting everything and just having fun, at least for a while. I was popular and funny and everyone wanted to get to know me. I told myself that I couldn't care less if my parents didn't love me; there was a whole world out there that did! At night, as I lay in bed, I would think terrible things about them. How dare Mother expect me to become her strength? I did not want to be strong. I wanted to be happy and carefree. I was angry that I was missing out on my childhood because my parents could not figure out what to do. I even thought that if they died, I would stand a better chance.

At that stage, I did not, or perhaps could not, analyse too much. All I could do was try to get on with whatever was at hand. On some days when the strain became too much, I would sit with friends and vent my feelings, blaming my parents for everything that had gone wrong and,

like a large festering wound, my resentment kept growing and wouldn't heal.

All the pent up anger prevented me from insisting on seeing Mother. I felt that if she didn't need me, then I didn't need her either. I tried to convince myself that I was completely self-sufficient and independent. Perhaps that attitude is what carried me through many difficult times in my adult life. Deep down, a part of me knew that Mother was a kind and gentle soul, who would never hurt a fly. But then how could she leave us? What was so important? What had superseded everything else? There were moments when I saw an expression of aloofness on my Mother's face, mingled with a haunting sadness. At times, I was unnerved to even look at her. I found my own feelings hard to grasp, because I constantly felt torn between my anger and my love for her. And no matter how hard I tried not to, I missed her!

My feelings for her were never clear-cut. Sometimes there was love in my heart, and at other times, anger as well as pain. Everything depended on my mood, on which way the pendulum swung.

One afternoon, after I had come home from school, I felt a great urge to go into Mother's room. Perhaps this was my way of feeling connected to her.

The room was cool and dark, with all her things just as she had left them. Everywhere I looked I saw pictures of gods, goddesses, the name of Allah, and the Star of David, and great spiritual beings like Buddha, Christ, Ramakrishna and Francis of Assisi on the walls.

I remember her often saying to me, "Never think your faith is somehow better than another. Everyone is on their own quest for God, which is as valid to them as your own faith is to you. Divine truths are the same, no matter what their outer shape or form may be."

Her room was simple. Beside her bed were her spiritual books, journals and diaries. A large altar stood on one side, beautifully decorated with motifs that she herself had painstakingly painted.

Now everything seemed strangely inert without her. She had plunged

so wholeheartedly into her spiritual quest that she had left everything behind, including the image of her beloved Krishna.

Occasionally, I received a letter from her, each time coming from a different location. Not finding anywhere permanent to stay, she moved from one place to another. Her letters were always brief and to the point, saying she was fine and that there was nothing to worry about; and how were we? She hoped we were keeping well and taking care of each other, etc.

But I heard rumours that she was undergoing great difficulties. With very little money and no place to live, she had to struggle endlessly to keep herself sustained on the barest minimum. Although Father did send her some money, it was not enough to meet the very basic needs. I felt that he didn't want to give her too much so that, without the means of living, she may be forced to return. She was in no mood for compromise and nothing could sway her away from her path. Having so little practical experience in taking care of herself must have made her journey all the more difficult.

I wanted to go and visit her, but Father was not very encouraging, insisting that we would never be able to locate her. I think he was afraid of what we might encounter, seeing her in a strange setting, and who knows, in what state. Moreover, my parents had drifted so far apart that there was no desire left in them to face each other any more. There must have been many difficult issues between them that remained unresolved. I don't believe they ever resolved those issues. They both felt hurt and misunderstood. Although Father appeared to be a fairly complex person, deep down, at the core, he was rather simple. He had a hard time dealing with complex issues and would naively seek simplistic solutions to solve difficult problems. I suppose he did care for Mother in his own way. Many times he would try to 'fix' the problem, which invariably would end in disaster.

We tried hard to hold on to some semblance of a normal family life by attempting to create a space that allowed us to function independently,

regardless of what was happening around us. But it was virtually impossible in such an unstructured and fluid situation.

At times, I tried to understand how Mother's departure and her spiritual journey had impacted us all. Being part of a family did not mean that we were all identical in our responses. Each of us had a totally different viewpoint on exactly the same situation and for each, our own experience was equally valid and true.

For Father, his wife had become a strange and mysterious woman, whom he could not reach or be intimate with. At the same time, he understood her need for a spiritual life, because he himself came from a background that was deeply imbedded in spirituality. Although a part of him clearly understood how extraordinary Mother's experiences were, he still could not find a way to bridge the gap between his world and hers.

Pebs missed having a normal mother, who would care for and protect her from the uncertainties of life — a mother with whom she could do all the usual 'mother-daughter' things. She was convinced that Mother didn't love her and had abandoned her. She could never reconcile herself to her anger, her sadness, her feeling of being rejected and of being unappreciated.

After the death of my parents, I began to realise that they were human, with their own strengths and weaknesses. They also possessed many amazing qualities that helped shape and make me what I am today. At the same time, they struggled with the problems and difficulties of life like everyone else. They had their conflicts, their doubts and their fears. Years later, I came across a letter that Father had written to Mother during that difficult period. His letter revealed to me something of his personal struggle in coming to terms with the unforeseen twist of fate. He wrote:

Dear Sudha,
It pains me to learn of your shifting to a charitable institution.

My Guru In Disguise

Do not for a single moment feel that I am merely an onlooker to this destiny over which we have no control. Your well-being is always in my upper mind but circumstances have dragged me to a level, which is probably responsible for creating such a misunderstanding.

Suffering is a great teacher of man —for what I could not learn in everyday affairs, I have learnt in pain. These bitter experiences in life have taught me severely the exact price.

Buddha had said, 'Struggle there must be, for all life is a struggle of some kind,' but I never knew that I had thrown the dice with destiny and the game was not to be concluded in the manner I had been led to expect. Many a blow falls on my head and I am fully aware that whatever I do unto others will return to me in some way and at some time. Life pays us back in our own coin. My misdeeds will find me out one day. But believe me, I have not done any harm to anybody willingly or deliberately; God alone knows through what hardships I am passing through. This must not be mistaken to mean that I am refraining myself from extending that much of help which you need most now, but give me a little breathing space.

A force, which will drive me back to the world, inevitably follows the force which drew you away from us in your quest for spiritual life; this is my destiny most probably.

I am not the down-to-earth type as you might think. My inner growth has been organic: the branches and leaves are now more widespread and the roots have not been cut away but simply penetrated into deeper ground. My prayer is that it should mature gradually into the fruit of spontaneous insight.

<div align="right">

Love

Ajit

</div>

I was moved after reading his letter. For the first time I saw Father in

a different light — not as an angry man, but as someone who was struggling with his own feelings and with the loss of the woman he loved.

Whatever their differences, they never became bitter with each other. At some point, in spite of all the turmoil, they both recognised the unique qualities of each other, and no matter how difficult, they accepted the fact that their lives had drifted in different directions.

Father always recognised that Mother was someone special and would often ask her for advice on important matters. Theirs was a difficult, and at the same time, a unique alliance in more ways than one. Perhaps that is why they never divorced.

No matter how unusual and strange my childhood may have been, I realise if I were given a choice now, I would not change a single moment of my life.

5

The Path to Self-discovery

Five years had passed when a family friend informed us that he had seen Mother on a recent trip to Vrindavan. He said that she looked withdrawn and emaciated and physically in bad shape. Moreover, as she had come from such a privileged background and was now placed in a rather vulnerable position, she was surrounded by hangers-on who exploited her plight. She lived in sparse surroundings of a small room in an *ashram*, her spiritual retreat, where she remained in virtual isolation. As the news reached Father and other members of the family, they felt the need to bring Mother back home.

Mother's homecoming was a shock to me. She looked pallid and thin and her face seemed smaller. Her clothes crumpled and threadbare, hung loosely around her body. I noticed her feet — they were cracked and bruised from walking barefoot. Her eyes looked distant and aloof and her hair had turned grey. To me, she seemed like someone else; her entire persona had changed. My heart broke and my stomach churned— to see her in such a condition was devastating. I tried to hold back my tears as I went to hug her. She smiled and touched my face.

"How are you, Priya? I am back now," she said, softly.

But I could immediately sense her awkwardness. She was distant

and I felt there was a barrier between us that I could not penetrate. She entered her room and headed straight to the altar to prostrate herself before the image of Krishna and remained that way for a long time. We left her alone to allow her to adjust back into our lives.

That night I wept, not for myself but for her. I realised, for the first time, that my anger was futile. I had wasted too much time judging and analysing for five whole years, not seeing and not accepting her for who she was, but rather wanting her to be someone who conformed to my own notions and expectations.

I realised Mother's loss must have been so much greater than mine. The severe hardships of those five years had stripped her down to the core of her being. She had staked everything, including the loss of her children's love. She faced so much criticism and opposition — accused of abandoning her children and her husband, not living up to her duties as a mother and wife and selfishly satisfying her own whims. The list was endless.

However, the criticism was justified to a certain extent , because everyday life demands abiding by certain norms that are laid down by society. If someone dared to break these rules to follow their inner calling, they were seen as outcasts with no place in the world. Mother found herself in that isolated place. Her isolation in turn affected us and we all paid a price in some form or other. But I think Mother paid the heaviest price of all. She did not forsake everyone she loved and everything she did to satisfy a whim. The driving force that pushed her to such limits was so powerful that she would have willingly given up her life for that calling.

Gradually, Mother settled back into the family. However, she had changed drastically. Her spiritual moods had intensified and she remained in a trance-like state most of the time, where she forgot the world and submerged herself in her own depths. For days on end she would remain suspended in that state, sometimes without moving, at other times sitting absolutely still or lying flat on her back on the floor. She would refuse to eat or drink anything.

One afternoon, as I returned from college, the servants informed me that Mother had stopped breathing! I ran frantically into her room and saw her lying on the floor. She looked pale, drained of all colour and her lips had turned blue. I felt her hands and feet. They were ice cold. Desperate to find out if she was still alive, Pebs and I held up a small mirror to her nose to see if she was breathing. Nothing happened! Her breath seemed to have stopped. We started to panic, not knowing what to do, when Father arrived. Seeing her in that condition, he decided to get her admitted to the hospital. We somehow managed to lift her into the car and rush her to the nearest emergency ward.

The doctors who examined her were a bit puzzled because she had not gone into a coma and her brain seemed to be active. They discovered that her heartbeat was a little slow, but otherwise she was healthy and so were her other organs. They decided to keep her under observation for a while. But when, after observing her for twenty-four hours, there was still no sign of movement, they told Father that her condition was not physical, but mental. Ultimately, they decided to administer electric shock treatment to her brain. Not knowing if they had any other alternative, Father agreed.

Mother's brain was given three or four jolts of that savage treatment. Although the shocks revived her back to consciousness, her whole system received such a severe jolt that she was debilitated and unable to even walk. She looked shocked, stunned and confused, not understanding why such a thing had been done to her.

When she returned home, she withdrew completely into her shell, refusing to move from her bed. After days she gradually started to regain her normal physical functions and slowly resumed her usual activities. It was a huge relief for all of us, but for her, something had changed — a part of her had become deeply scarred by the shock treatment.

Meantime, her trances became more and more frequent and at times very deep. We had no idea how to cope with her condition; even the doctors who examined her could only prescribe vitamins and rest.

Nothing seemed wrong with her physically. Mother meanwhile continued insisting that nothing was wrong with her mentally, but no one believed her.

One day, a cousin of my father arrived for a visit. He was a monk and a teacher, who was considered a man of sufficient learning by many of his followers. He took one look at Mother and instantly realised that her symptoms were the result of an intense spiritual experience and what she was experiencing is known in Sanskrit as *samadhi* — an exalted state of divine communication.

His compassion and understanding brought some relief to Mother. At last, she seemed to have found someone who could feel what she was going through. He became her spiritual guide and teacher.

He would sit patiently with Mother for long hours, guiding her, talking and listening to her. They sat and meditated together. For the first time in years, I could feel her happiness. She suddenly became infused with a vital energy that was obvious for all to see.

Guruji, as we all respectfully addressed him, said that there is a latent energy within each individual, which in Sanskrit, is known as *kundalini*. Normally, this energy lies dormant and, therefore, cannot be felt. But with the practice of yoga and meditation, this energy can be aroused. When aroused, the energy moves through seven subtle centres within the body, known as the *chakras*. Moving upward through all the *chakras*, the energy reaches the highest point in the brain, which is the crown *chakra*, the transcendental centre. When that occurs, ordinary consciousness unfolds like a lotus with a thousand petals, expanding into consciousness that is universal and cosmic. The individual then transcends the limitations of time and space to enter the realm of expanding consciousness known as *samadhi*. This is an exalted state of divine communication. He further explained that at such moments, the person should not be touched or forcibly fed, because it can jolt the nervous system and do immense harm. The *kundalini* energy is a very potent force and therefore under no condition can be trifled with. If

My Guru In Disguise

improperly handled, the *kundalini* can play havoc with the body, causing loss of sleep, anxiety, tension and, in extreme cases, even madness.

An experienced teacher is needed to help guide a person to be able to harmonise the current. The key is to allow an unobstructed flow of energy to move through the body, without which, serious physical, mental and emotional trauma results.

A spontaneous arousal, as in Mother's case, had to be treated with great care. He advised us how and what to feed her, when to touch her, or take her for a bath, etc. He explained that when she regained her normal state, she should be given only liquids like water or fruit juices, but no tea or coffee. Gradually, solid food could be introduced. The food had to be lightly steamed and devoid of spices and salt. He further explained that in such a state the body becomes extremely sensitive and reacts adversely to the wrong foods.

We tried to follow his instructions as closely as possible. However, the task of looking after Mother was not that simple. We employed a woman specifically to take care of her physical needs but, in spite of that, there were moments when she would not move for days and she became still like an inanimate object. This symptom remained with Mother for the rest of her life and as a family we somehow tried to cope and live with her condition as best as we could.

Mother emerged from such experiences with a deep understanding of spiritual matters. With her spiritual insight, she could now foresee events and developed a healing touch. She spoke with the eloquence and wisdom of someone who had truly attained divine power. Although she never, ever talked about it, her insight was apparent to all.

Guruji left, assuring Mother of his support and promising her his guidance. Mother began to submerge herself day and night in spiritual pursuits, spending her time meditating, chanting and singing songs of devotion.

In 1965 a curious incident occurred. Two women used to regularly pass by the street that ran parallel to our house. Every time they did so,

they could hear Mother's voice drifting across the street as she sang her songs of devotion and would feel drawn to see her. After contemplating for days, they mustered the courage to knock on our door. The two women informed us they wanted to meet Mother, demanding forcefully to see her. Mother was taking her afternoon nap. They refused to leave and waited patiently for her to get up. Having no choice in the matter, we had to let them in. They remained with her for some time and then left. We never thought that we would see them again, but we were wrong. The women came back with offerings of fruits and flowers. One woman came with a child in her arms.

The woman placed the child at Mother's feet. She explained that her child was severely ill with no hope of survival. Many doctors had been consulted and the child had been in and out of several hospitals without any sign of progress.

"I am insignificant; God is the healer and protector of everything," said Mother, gently stroking the child.

She placed the child in front of the altar, at the feet of the wooden image of Krishna and began praying silently. Then she handed the child back to his mother.

"He will be alright. You must have faith in God," she said, reassuring the distressed mother.

The women did not return for some months. Then suddenly one day they came back with three other women. They streamed into her room and sat down. This marked the beginning of the arrival of many of her future disciples.

The woman with the child came again with her infant son. "Mother," she said, weeping, "I don't know how this happened. My son is much better now; his fever has subsided and he is eating again! The doctors are surprised! My husband and I can't believe this. Mother, you can never leave us now; please let us remain with you."

All at once, the women surrounded her, falling at her feet!

Mother looked a little bewildered. "I am not the doer. I don't

know anything. Please bow before that which is the supreme cause of everything," she said, pointing towards the altar.

Gradually, as the news spread, more and more people started arriving at our door. Our home became a haven to streams of men, women, children, including monks, *yogis* and mystics, all of whom congregated in Mother's room like bees around honey. Every single person felt a personal connection that drew them to her and they eventually became her disciples.

Years later, I met a young man of 25, who was one of Mother's ardent followers, only to realise he was the same person who was carried by his mother as a sick baby to be healed years ago.

As far as I can remember, our house was always filled with people — mostly women and a few men. They came from all over Delhi and the outskirts, sometimes travelling long hours to reach where we lived. Most of these women came from simple and very humble backgrounds. With the exception of a very few, none of them were highly educated, nor did they have much money. In fact, some of them were so poor that they could barely afford even the most basic elements needed to survive. The thread that bound them together was their love and devotion to Mother.

At some point in their lives, they came to her with their personal anguish and problems and preferred to remain close to her even after their problems were resolved. Each one had individual experiences that changed their lives so dramatically that they became her disciples. Although Mother disliked the word 'disciple' and never saw herself as being anyone's 'guru', her followers believed they had found in her everything that they searched for.

"God is the only guru. We are all children of that divine light," Mother would insist.

Nevertheless, they all called her 'Mother', literally worshipping the ground she walked on. They always came bearing offerings of fruits, flowers, sweets or some special dish, of which Mother was particularly fond. Even the humblest would never dream of entering the house of their guru empty handed.

Once I saw a woman bring one mango. She was so poor that she had to save for days to afford this. Mother adored her and would always eat the mango with great relish.

Those days when I was growing up, I often resented the fact that Mother lavished so much attention on them. She always seemed to be preoccupied with everyone who visited her, never giving Pebs and me the attention that we craved for.

Years later, as an adult, I gradually began to understand the ways of Mother's inner life. Her long and difficult spiritual journey had awakened in her a realisation that carried her beyond her own personal self and there came a point when she stopped identifying with only her own life and family. From that moment on, she ceased to be just a wife or the mother of her two children. For her, everyone who came to see her became a part of her larger family and, therefore, was as important to her as we were. We could never hold her exclusively, because her world had opened to include all.

But for us that was difficult to accept. We *had* a personal connection with her — for me, she was my mother and not my guru. Therefore, I saw her in a completely different light. My own feelings at not being able to penetrate beyond what I perceived to be a 'spiritual shield', surrounding her was, at times, extremely frustrating. What was difficult for us was to forget the personal aspect of our relationship with her and view her as someone from whom we sought spiritual guidance. That made our relationship far more complex and difficult. On the other hand, her interaction with her disciples was fairly simple. She was their teacher and their spiritual guide, with no other complex, personal agenda. Therefore, I often felt she found being with them much easier than being with us.

Yet, Mother never expected me to be anything other than myself. She accepted my qualities as well as my shortcomings with complete ease. I realised that, many years later, when the course of my life and the choices I had made forced me to break every mould I was cast in, I too came to reject everything that was the expected norm. In a strange twist of fate, I

My Guru In Disguise

ended up going through what Mother had been through and even though our paths were divergent, they converged in uniquely compelling ways.

I then found strength and comfort from observing her life, which stood apart from that of all others. She stood alone because of what she truly believed. If we are thinking of evolving beings, there comes a point when we have to stand alone and come face to face with our own inner truth. However, sometimes on that journey there might come a time when we feel the need for someone who would understand and support the choices that we make.

I could now understand what she meant when she wanted me to be her strength. She was not trying to hand me her burden; she was simply asking for my help and support. There was nobody else she could turn to. It was not something tangible that she wanted, all she desired was to know that I would be there and that I would stand beside her through that difficult period of her life. Unfortunately, I lacked the maturity at the time to have fully comprehended what she had meant. While Mother's destiny changed dramatically, we got on with our lives as best we could.

Meanwhile, my five-year course at the art college in Delhi ended and I began applying for admission to various colleges abroad. I wanted to experience another country. After months of planning, I received a letter of acceptance from an art school in London, and I left India to complete my post-graduate studies.

I knew a part of me wanted to escape from home and my family life. I felt that if I did not get out, I would forever be trapped in the role of a caretaker, always trying to patch and hold things together. At the same time, my mind was troubled with a feeling of guilt for leaving. I kept thinking that I was the chief binding factor that held the family together and without me to keep an eye on things, the household would fall apart. However, I later discovered that this was not true. Everything eventually fell into place and life went on for everyone. That taught me an important lesson in humility.

I remembered Mother's words, "Life will go on with or without us.

We may feel we are all-important and that without our intervention everything will fall apart. To think so is to delude ourselves. All we can do is our best and then, we simply must let go."

The day arrived for me to leave. A part of me was sad but another was excited. As the aircraft lifted off the ground, I felt pangs of separation that brought a lump to my throat. I also felt I was physically getting removed from my roots and going towards a new beginning.

I stopped in Italy on my way to England and as the plane descended in Rome, I felt my heart skip a beat. Rome opened up before me like an undiscovered distant planet and I was swept off my feet by its breathtaking beauty. I sent Mother a postcard of Michaelangelo's 'Pieta' — a hauntingly beautiful image of a mother and her child.

I arrived in London and quickly got down to settling in. Time flew for the first few months. Mother and I would write to each other at least once a month, except when she entered her intense meditative states. But she always wrote to me whenever she physically could. As the months sped by, I found myself relying more and more on the strength of her words to pull me through the many new experiences I faced.

Strangely, being away from home gave me a clearer view of my own family and my life. Living in an environment very different from what I was used to, literally matured me overnight. I faced my independence, where I had to make my own decisions, good or bad. At the same time, I had to completely fend for myself for the very first time.

I was excited to be in London. I felt free and uninhibited, but there were moments when I was lonely. At times I felt I was being judged by the colour of my skin and the accent of my English. All that profoundly affected me and rudely jolted me out of the playful world of childhood and early youth, which, with all its flaws, now seemed strangely comforting. At least there I could always fall back into a safety net. No matter how frayed, there was always someone, somewhere, who reached out and held my hand. Here I was alone.

The spontaneous lessons of childhood then surfaced, becoming my

inner guide and strength, without which I would have drifted like a leaf blowing in the wind. I began to view Mother's life in a completely new way, like an observer looking on. I became more objective and less personal.

I understood for the first time how important it was to be true to oneself, no matter how adverse the circumstances, and no matter how much opposition I encountered. To safely conform to a mass-produced ideology was no longer an option that appealed to me. However, I would need courage to do that — to walk firmly on the path of self-discovery, as Mother had done.

6

A Divine Experience

I returned to India after nearly three years, completing my post-graduate studies, and travelling around the world. I felt enthusiastic, hoping to apply all my skills to starting a new venture in India. However, my enthusiasm was quickly dampened. For me, my homecoming was not a happy one. I found everything strangely gloomy and the atmosphere heavy and depressing. Mother's moods had intensified still further and most of the time she remained withdrawn from the outside world. I don't think she was even aware of my return.

Being away from home had made me lose my capacity to cope with the reality of my family situation and the years of living abroad had changed me in many ways. All my energy had been spent coping with my new life in London. And now I felt that I had lost my ability to deal with the rigours of Mother's worsening condition. She had become thin and weak. Her trances had obviously taken a great toll on her body and for me, to see her in that condition was very difficult.

One evening, I walked into her room and found her sitting in the dark. I turned on the bedside lamp and sat down beside her, quietly observing her. Her eyes were closed and she was still like a rock. I could not help but wonder where her destiny was leading her. How long could

this go on? Some day her body would surely refuse to cooperate. What would she do then?

As I sat pondering these questions, I saw in the dim light, blister-like patches on both her arms and feet. I moved closer trying to get a clearer view, when at once I withdrew in horror. What she had were burn marks! My first thought was, *how on earth did this happen?* I was greatly disturbed by what I saw, and gently tried to nudge Mother to get her mind back to reality as she was in a trance-like state. Slowly she opened her eyes and stared blankly at me for a few minutes. There was no hint of recognition in her eyes.

"Ma? Can you hear me? Ma...Ma, it's me. I am back," I whispered.

For a moment, her eyes flickered and then she looked straight at me. I saw so much pain and loneliness that I was heartbroken. I knew she was going through a severe internal struggle, trying hard to strike a balance between her inner and outer worlds. I am sure she felt spiritually isolated. Guruji had died a few months ago and without his spiritual guidance, she was once again bereft of outside support. I could sense her inner turmoil. She had, what seemed to me, suddenly been thrown off the edge of a cliff, where she would have to either grow wings or fall to her destruction. She had absolutely no choice.

"Ma! Ma! Please speak to me," I begged with a strange urgency in my voice.

"Oh! You are back! How are you? Have you eaten something?" she replied, in a daze.

"I am fine. How did you burn yourself? How did that happen?" I asked her, firmly.

"I did it to myself. I wanted to check if I still identified with the body and the pain it causes. Am I truly detached, or am I simply deceiving myself? I wanted to see where this 'me' that I identify with ends and where the real truth of who I really am begins. That's all."

I was so shocked by her reply that I could hardly think straight. I jumped up and began to pace the floor angrily.

"How could you do this? This self-inflicted pain is not the way to find answers to your inner conflicts! That is a way of torturing us all! Most of all yourself! How could you?" I shouted.

Something tightened so hard in my chest that I felt I would explode. Such an overwhelming sensation gripped me that I ran out and locked myself in my room. I felt restless and strangely helpless. I knew a part of me no longer belonged here; a sense of detachment engulfed me, making me want to just get up and leave. The safety net I was so hoping to find had actually been an illusion that no longer existed, or perhaps I had outgrown its boundaries. Why did I return? What had I expected from my family? My shoulders were no longer capable of carrying the weight of this bizarre family situation.

Mother was going through a crisis. All we could do was helplessly stand by and watch her fade. There was nothing anyone could do to help her and that really made it hard for us all. She was putting herself through a severe test, to see how much her faith could endure, and for that, she had to walk alone. According to the rules laid down by the ancient Indian law of *dharma*, which literally means, 'to do', an individual's life is divided into four distinct stages — the child, the student, the householder and the ascetic. Only mystics, madmen and geniuses had the freedom to break the expected norms. Perhaps Mother belonged to one of those categories.

I could see her struggle to find an anchor within, something that held her steady when she fluctuated between the physical realm and that of the spirit. On some days she seemed as if she had succeeded. She looked content and happy. People would surround her, sitting with her for hours and listening to her speak. But that would soon change when the inner pull was so powerful that it would sweep her away into a different reality, making her once again lose all sight of the present one.

Many people thought Mother had become insane, and that included some members of our family. But there was something in me that always believed her state to be beyond our limited understanding. Whatever

was happening to her was certainly not madness, because never had I ever seen so many lives so profoundly transformed by a mad person! There was something much deeper, much more powerful, that attracted people to her like a magnet. To me, the only madness she was touched by was of a divine nature, which gave her unspeakable inner joy, yet at the same time making her day-to-day life difficult and lonely. Nobody from the outside could understand and reach her inner world, except, perhaps, her guru, who was no longer there.

Father, in the meantime, was touring abroad where he was invited to show his unique collection of *tantric* art, which he had accumulated over many years, and which had now grown into a significant collection. His book, *Tantra Art*, was recently published, creating a great deal of interest in the West and in Japan. He was constantly on lecture tours, away from home for weeks. During this period Father met a young woman with whom he shared many interests and had a lot in common. They became good friends and their relationship gradually evolved into something far more serious.

Unlike our family, this young woman came from a very normal and loving home. However, since she was only a few years older than I, her parents were deeply concerned with a situation that was rapidly getting out of control. They knew how difficult the consequences of such an affair could be for their daughter, especially in a tradition-bound country like India.

They decided the most prudent thing to do would be to meet Mother to discuss ways of putting an end to the alliance. They arrived one afternoon to talk to her. Even though the circumstances of their meeting were highly unconventional, they were most respectful of each other.

I remember Mother sitting in silence, listening to them and what became obvious was that they were deeply distressed and hoped for a swift outcome. But much to everyone's surprise, Mother gently declined to take any action whatsoever. Realising the futility of their visit, they took their leave.

As soon as they left, I angrily rebuked Mother for not taking a stand and for always avoiding any situation that demanded direct confrontation. I told her that her lack of interest in keeping our family together was absolutely unforgiveable.

As usual, Mother sat in silence until I had finished. Then, in a very calm voice, she said, "They have very strong *karmic* (past life) connections. Don't you see? They were bound to meet in this life in order to fulfil their joint destiny. No power on earth can stop them from doing so. Nothing happens by chance; nothing is an accident. Remember that always."

Much later in my life I understood how evolved and wise Mother's approach was. Ironically, Pebs and I later became the best of friends with that young woman and, to this day, she remains a part of our family.

By the time I returned to India, Pebs had entered her teenage years and was going through all the normal experiences of growing up. She had a large group of friends who constantly hung around our house. Even though our house was a carefree and easygoing place, Mother's condition made our household unlike any other. Pebs had a hard time reconciling the opposing sides and this alienated her from Mother even more. Some of her friends were not even aware that our Mother lived in the same house as us.

Over the centuries, much has been written about many spiritual masters and mystics of India. These individuals are deeply revered and respected because they are viewed as a physical link between the earthly and the divine realms. Although there are numerous written testaments on mystical lives, there are hardly any from a family's perspective. A guidebook on how to cope with the day-to-day difficulties of living with one, within whom a spiritual storm is constantly raging, simply did not exist.

Mother's spiritual experiences were so powerful that she would be shaken to her very core. Her body became helpless, unable to sustain the force of the energy that charged through her physical form. On many

Mother dancing in ecstasy

occasions, I found her pacing back and forth, reminding me of a caged *cheetah*, brooding over his lost freedom. I found that perplexing and very painful to watch, especially because there was nothing anyone could do to relieve her.

I thought a change would do Mother good. I suggested we take a trip together. We decided to visit some places of pilgrimage in the northern regions of India. On the morning of our departure, I found the keys of our suitcases missing. Without thinking, I immediately presumed Mother had misplaced them. I literally jumped on her and accused her of being careless and indifferent towards everything. I told her that her moods were out of control to such a degree that she could no longer function like a normal human being. I accused her of never remembering where she was, or where she had placed anything. As I spoke, I could feel my temper rising, making my face hot as my emotions gushed out uncontrollably.

Suddenly, the lost keys were no longer the issue, but those years of feeling lost and alone and without any support. I told her that both she and Father were unfit parents who did not deserve to have any children, as they were both utterly selfish with only one aim in life — fulfilling their own desires, whims and fantasies.

All through my verbal onslaught, Mother sat in stony silence. I knew I was stepping over the line and becoming truly hurtful, but I was in such a frenzy that I was powerless to stop. Seeing Mother sitting there, without uttering a word, angered me even further. I would have preferred some reaction and then I could stomp out without any feelings of guilt. *Why should I feel guilty*, I thought. *They are responsible for what has happened, not I.*

As I shouted, I turned her suitcase upside down, hoping to find the keys. On not finding any keys in her siutcase, I turned mine around, pulled all my clothes out and began throwing them in every direction. All of a sudden, I spotted something shiny at the bottom of my suitcase. There were the lost keys! I must have misplaced them while I was packing.

I felt as though someone had hit me hard on the head with a sharp instrument. For a second, my breath left my body and I felt my hands and feet getting sweaty.

I turned to Mother and said in a shaky voice, "Ma, I am so sorry. Please, please, forgive me. I didn't mean to hurt you. I am sorry, so terribly sorry."

By now I was almost on the verge of tears. I kept looking at her face and caught a fleeting glimpse of hurt and sadness cross her face as she sat still without uttering a word. I think she was contemplating how to respond.

"I can understand your anger," she replied, softly. "But remember, we are all here for a reason — to learn and discover who we really are. This is the main objective of life. We are all walking the same path. Priya, if you were to remove the mask that hides your true nature, you would find that we are all on that same journey. All of us stumble, and sometimes we even fall, but the infinite love and grace of God always lifts us gently back on to the path. We must never lose sight of that truth. Come, let's prepare for our trip; we don't want to miss our train, do we?"

I felt so devastated by my own folly that I couldn't utter a word. I sat opposite Mother, staring blankly at the countryside as the train moved rhythmically along. Mother's face was calm, her expression still and she was silently praying.

Her immense faith in a divine plan which would support and carry everything, including her own life, was so strong that absolutely nothing could shake her conviction. She never saw the hardest suffering as an impenetrable barrier. Her eyes had the capacity to look beyond the obvious, to see and understand that everything that happened was like a gateway that would ultimately lead to true self-knowledge. She never argued or defended her actions. Instead, she always showed me a different way of looking at and understanding life and the struggles that we faced.

I took this incident deeply to heart. I was reminded that words hurt

as much as any weapon, therefore I knew that I must never misuse this power. I learned a bitter lesson, that uncontrolled anger is poison, which eventually destroys you from within and that we have no right to presume anything regarding anyone. Even when we think we know all the reasons, we can still be wrong and words once uttered can never be erased.

Mother and I reached Jaipur — the 'pink city' of palaces and temples, the capital of the desert state of Rajasthan where ancient ways co-exist with the new.

Mother walked briskly ahead as I ran behind, trying to keep up. Her pace was urgent, like that of a long lost lover who was going to meet her beloved after a long separation. We were headed towards the temple of Krishna, a well-known place of pilgrimage. The temple had been built by the Maharaja of Jaipur, who, according to legend, was told in a dream to re-locate the image of Krishna, which was at that time in a small temple in Bengal. The image was transferred from its original site to Jaipur, where the Maharaja built an elaborate temple surrounded by a beautiful garden.

It is customary for us to always enter a sacred place barefoot. Mother and I removed our shoes and left them with the 'shoe-keeper', who sat by the temple gate. In a way, this symbolised leaving behind the ordinary level of existence outside the threshold. Hundreds of pilgrims were gathered outside to buy flowers, incense and fruits to take as offerings. We bought beautiful garlands of fragrant, white tuberoses interspersed with blood-red roses. Mother carefully chose ripe pomegranates and sweet grapes. She picked up a packet of sandalwood incense and then, dodging through the crowd, reached the main courtyard.

There were old and young, men and women, as well as children. They all stood waiting impatiently for the altar doors to open. We moved slowly through the crowd towards the front end of a large courtyard where devotional songs were being sung. The crowd began to join in, swaying in unison with the rhythm of the songs in praise of Krishna. Mother and I joined in the chorus. Soon we were lost in the intense

My Guru In Disguise

fervour of the moment. Some wept, some laughed, while others closed their eyes in meditation. Some were seen praying loudly, calling out to Krishna, their beloved flute-player.

Krishna is not a historical figure but rather a concept, a personification of the God-head. To his devotees, Krishna is the embodiment of pure love; the divine one, who attracts all to himself through the enticing sound of his flute. He is worshipped in many forms — as a child, a friend, a lover, a king, depending on the temperament and attitude of the worshipper.

Mother was totally lost to the world. Her eyes were glued to the altar and her whole being seemed to be strung up like a finely-tuned instrument awaiting the touch of the master musician. Her voice quivered with emotion as she sang along with the crowd. At last, the doors of the shrine opened. The crowd let out a roar of appreciation and surged forward. "Praise Lord Krishna! Praise Lord Krishna! Praise Lord Krishna!" they chanted.

I caught a momentary glimpse of the image when the priest quickly opened and closed the curtains three times in a ceremonial ritual, as if to entice the devotees.

At last, the image of Krishna appeared in full splendour! He stood with his head tilted to one side, his crown of gold studded with precious stones gleaming in the warm glow of hanging oil-lamps. Garlands of marigolds, roses, and tuberoses draped his neck and the perfect peacock feather on his crown swayed gently in the breeze. His blue form was wrapped in vivid turmeric-yellow cloth of pure silk, under which his delicate feet appeared adorned with tiny anklets made of gold. He held a beautifully carved silver flute to his ruby-red lips, playing his enchanting music of love that only his true lover could hear. His skin was dark blue like a velvety starless night and his eyes shone like milky white lotuses, within which floated two black orbs that pierced the heart, attracting Mother like iron to a magnet.

The priest prepared for the morning prayers. Large copper platters

laden with a variety of fruits and flowers were placed before the deity as offerings. The fragrance of incense drifted through the air, as a gentle winter breeze rustled through the branches of ancient banyan and *neem* trees that had stood for centuries, bearing witness to this unbroken rite.

Noticing Mother's intense devotion, a priest came up and took her offering to the altar. He garlanded Krishna with Mother's flowers, placing the fruit and incense before the image. I observed Mother from the corner of my eye. I could see her absolute delight. For her, that gesture had personal connotation which was very special. Her darling Krishna had accepted her heart-felt offering of love.

Soon, the ceremony began with the sounding of bells and gongs and the blowing of conch shells. The crowd started to chant slowly as the priest began the ritual by making offerings that symbolised the five elements.

Next to Krishna was the image of Radha, who is considered the supreme embodiment of devotional love. By meditating on her, the very essence of Krishna can be reached. She symbolises the individual longing for the divine. The ultimate goal of the devotional aspirant is to unite individual consciousness with the object of devotion, removing all notions of separation.

The priest waved an elaborately configured oil-lamp before the deities with the skill of an elegant dancer. The flames leapt up, reflecting off the gold ornaments, dazzling the eye and simultaneously casting deep shadows that moved across the images, creating a lucid interplay of dark and light and making the figures seem strangely alive. The ritual known as *puja* drew to a close, with a showering of crimson rose and marigold petals descending in a cascade from above. The crowds gradually began to thin out as Mother and I started to walk back to the main gate to collect our shoes. We walked up to the man and pointed to our shoes. He tugged at Mother's feet, insisting on helping her. Mother told me to give him twenty rupees, which was far more than usual. As soon as he reached out for the money, I noticed that two of his fingers

My Guru In Disguise

were disfigured with leprosy. Instinct made me recoil as I dropped the money on the ground rather than touch him. At that moment, Mother turned and gave me a steely look. I could sense her anger, even though she did not utter a word. Instead, she leaned over and touched the man's head. She gently ran her fingers through his hair and touched his face tenderly. The man was shocked. Being a leper, he was shunned by everyone and was an outcast from society. To be touched in such a way was so overwhelming that he began to weep.

"Mother, Mother, Mother," he whispered, looking up at her with liquid eyes that would melt the hardest of hearts.

"Why do you cry? You are the most blessed amongst us all. The Lord has chosen you to be his gatekeeper! How lucky you are to be so close to Krishna!" she said, tapping him gently on the shoulder.

His little son stood wide-eyed, leaning against his father. I studied the boy carefully — he was completely free of the disease.

Mother caressed the little boy's face. "Look after your father when you grow up," she said.

The boy nodded his head and clung tightly to his father.

An indescribable feeling engulfed me and I felt the urge to move and touch them both.

Mother and I hopped on to a bicycle-rickshaw to head back to the hotel. We sat in silence. Mother's gaze was distant and contemplative. We rode along through the crowded marketplace where buying and selling was in full swing. Voices raised loud in bargaining filled the air, along with the hustle and bustle of noisy traffic and the blaring sound of Bombay film music.

My mind was distracted. I looked at everything without really seeing anything, feeling more like an onlooker than a participant. All images and sounds passed me by in a haze, like shadows behind a screen. I couldn't forget that father and his son.

We arrived at our hotel, feeling exhausted. That evening we sat outside on the veranda and watched the pale light of dusk shrouded in

a faint winter mist. As the sun slipped below the horizon, we felt a slight nip in the air. At last, Mother and I settled down for the night. Although I felt tired after a long day, no matter how hard I tried, I could not go to sleep. I felt restless and unsettled.

I woke up early next morning. Mother was already up and sitting in the veranda, absorbed in her morning meditation. I went and sat down beside her. To my surprise, the moment I sat down, I was swept away by an overwhelming emotion that shook my body and made me weep. My throat hurt and I kept wiping my runny nose against my sleeve. I was being carried away by something that I could not understand. Mother opened her eyes and looked at me in such a calm manner that I was taken aback. I felt, she had known that I would react in this way.

"Ah! This is very good. I see the bug of devotion has bitten you too! I think your heart is aching for another glimpse of Krishna. He has managed to steal your heart, don't you think?" she asked, almost gleefully.

Suddenly I knew she was absolutely right! At that moment, more than anything else, I wanted to go back to the temple.

"Let's go," Mother responded, getting up at once. She never hesitated at times like this.

There was an urgency in my heart that I simply could not comprehend or analyse. I felt somewhat helpless and confused.

Reading my thoughts, Mother explained, "Deep internal feelings can never be fully understood by analysing; they have to be experienced. Try not to think too much. First, experience and feel, and then automatically all questions will be answered. What you are feeling is a longing, a thirst for your inner spiritual connection to the truth of who you are, which is nothing less than that divine light. The time has come for you to awaken to your spiritual destiny."

We went back to the temple and the moment I stood before the altar, I experienced a wave of delight that was beyond description. I totally let go of myself without any feeling of self-consciousness or restraint. Mother raised her arms high above her head and started dancing like a

My Guru In Disguise

whirling *dervish*. I joined her, pacing my step with hers. My body moved effortlessly, feeling light as air. Soon, I felt layers of my outer persona falling away, freeing me from the conditional and limited view I had of myself. I felt a great sense of freedom that is hard to describe. All feelings of restlessness magically disappeared, and that night, I slept like a baby!

After our stay in Jaipur, we headed towards Vrindavan, a spot held sacred by all devout believers. According to myth and legend, this is believed to be the birthplace of Krishna and is associated with his childhood pastimes. The call of Vrindavan was what compelled Mother to leave home.

Mother and I walked through a thicket of wild grasses growing by the banks of the Yamuna river that flowed though Vrindavan, on that crisp, clear evening. The full moon had already appeared radiating a pale glow, which cast a misty halo that merged into the dark ultramarine blue sky.

"Every particle, every grain of dust in this place is sacred. So many great souls have stepped on this soil, spending years, seeking Krishna within their hearts. The spiritual energy they emitted has made Vrindavan so special," she explained, rubbing a fistful of dirt on her face and arms, and putting a little into her mouth.

"Don't think this is just ordinary dirt. This earth is charged with spiritual energies that can have a transforming effect. Wherever you are, you should scatter this dust and sanctify that place; then, no matter where you live, that place will become as sacred as Vrindavan. Go on, put some in your mouth," she urged me, putting some more in her mouth.

I gathered a handful and tied a portion to the corner of my shawl, licking what was left off my palm.

"Have some more, have some more," Mother kept on insisting.

The dirt was dry and gritty, but somehow I managed to gulp down a little more. Mother looked on with great satisfaction. "Good! Very good! May you get infused with great love for God; may your spiritual life blossom like a beautiful flower," she said.

Vrindavan is not the kind of place that reveals itself to a casual visitor. From outside, the place looks old and dilapidated, filled with ancient temples that are in ruins and inhabited by a large population of what Mother Teresa called "the poorest of the poor." Then there are the local priests and shopkeepers, hordes of devotees and a few extraordinary souls and mystics.

In other words, this is not the usual tourist spot with grand places of worship that can be photographed for posterity. Here all preconceived notions have to be shed in order to truly experience the undercurrent of spiritual energy that permeates this place. For the devout believer, this is paradise — a place where their beloved Krishna dwells. But to the non-believer, this is just another shanty town in India.

For Mother, Vrindavan was paradise. As we passed through a narrow path that was lined with trees, she touched some of the branches and leaves. At times, she paused before a large tree to caress its massive trunk lovingly.

The air was filled with the heady fragrance of some exotic tropical flower. From somewhere the sound of bells drifted in gently with the breeze. At a distance, I could see a small shrine with a few oil-lamps.

Mother quickened her pace and repeated under her breath. "Come! Come! Oh, light of all lights, Krishna, the treasure of my heart, Krishna, the breath of my breath. Krishna, Krishna, Krishna, Krishna."

In her haste she dropped her shawl and her sari fell off her shoulders, trailing behind her. I ran behind her in a futile attempt to cover her shoulders with her sari and her shawl. That was not easy because I just could not get her to stand still for even a moment.

"Just a minute, Ma! Keep still. Just a minute," I kept repeating.

Her consciousness was so deeply focused on the object of her devotion that she was totally oblivious of me.

We arrived at the shrine. Mother lit an oil-lamp and sat cross-legged, facing the dancing images of Radha and Krishna. The figures were

My Guru In Disguise

intertwined, depicting the embrace of the lover and the beloved, symbolising the union of the individual soul with the divine.

I sat beside Mother and closed my eyes in an attempt to meditate. I could hear a dog barking in the distance. The sound of chattering crickets and rustling leaves were intrusions distracting my mind, which was jumping from one thought to another. I opened my eyes and looked at Mother. She sat still like an inanimate object. I closed my eyes and tried again. This time I simply listened to all the sounds without trying to block them out. As I did this, all the sounds gradually blended into each other and faded away, taking my mind into a new state, where I could actually hear my heartbeat and became conscious of the flow of my breath. Gradually, without any conscious effort, I became perfectly still.

I had no awareness of how long I remained in that state. I felt as if I had left the realm of time and moved into a space where there was no time. A deep sense of peace descended upon me, and momentarily I forgot my body and its limitations. I felt no aches, no pains, no itch; nothing. Yet, at the same time, my awareness became highly acute. As soon as that moment passed, I felt as though something had burst inside my head suddenly. I could feel pins and needles in my feet and my arms felt fatigued and my back started to itch. I tried hard to visualise a beautiful lotus to regain my concentration but to no avail. Soon my mind started to jump like a monkey from one thought to another.

I opened my eyes and found Mother seated in the same position. I observed her face — her eyelids did not flutter, her eyeballs did not move and her breath was hardly perceptible.

The sound of crickets had reached a maddening crescendo when she opened her eyes. She prostrated herself before the altar and I did the same. Pausing for a moment, she gazed at the deities. Her eyes were transfixed, her lips moving from time to time as though talking to someone. I strained my ears to hear what she was saying but could not understand a word. She smiled and pointed in my direction, whispering

something in a strange language. We returned to the guesthouse late at night.

Next morning, Mother and I had breakfast on the covered porch outside our room. Promptly, several monkeys appeared. They sat on branches of the large trees that surrounded us — the bolder ones ventured close to where we were seated. They were most amusing to watch. Their eyes were full of curiosity and mischief as they sat eyeballing us, trying to threaten us to give up our food. They scratched, fidgeted, and screeched, jumping about from place to place and from branch to branch. Their expressions looked almost human as they pulled comical faces at us.

Mother observed them. She was very amused at the antics of these natural clowns. She threw them bits of bread from time to time, which they all grabbed greedily, stuffing their mouths with such gusto that their cheeks bulged out, reminding me of inflated balloons.

"The uncontrolled mind is like these monkeys — thoughts jumping from one point to another, constantly filled with anxieties and desires that are non-ending. Most of us are enslaved by our minds. The problem is that we all lead our lives as victims, not as free beings that we really are. Habits hold us captive like slaves. On the other hand, a calm mind is like a still lake without any ripples and is tranquil and fully present," she said, gazing at the monkeys.

"How can one reach this state of stillness? This is not so easy," I responded, remembering my meditation of the previous night.

"Nothing worthwhile is ever that easy; there can be no growth without inquiry, without sacrifice. When we see a graceful dancer, the movements feel so effortless, but to achieve that level of mastery requires perseverance and effort. The mind, which is restless by nature, also requires perseverance to become still. Then there is no struggle, no agitation; everything becomes effortless because that is our true state," she explained.

"Why is it important to be still?" I asked.

"Why? Otherwise we are just like these monkeys! That's why. Have

you ever tried to see your face in a lake with ripples? What you see is a distortion, not your true reflection. Remember, we have not been put on this planet just to eat, sleep, procreate and die, and to spend all our lives working towards selfish self-preservation and fulfilling just our bodily needs. We humans are endowed with awareness, a consciousness, that has the power to unveil in each of us the infinite capacity and mystery of who we truly are.

"Once you strip away all external forms of self-identification and question yourself, who are you then? Does everything stop with your transitory outer self? Always ask yourself, 'Who am I? Why am I here? What does all this mean'?"

"What does all this mean, Ma?" I asked.

"To realise that we are infinite, boundless, unlimited, and the infinite is a part of us and that we are a part of the infinite. This is not just an abstract notion. This is the *truth*. We all are an integral part of the whole, but we have forgotten this. We allow our minds and bodies to define who we are, erecting walls that are built on our limited egos and which segregate us. This state of delusion, of disconnectedness, makes us cling to an ever-changing, transitory reality as we perceive it to be the *only* reality that exists. The *Upanishad* describes this so simply: '*He alone sees, who sees all beings as himself*'."

Mother and I returned home only to find that everything in our lives was about to change drastically.

7

A Drastic Upheaval

Father announced that he had received an invitation to go to Germany to work on a project for two years. At first, nobody was sure what to do with Mother. She needed special care and attention and to move her would be difficult. I would have to remain with her, or else we would all have to move.

I felt so drained physically, emotionally and mentally that I knew I could never cope, even with all the help that was around me. I knew I had made a mistake by coming back to pick up the pieces of a life I had left behind. I felt as if I was trying to drive a car in reverse. My enthusiastic plans to start a project in India did not work out for many reasons, primarily because of my unsettled family situation.

In the end we decided that we should all move. I felt I needed to get away from home, to re-evaluate the direction of my life. I thought, perhaps, being in a different country would give me some clue as to which way to turn.

Soon we all found ourselves in the throes of packing and wrapping up the house in India. Our loyal staff was heartbroken to see us leave and so were we. I think we knew that this was the end of an important era for all of us.

Mother at our house in Hamburg, Germany

Although Mother would have preferred to remain behind, there was no way we could leave her alone. We moved to Hamburg, into a nice house just outside the city. At first it was pleasant enough. Perhaps, we all needed a change of environment from our lives back home.

Father decided to take Mother to see a specialist who could treat her both physically and psychologically. The physician was a kind and sensitive man, who took a special interest in her well-being. Under his care, Mother's physical condition improved. However, her inner experiences continued as usual. Without the support of an experienced staff, we could not adequately take care of her needs, which were increasingly more demanding. Like a child, she now had to be fed, bathed and kept under constant surveillance, in case she fell down or hurt herself, but most days she would be lost in a trance.

I soon found myself in exactly the same position as before; in fact, it was much harder without the support we had back home. As time went by, I began to feel strained, trying to cope with everything around me. Learning a new language, as well as adapting to a strange environment, plus the added responsibility of looking after Mother finally became too much for me.

The familiar sensation of being hopelessly trapped returned with a vengeance. I felt like a vagabond with no sense of belonging anywhere. Lying in bed at night, I found myself filled with anger, and all ideas of forgiveness and understanding vanished. For me, that was heartbreaking. I had struggled so hard to resolve and to forgive, but now, obviously I had failed the test. Faced with a difficult situation, I simply buckled under the pressure. I was angry with myself for not having the strength to rise above everything. Now I knew for sure that the summit of the mountain had moved further away than I had believed.

I felt torn between my need to be close to Mother and take care of her and my desire to leave, to be free and unburdened. I faced the two sides of my own nature, where I saw nothing clear-cut, black or white. All my feelings and emotions overlapped, creating new layers that again needed

My Guru In Disguise

to be witnessed. The moment I thought I had found the answers, the scenario shifted, leaving me baffled and uncertain.

Perhaps that is where the mystery of truly discovering myself was hidden. I knew I would have to keep struggling, to peel away the layers, and go through the process of learning all through my life. I found myself standing at the crossroads, where I would have to either break away and carve my own destiny, or remain in a difficult family situation, eternally playing the role of the caregiver.

Although I knew my family was capable of managing without me, I felt I couldn't just sit back and do nothing. I was deeply affected by my surroundings. I could no longer continue to pretend that everything was just fine.

At times, Mother would tell me how she would have liked to spend the rest of her life in an *ashram*, now that Pebs and I were no longer children, who needed her presence. That was not an option given her present condition — leaving her on her own was too dangerous. A powerful force ripped through her and I could see her struggle painfully to cope. There were brief moments when she would come back to this reality and that was when we would interact a little with each other.

Father decided that Pebs and I should take Mother to London for a short trip. He felt it would give us all a much-needed break. However, that turned out to be an unwise decision. We found getting around very difficult, because Mother remained in a semi-trance throughout the ten days we were in London. Sometimes people would stare at her when she staggered and walked in an unstable manner, thinking she was drunk. Pebs and I had to hold on to her from both sides to prevent her from falling.

I think that was the darkest hour in Mother's life and what was perhaps known as the 'dark night of the soul'. To me, she was like the lone voice crying in the wilderness. I heard that voice but was powerless to respond in a manner that truly supported her. I could not join her on her quest. She was alone on her journey; so was I.

Deep within myself, I felt I was one of the very few who could understand a little of what she was going through. Because of that I found I couldn't simply disengage and leave. Was I being selfish, wanting to live my life without the responsibility of caring for Mother? Was I prepared to dedicate my whole life to looking after her and following her on the spiritual path? I grappled internally with these questions constantly.

Finally, I came to the conclusion that I would have to follow my own path and learn my own lessons. That was exactly what Mother had done. I needed to experience what my destiny had in store for me. I would still care for Mother — being there for her when she needed me, but I was not prepared to dedicate every moment of my life to her. I decided to leave again for good. I went back to London and settled there.

Ultimately, Father completed his assignment in Germany and moved the family to London to work on his new book with his publisher, who was based there. Pebs enrolled in a design college, and soon after graduation, she married her English classmate and settled down in London. Mother was moved to London temporarily, until a more suitable situation could be found for her. I lived about thirty minutes away by tube and visited her often. Sometimes I would bring her over to my flat to spend the day with me.

I remember the afternoon she was with me. I was suddenly jolted by the sound of loud music from across the living room. She was playing one of my old long-playing albums.

Mother loved every form of music. For her, music was the universal expression that connected us all. I remember when she was younger, her voice was clear and exquisite, but as she grew older, the strains and inner turmoil of her life took a toll on her voice. Nevertheless, she always sang with so much heart and feeling, that everyone who heard her would invariably be moved by her voice.

"You must develop a spiritual ear. Once you can do that, no matter what you listen to, it will remind you of God, making every feeling a

My Guru In Disguise

gesture of devotion, no matter what the song. If you can direct those emotions to God, it will have a transforming effect and become meditation without any effort," she would tell me, knowing my love for music.

That day my curiosity got the better of me. I noticed right away that her face was glowing with joy, but her eyes were focused elsewhere. She swayed from side to side to the rhythm of the music. Her heart, her mind and her whole being were lost in divine communion. I knew what I was witnessing was something rare — a world that was so joyous and intimate for her, but remote for the rest of us, for whom that secret door of inner communication still remained locked. I stood and watched her silently for a long time.

The music played on, each song evoking a different feeling, triggering a different emotion. The music was not a chant or a devotional song, as one would expect, but the voice of Nat King Cole! His smooth, velvety voice filled the room with tender and beautiful love songs. Sensing that someone was in the room, she opened her eyes and smiled at me. I felt as if I had intruded upon a very private moment.

Seeing me standing at the door, she swiftly moved towards me with her arms outstretched. "Come, let's dance," she said.

In no time, I found myself holding her and we started twirling around. Her feet barely touched the ground and she felt light and airy. The room disappeared in a haze as we moved across the floor in total abandonment. The music played on.

The very thought of you
and I forget to do
the little ordinary things
that everyone ought to do.
I am living in a kind of daydream,
I am happy as a king.
And foolish though it may seem,
to me, that's everything.
The mere idea of you,

the longing here for you,
you'll never know how slow
the moments go,
till I am near to you.
I see your face, in every flower
your eyes, in stars above.
It's just the thought of you,
the very thought of you
my love.

I could hear her humming softly. From time to time she would heave a sigh, repeating, "O! Krishna, O! Krishna, where are you?"

She was so engrossed in that mood that I could only describe her as being inebriated. She reeled like a drunkard and I held on to her tightly to prevent her from falling.

After the music ended, I led her to a chair. She sat with her legs crossed and her eyes glistening with tears. She wept like a child, like someone who had lost the greatest love of her life. I sat with her in silence for a long time. As I watched her, I tried to imagine what her inner state was like.

Although a part of me shuddered seeing the intensity of her spiritual moods, there was another part of me that was extremely curious to find out all that I possibly could about her spiritual ways. I tried to grasp what was happening to her and look beyond what many were saying about her. Their implications were that she was losing her mind. Perhaps in a strange way, that was true, because the realm she was in was beyond the limitations of the mind and logical thought. To the so-called 'normal' world, which is governed so completely by the power of the mind, her world seemed bizarre and strange. Observing her I could see, once again, that she was experiencing her great love for Krishna.

"Ma, please drink this," I said, handing her a glass of orange juice.

I knew that listening to the music had brought to the surface intense spiritual emotions. At times, giving her a drink helped to bring her mind

back to a normal level of awareness. I coaxed her gently to drink the juice. She took a few sips as I held the glass to her mouth. Gradually, she began to regain her outer awareness.

"Are you feeling a little better?" I asked.

"Why? There is nothing wrong. I am fine. I was experiencing such joy that is very hard to describe. When I am in that state, it becomes very hard for me to come back," she explained, looking at me in the most normal manner.

"Well, I am glad you feel fine. Want to watch some TV?" I asked, trying to divert her mind.

"No, no! They show such rubbish, such a waste of time," she said, crinkling up her nose in displeasure.

We sat in silence for a while. I found myself vacillating between opposing feelings. A part of me was drawn to Mother's spiritual life, yet at the same time, I was afraid of what that entailed. Seeing her go through those spiritual storms was frightening and a part of me was terrified of what I might encounter if I followed the spiritual path like hers. However, Mother always reassured me that it would not be the case for me. Mother would speak of spiritual matters only when she was asked. Therefore, my conversations with her were borne out of a sense of inquiry. For me, those conversations were like teachings that made me feel and see things very differently. That was also my way of connecting with her, because nothing else held her interest for too long.

So I broke the silence and asked her, "Why do you weep when you remember God?"

"When tears flow at the sound of the divine name, when you are deeply moved by something that reminds you of God, then you can be certain that you have walked through that last door into the very heart of divine presence.

"Tears wash away all the egotistic imperatives of the mind, softening the heart as it begins to directly experience the magnitude of divine love. But who loves God that way? Very few," she said, shaking her

head sadly. "Do you know why? When you love God more than anything, you forget everything else. Divine emotion carries you away so powerfully that the whole world dissolves and all that remains is pure, unadulterated love," she explained.

"What is this divine love? How can I know that?" I inquired.

"You already know that somewhere within the very core of your being. That love is God. Your conscious awareness has to be awakened to this wisdom. Have you seen a grasshopper?" she asked suddenly. "Well, look carefully and you will see the face of God."

"Why a grasshopper, Ma?" I asked.

"Well, why not? The light that is God is everywhere, in everything, in every creature. When you develop spiritual eyes, spiritual ears, a spiritual mind and body, then all becomes clear that everything stems from a singular divine essence, both within and without.

"When all that you do and everything you think and feel becomes linked to only God, then all disparities and differences disappear. Then there is no distinction between looking at an ant or a grasshopper, the face of a child or a mountaintop, going to a temple or a church. Everything becomes a reflection of only that divine light that shimmers like molten silver, permeating everything. There is no point in just analysing with one's intellect. Everything has to be experienced and felt fully," she explained.

Observing Mother, I realised that she was a true free spirit; one who was not bound by any dogmas whatsoever. She could not be categorised or defined by the usual established social idioms. Her spiritual insight and experience had allowed her to liberate herself from any kind of narrowness and to develop a wider, more universal vision, where everything she experienced and felt became a part of her own being.

Living in London was tough for Mother. Most of the time she remained at home, except for a few rare occasions when Pebs and I would take her out to do a little shopping. She missed the company of the women and the spiritual atmosphere of home. Sometimes, to occupy herself, she would draw and paint.

My Guru In Disguise

One day I found Mother sitting on a couch, with a small sketchbook on her lap. She was working with colour pastels, her hands moving rapidly across the page and creating images with a spontaneous sense of abandonment. Seeing me standing by the door, she gestured me to take a seat.

"Felt like painting today," she said.

She was making little pencil drawings at great speed. She was tossing the drawings over in a casual manner after she had finished them. Her hand moved with equal ease with the watercolours. She held the brush deftly, moving across the paper with a great sense of freedom.

"Why did you stop painting? I remember you used to paint for days on end when I was little," I asked.

She hesitated for a moment, as if to gather her thoughts.

"Yes, I really did love to paint and still do. I like to play with colours. But, Priya, when those spiritual storms were raging within me, I became lost to the world. I didn't know if it was day or night. I had no sense even of my own body. How could I possibly paint in that condition? Moreover, I started to understand that painting, like any other creative pursuit, could only be a means that carries one to an end, but is not the end in itself; at least not for me."

"What do you mean?" I asked curiously. "Don't you think that when we paint, or write poetry, or do any other creative activity, it is like meditation?"

"Yes, it is, provided you do that in the right spirit. First and foremost, creative activity must always give you joy, sheer pleasure and should never feel like work but always like play. You should never feel self-conscious about the outcome. Just be carefree, never worry too much. If, in the end, you don't like what you see, just try again," she explained.

"But my work, as you know, is very precise. I think before I start. Is that wrong?" I asked.

"No, no! You are confusing what I am saying. It doesn't matter how you paint or what you paint. What matters is what you *feel*. Whatever

you do should free you from your limitations. If not, then, it is no longer what being creative is all about. Do you understand?

"For me, all creative activity is like a vehicle that takes you from one point to another and once you reach your destination, you have to leave the vehicle and step out. You cannot be content just sitting inside," she explained, trying to make me understand.

"Why can't creative activity be an end in itself? Why does it have to lead somewhere?" I asked.

"True creativity is a tool for self-discovery. Meditation, too, is a tool. Remember, a tool gives you the means to unlock a door, but once you have arrived at the threshold, you cannot just stand there looking at the tool; you have to cross the threshold. You have to move even beyond what you consider is your creativity. Mind you, if your creativity becomes something that traps you into excessive self-involvement, then it becomes like a chain attached to a ball that holds you down. True creativity should always set you free!"

Mother's attitude regarding her own art was a total sense of play and complete freedom. At times, during her early days of painting, Father would organise exhibitions of her works where collectors bought many of her paintings. But as soon as she felt she was expected to make her art into a career, she immediately lost all interest. For her, it took all spontaneity out of her work and became too structured. I remember reading something Mother had once written about her art:

"From my childhood I have had a passion for singing. Later, inner tensions led me from music to painting. Music now inspires in me visions of colour, moving rapidly in circular and other geometrical patterns. Shapes then begin to emerge, with no conscious aim at first. But as my mind takes in what is so produced, some idea crystallises into form. The image carries its own environment, generating its own space, ground and background. I try to identify myself with it.

"I would be ashamed of projecting my ego into my work. My first duty is to forget myself. I look at beings and things as they emerge and

meditate on the meaning behind their appearance. While searching for the core, I am disinterested in the physical beauty of a woman, or a horse or an apple. I never discriminate: to me a spider's web is as fascinating as the sky.

"Looking out on a busy street, the first glance seems to take in everything. But if we go beyond the surface impression, the inner eye reveals another kind of image which is total, penetrating and self-transforming. I draw it in; I try to discover its inner spirit.

"In fixing my experience on paper, I use pure colours, *kajal* (kohl), *harital*, *sindhoor* (vermilion), *khori* (indigenous colours). I prefer handmade paper with its flavour of the soil. I cannot limit my vision within a picture-frame — the figures sometimes seem to come out of the paper and I do not try to push them back because I feel they have an identity of their own. I know that the more I forget my 'I' and merge my personality with beings and things, the more I am present in the work and transform it."

I watched her as she painted. She was concentrated, happy and totally free.

"This is enough for today," she said, putting her brush down.

"May I see them?" I asked, curious to see what she had painted.

"This is all very playful; nothing serious," she said, handing me some loose sheets of paper and her sketchbook.

What struck me at once was the vivid use of pure colour that flowed across the paper with spontaneity and a surety that was quite apparent. The images were simple and direct, without a single superfluous line or stroke. The theme was varied — from the many pastimes of Krishna to different birds and animals, and some were rather symbolic and abstract. There were a few that I particularly liked. There was one, which depicted a beautiful figure of Radha kneeling in an ecstatic mood and waiting for her beloved Krishna, her pale gold, naked body arched in anticipation, and her face lifted towards a little bird that sat perched on her hand.

"I love this one, Ma. This is so simple, so beautiful, I would love to have this one," I remarked, admiring the painting.

From my childhood I have had a passion for singing. Later inner tensions led me from music to painting. Music now inspires in me visions of colour moving rapidly in circular and other geometrical patterns. Shapes then begin to emerge, with no conscious aim at first. But as my mind takes in what is so produced, some idea crystallizes into form. The image carries its own enviornment generating its own space, ground and background. I try to identify myself with it.

I would be ashamed of projecting my ego in to my work. My first duty is to forget my self. I look at beings and things as they emerge and meditate on the meaning behind their appearance. While searching for the core, I am disinterested in the physical beauty of a woman, or a horse or an apple. I never discriminate: to me a spider's web is as fascinating as the sky.

Looking out on a busy street, the first glance seems to take in everything. But if we

Mother's handwriting

go beyond the surface impression, the inner eye reveals another kind of image, total, penetrating and self-transforming. I draw it in, I try to discover its inner spirit.

In fixing my experience on paper, I use pure colours - kajal, harital, sindur, khori. I prefer handmade paper with its flavour of the soil. I cannot limit my vision within a picture frame: the figures sometimes seem to come out of the paper and I do not try to push them back because I feel they have an entity of their own, because I know that the more I forget my "I" and merge my personality with beings and things, the more I am present in the work and transform it.

"Take whatever you like; I have finished with them," she replied.

I chose a few drawings of birds, a very comical fox that seemed to leap out of the page and a horse which reminded me a little of a Chagall painting.

I recall, as a child, I would be furiously painting away in my colouring book, running every few minutes to Mother to show her my progress. She was always interested in seeing what I had painted and would encourage me to continue. Sometimes I would ask for advice and she would invariably reply, "Just be free and follow what your heart tells you."

Once, Mother and I were sitting silently in her room, before a small shrine she had erected in a corner of her bedroom in the London flat. There were many pictures and images of the different gods and goddesses, all arranged beautifully on the altar. But on that particular morning, the image of the infant Krishna, affectionately addressed as Gopala, the cowherd, had caught her attention.

She kept staring intensely at the beautifully chiselled black stone image of Gopala, as though trying to unveil the secrets of the gods. I sat by her on the floor and observed her every move.

An oil-lamp burned beside a vase filled with beautiful flowers. Mother wiped the pictures of the different gods and goddesses very carefully, occasionally whispering something in a strange language. She picked up the black stone image of the crawling infant Krishna and started to clean the figure with extreme tenderness. She whispered something in his ear and then placed him back on the altar, before lighting an incense stick. She handled the figure like an animate object. For her, the image was a living, breathing entity. Her eyes began to twinkle and her face lit up with a joy that came from deep within.

"Priya, can you see the dancing flame?" she asked, pointing at the flame of the oil-lamp. "Look! Look! The flame is becoming smaller and smaller. My beloved has become so small," she said, holding her thumb close to her forefinger.

"What makes you think that?" I asked, a bit baffled by what I was witnessing.

"You see, I have captured Gopala with my love and now he fits right into the palm of my hand!" she exclaimed, beaming with child-like excitement.

I was amazed! I had never heard of anything like that. Could one love God this way? I had heard of 'God fearing', but looking at Mother, I realised one could never fear what one loved more than life itself.

To me that was the most profound expression of love I had ever witnessed. Yet, at the same time, her expression was so uncomplicated and childlike. It moved me intensely.

She would say to me, "When you stand before the divine within, you have to be naked like a child, stripped of all sense of false pride and ego. Name, fame, lineage, caste, creed and colour, all are shackles that bind you to your limitations.

"You have to realise you are not just this impermanent body and as soon as you drop your body, all that will also disappear in the blink of an eye! Therefore, never give those external identities undue importance. Always remember, you are the child of immortal bliss. Wake up! Wake up! Know who you really are!" she would insist.

As the months went by, what became obvious to us all was that Mother could not remain in London for such long periods of time. We knew that soon a solution would have to be found. Since we no longer had our house in India, Father felt Mother needed to be moved to a place that was safe and did not require a whole slew of servants to run. An apartment complex was found and we employed a couple to take care of her needs. Father remained in London and visited India as often as he could, but by now they were both leading separate lives.

8

A Christmas Gift

After Mother left London, my visits to her became infrequent. The only time I saw her was when I went back to India. Each time I would notice a change in her. She was becoming less and less interested in things that were not directly connected to her spiritual life. I found the only way I could reach her was through something spiritual. My own inner experiences had also changed me, allowing me to receive what she had to say without eliciting an emotional reaction. I started to feel connected to her in a very different way. I became much more interested in hearing what she had to say.

I left London in 1978, to live in New York. Even though I couldn't visit India as often as I would have liked, I made an effort to be with Mother whenever I could. In the winter of 1980, I decided to surprise her. When I arrived, I found that she was away on a pilgrimage with some women, somewhere in the Himalayas. I decided to stay at home and wait for her return.

One day, I started to have severe abdominal pain and had to be hospitalised. My condition was so bad that I needed immediate surgery. As I lay in bed, after my operation, I felt myself drifting in and out

of consciousness. My awareness suddenly shifted and I found myself before a very beautiful waterfall that felt extremely healing. I felt as if I was on another planet where everything was pure perfection. I stepped into the waterfall and as the cool water gently caressed my body, I felt comforted and soothed. When I opened my eyes, I found Mother sitting by my bed, gently stroking my bandaged stomach.

I was surprised to see her. There was no way anyone could have informed her of my condition. Later, I found that she had suddenly become very restless and insisted on getting back to Delhi as quickly as possible, much to the amazement of her other female companions. They knew under normal circumstances nothing could have dragged her away from a place of pilgrimage.

I recuperated very quickly, surprising the doctors by my rapid progress. I was discharged sooner than anticipated. Mother insisted that I move into her room, because my room was on the top floor of our house and climbing the stairs would have been a strain on me. She supervised my meals and kept an eye on my recovery. That gave us an opportunity to spend some time together, which we would not have had under normal circumstances.

"How are you feeling today?" she asked, handing me a bowl of soup.

"Much better, but I still have some pain," I replied, rubbing my bandaged belly.

"That is normal after surgery; you'll be absolutely fine soon," she said reassuringly. "I don't know if you remember, when you were five, you fell seriously ill. You were running a high fever and had lost your appetite. As a result, you lost a lot of weight. We called the best doctors to examine you; they prescribed all kinds of cures, but your condition kept deteriorating. I sat by you day and night, keeping a close watch on you.

"One night, your condition took a turn for the worse and you lay nearly lifeless, your life-force slowly ebbing. I started to pray. Suddenly, I saw before me a figure standing by your bed. I knew instinctively that it

was a spiritual entity. I could see and feel that presence very clearly. I folded my hands and prayed, 'Oh, Lord! I surrender my all to you; I am helpless without your support,' I cried. I somehow knew this being had come to take you away and your earthly life was coming to an end. I prayed with my whole heart and soul.

"'Father, this child is yours; I am merely the physical caretaker. If you take her, I will surrender to your greater will, but if, by your grace, she is saved, this mother's heart will offer you its deepest gratitude. Oh, Merciful One, the giver of all life! I surrender,' I pleaded. At once, I felt as if a load had been lifted from my heart and I had received a blessing. All night I meditated, sitting beside you. The next morning you opened your eyes and the first thing you said was, 'Mummy, I am hungry!'

"Much to everyone's amazement, by the afternoon, you were sitting up and playing with your toys, and your fever dropped steadily. With the grace of God, you became well again."

"Really? I don't remember any of this," I remarked, astonished.

"You see, Priya, you were given the gift of life for the second time. Make good use of your life. Don't lose precious moments or waste time: live every moment as if it were your last," she advised, looking straight at me.

"That is amazing!" I exclaimed.

"The power of sincere prayer and whole-hearted surrender makes the impossible possible. That is the mystery of grace. You can never find a logical answer to the events that occur. All you can do is to accept. When your small willpower merges with the greater willpower, everything becomes possible," she explained with conviction.

We both lapsed into silence. I could feel myself struggling within, feeling as though I was playing a role and so was everyone else around me, except for Mother. This was because when I was near her, I felt closer to my own inner core. Why was there so much worry and restlessness in me? Maybe, I was trying to gain and achieve things that would supposedly make me happy in the future. Achievements no longer

satisfied my inner hunger for something greater. But I was not sure what that was and neither could I find what my heart truly desired. Mother was like a mirror that showed me my heart, but still I could not shake off that feeling of not belonging anywhere.

That night I felt I could no longer bear my inner restlessness and decided to ask Mother for some guidance, hoping to receive comfort and a sense of direction.

"Ma, why do I feel so restless? I feel like I'm drifting and no place gives me a true sense of belonging. When I was in America, sometimes I felt like running back to India and then when I am here, I can't take it after a while. There is a part of me that is searching and trying to find some meaning to my life. I somehow know I must do something, but I am not at all sure what," I said in desperation.

Mother's eyes twinkled and she smiled happily at my dilemma. I was hoping for some empathy and couldn't help but feel a little irritated by her response.

"You are on the right track. Spiritual growth usually begins with a sense of discontentment with the present condition of your life. This doesn't mean you have to run around the world to amuse yourself. It simply means that no matter what your external condition is, you have to find your inner happiness — that point which connects you to God," she said.

"How does that happen?" I asked.

"By inquiring and questioning all the time," she replied.

"How can I know what is the right question?" I inquired.

"Why are we here is the first question. Feel this in your heart; not just in your head," she said.

"That doesn't answer my question," I replied.

"The answer is irrelevant because everyone has a different point of view. You can spend your whole life contemplating and still not find the answer. Simply becoming aware of such a question will have a transforming effect upon you," she explained.

Gradually, I started to feel much stronger and the pain in my belly subsided. One day, I felt that Mother's room needed tidying and so I started with her closet. As I was rearranging her clothes, I noticed some termites had burrowed into the wood behind her things. It was dangerous because they could spread throughout the house and destroy all the woodwork. I swiftly got a can of poisonous spray and sprayed the infested area profusely in an attempt to destroy the wood-borers promptly. Mother was in another part of the house, talking to some women. All of a sudden I heard her hurried footsteps approaching.

"Stop! What are you doing? Stop it at once!" she cried out, in a loud voice.

"What!" I answered, startled by her reaction. "You had an army of termites living in here, so I had to get rid of them immediately. They will chew the whole house down if we don't do something!" I told her in my most matter-of-fact tone of voice.

"Give it to me, give it!" she insisted, snatching the spray from my hand and flinging the can on the floor."You are such a fool! You can't see anything, feel anything; you don't have a clue!" she scolded in a rage.

"What do you mean? I am not a fool. Here I am trying to rid your closet of termites, and you think I'm a fool," I replied, irritated.

She examined the back of her closet with great attention. I noticed that there was a picture of Krishna stuck to the back panel. The termites had built small mounds all around the outer edges of the picture like a frame.

Mother stood with her palms folded, her head bent forward in prayer.

"In your zest to tidy my closet, you killed these tiny creatures. Don't you know they had come into my closet to view Krishna? They would have given up their bodies, looking at that divine image and this would have released them from their termite bodies and pushed them towards a higher state of evolution. Do you think we are the only ones capable of evolving? Every living, growing thing is constantly evolving towards a

higher and higher stage of existence. Remember, every little speck is an integral part of creation. You had no right to stop their progress. Moreover, they were under my care and protection," she rebuked me angrily, replacing her things in the same place as before.

I noticed Mother's arm peeking out from under her shawl. Her arm had turned blotchy and red, covered with a rash that seemed to spread even as I watched.

"Gosh, Ma! What has happened to your arm?" I exclaimed, trying to examine the affected area.

"Look what you did," she remarked, examining her arm.

"What! What did I do? You were not even in this room when I sprayed!" I replied, shocked.

"You sprayed all that poison, didn't you? Those poor creatures died in such pain. I had to pray for their peaceful passage into their next stage of existence. I tried to share some of their pain, to relieve them a little. Don't worry, I'll be fine soon," she said, shutting her closet.

"I'm sorry, I didn't realise you were allergic to this spray," I said, trying to make sense of what had just transpired.

"No, no, it's not that at all; it's not your fault. You didn't know. Next time you must think twice before you take any action; nothing is ever as simple as it looks," she said calmly, leaving the room.

I was absolutely baffled by what had happened. I just could not shake the incident from my mind. I felt silly that I could not get the killing of a few termites out of my system. That evening, I ran into one of the women. I told her what had happened and how I hoped I hadn't made Mother sick with that spray.

"That has happened to Mother many times. If something around her is killed or caused any harm, she feels their pain and anguish. We have all seen this with our own eyes," she explained.

"I never knew she was like this. I have seen her kill mosquitoes and other bugs many times. What about that?" I inquired, feeling a bit confused.

"Yes, that is true. You see, she is not a fanatic about things like that. But she has her own reasons for not killing something. We always say how lucky those mosquitoes are to be released from their insect birth by a spiritual soul like Mother!" she explained, smiling at my confused expression.

I went up to my room and dropped on the bed. I felt foolish, unable to make any sense of what I had witnessed. I kept thinking, *What does all this mean?* I could not deny or ignore what had happened right before my eyes.

Gradually, what dawned on me was that, for Mother the state of oneness and unity was not some kind of a cliché. For her, it was a living, breathing reality. She could literally feel every sensation, every emotion, within her own form so tangibly that sometimes it manifested physically on her body. Curiously, the rash disappeared the very next day and her arm looked normal with no trace of any reaction whatsoever.

"The divine spirit dwells in every being, large or small, old or young, pretty or ugly. You must always show compassion to all creatures. You must know we are all children of that divine light. When you feel for others as intensely as you do for your own family, your own friends, then you can be sure you have reached the point of spiritual oneness, where the whole world becomes a part of your extended family. Some might think it to be impossible, but many great souls throughout history have proven this to be true time and again. Can you imagine what this world would be like if we all felt this way? We could never harm or hurt each other then," Mother said to me the next day, as I sat near her, applying a moisturising lotion to her arms and legs.

Many times I would play the devil's advocate, just to see how far I could go. Sometimes, I may even have tried to unnerve her and make her feel guilty for following her calling. Perhaps that was my naïve way of trying to break through what I perceived to be an impenetrable barrier that divided her from me. Yet there was this insatiable desire and curiosity that kept pushing me to unveil and probe into her world, which I

My Guru In Disguise

simultaneously found both difficult and fascinating. That afternoon, as we sat together sipping our tea, I asked her a question that had been on my mind.

"I know you think everything is divine play, but real life is too tough, Ma. The struggles are colossal in work, relationships, everything. To think of life as only a passing game is not so easy. Then, I just don't get the point in living a life. You can't understand that. How can you? You have never really been a part of real life. Your world is a very different place," I commented, with a slight edge to my voice.

"You are right, I have never really been a part of what you call 'real life'. What are you labelling as real? Why do you presume that my reality is less real than yours? Each one of us has our own particular reality, within which we feel the whole spectrum of our humanness. Do you for a moment think I don't struggle?" she asked.

"What kind of struggle? I don't understand. You have always followed your own path. Where is the conflict?" I responded.

"All struggles start with the activity of the mind, no matter what you choose to do. That also applies to spiritual life. There is a misconception that if we are 'spiritual', whatever that means, we are above everything, but we are not. In fact, the more acutely aware we are, the more we feel as if we were standing on a razor's edge. If we are not vigilant, we can fall, sometimes rather painfully," she explained.

"Then how do you cope?" I asked, curiously.

"I try to see everything with a new pair of eyes. I struggle constantly to break old habits. This is just mental conditioning and not who we truly are. When we strip away the outer layers of old habits and thought patterns, we begin to understand that everything around us, including us all are in a constant mode of flux, ever changing," she explained.

"What do we do then?" I asked.

"You see, the more we try to analyse and make everything concrete, the more confused the mind gets. Then the struggle becomes harder and harder. The mind simply cannot keep up or comprehend that which is

not structured. It is really a blessing in disguise, because we are compelled to stop and give up the futile struggle. The moment we stop and become still, the mind has no power. Then something magical happens — everything mysteriously begins to harmonise, flowing with the rhythm of a universal wisdom. Then we are guided to exactly where we are supposed to be and what we are supposed to experience. That is a wonderful place of sheer joy where no problems can enter, where all struggles stop and mysteriously dissolve," she said.

"Does that mean all problems of life suddenly disappear?" I interrupted.

"No, problems don't disappear, but what radically alters is our own perception. Then we learn to just float over all the ripples of life, instead of drowning in it. As for me, I totally rely on God," she said.

"These days people are very cynical. Words like 'God' and 'religion' turn people off, especially in the West," I remarked.

"We can never truly describe that which is infinite in finite terms. All words will stop, all explanations cease, once we truly experience God in our heart and in our soul. Where do you think God is? Not up in the clouds! That divine light is everywhere, including within each one of us. We can call God by whatever name, or no name; we can be religious or not, believe or not believe, all that matters is our intense desire to know and experience the purest essence of love. Because that is what God is. Words are only important to us. God is beyond words and in the ultimate stage, beyond even experience. At that stage all sense of duality and separation dissolves," she explained.

"What about human love?" I inquired.

"Human love, no matter how good, can never be perfectly selfless; it is always wanting something in return, to be rewarded and to be acknowledged. But divine love is totally unconditional and non-judgemental. Whenever the soul's cry is sincere, the response is immediate. We have to learn to truly *feel* this; there is no other way," she said.

114

That night, I got out my journal and started jotting down our afternoon conversation. I don't know why I felt a strong inner urge to do so. My intuition was that one day I would look back at these words and receive great comfort, solace and strength from them. So I started off by writing, 'Remembering Mother' on the first blank page of my diary.

Next day, some women came over as they wanted to take Mother and myself to see *Krishna Lila* — a play entirely staged by children, depicting episodes from the legends of young Krishna. The play was being staged at the house of one of the women, who lived in the older section of Delhi. Mother was delighted and soon we found ourselves sitting in a speeding cab, making our way through the heavy, unruly traffic.

I heaved a sigh of relief when we reached the doorstep of that woman's house in one piece. The whole family was overjoyed to have Mother visit their home, because she rarely went anywhere. They garlanded her and touched her feet with reverence. We were greeted with a shower of rose petals and with voices raised in welcome to their guru.

"*Jai* Gurudeva! *Jai* Gurudeva! *Jai* Gurudeva!" they chanted in unison.

An area of the house was specially prepared for Mother to sit. Because she disliked any form of ostentation, a simple rug was laid on the floor, which was covered with a white sheet and a row of bolsters were placed against the wall. We all took our seats and soon the covered courtyard was filled with people. Most of them were Mother's disciples.

The musicians sat on the carpeted floor, tuning their instruments and preparing to start. They acknowledged Mother by folding their palms together and bowing their heads.

"*Namaste*," she reciprocated, smiling. This is an ancient form of greeting, which literally means, 'I salute the divine in you'.

Soon the young actors arrived and took their positions on a slightly raised platform that served as a makeshift stage. The young boy, who was playing the part of Krishna, was about ten-years old and looked exactly like the living counterpart of the image in Jaipur. He was dressed

to the hilt, in full regalia. A cummerbund that was decorated with coloured stones, held his saffron garment, trimmed with gold, together. He wore a gold crown with beautiful peacock feathers, and around his wrists and ankles were bracelets with tiny bells that jingled with every step. A necklace of gold with a carved medallion covered his tiny chest like a shield. Garlands of marigolds and roses swung back and forth, as he danced, holding his flute.

Little Radha, who was not a day older than eight, made her grand entrance in a full-length, rose pink skirt, trimmed with silver stripes that radiated down from the waist. Her blouse was a palest of all pinks, covered with a shimmering, silver, transparent scarf that was wrapped around her shoulders. She too, was decked with garlands and bracelets, all of which made her look like a china doll. The stage was filled with little kids, ages ranging from six to twelve and all playing different roles, including the cowherds and cowherdesses who were the playmates of young Krishna.

The music began with the melodious sound of the bamboo flute. Traditionally, the whole play is sung, very much like an opera. That day's episode was about Krishna leaving Vrindavan to go to the city of Mathura, the seat of his princely kingdom. The whole of Vrindavan was plunged in grief. Even Nature mourned the loss of the divine flute player. All the trees drooped, bending their branches in sorrow; the flowers lost their fragrance and forgot to bloom. The birds stopped flying and sat in silence, not chirping gaily. The peacocks didn't dance and the parrots became voiceless. The river wept, changing its course, and the wind rushed, howling aimlessly. The cowherds and cowherdesses sat listless, not tending their cattle, who were lost as they wandered aimlessly across the meadows. Krishna's parents shed tears of sadness day and night, lamenting the separation from their beloved son.

Radha was inconsolable. She ran like a mad person from place to place, pleading for news of Krishna. In her state of extreme despair, she had lost all sense of reasoning. She ran to caress the dark trunk of a tree,

which reminded her of the lovely form of Krishna. She embraced the tree with great tenderness, exclaiming, "O Krishna! I knew you could never go. I knew you could never leave me."

The play concluded with the return of Krishna to Vrindavan, where everyone rejoiced, culminating in a dance surrounding Krishna. The little boy stood in the centre of the circle, holding the flute to his lips while Radha danced next to him, her tiny arms and feet moving to the rhythm of the music.

The boy who played Krishna moved across the stage towards Mother. He smiled widely, holding his flute out to her. In a flash, Mother rushed towards him and tenderly hugged him in her arms. Soon all the children ran and surrounded them, scrambling to get hold of Mother. The musicians began to play louder and Mother held on to the hands of Radha and Krishna as they began to dance. All the children joined in, circling them as they spun like tops with their arms raised in the air! Spontaneously, the audience responded. We all raised our arms and moved our feet in step with the music.

For Mother, it was not just a play, but a transcendental and ecstatic experience. She was so engrossed and captivated that she had forgotten everything that surrounded her.

At last, the evening concluded with a feast, where everyone sat in rows on the floor to enjoy the specially blessed meal that was served on banana-leaf platters. Everyone then moved into the living room, which had been emptied for the occasion. Mother sat on a rug, leaning against the wall. Mostly women, some men and a few children, sat around her.

"Did you enjoy today's performance?" Mother asked, looking around.

"Oh! Yes, *Maji*," they replied in unison.

"These children are so innocent, so spontaneous; the divine spirit manifests itself very easily through them," she remarked, looking at the children. "You must learn to become childlike if you want to uncover and truly feel the divine essence."

"Yes, they looked so cute in their colourful clothes," remarked one woman.

"Yes, yes, that was obvious, but what did you really see? What did you learn?" she asked. I detected a slight tone of impatience in her voice.

No one uttered a single word.

"There was a much deeper meaning behind today's episode than was apparent. Life becomes utterly meaningless, with no purpose, without the divine aspect in our lives.

"Vrindavan can be compared to heaven. That is where the Lord himself sported and played, but as soon as he left, it too lost all its charm. What does it mean? Even heaven has no meaning without the divine presence. If the sun disappears from paradise, it would cease to be paradise.

"So, you have to search for God in your soul; it is only then you will never lose him; then you will dance with him forever! By God, I mean the purest essence of our soul, the innermost core of our being. The return of Krishna to Vrindavan symbolised the awakening of divine consciousness within each one of us.

"The ultimate, omnipotent, eternal truth is beyond all word, all thought, beyond heaven, beyond all concepts. The only way to feel this is through personal experience. At some point, one moves even beyond one's experience because there is nothing left to experience any more. You, and what you experience, become one and the same. The only way you can achieve this state is to have an intense longing for God which supersedes all other thoughts and desires," Mother explained, with conviction.

A man got up and knelt before her. "Mother, please bless me so that I too am able to cultivate such devotion to God," he pleaded humbly.

"I am nothing, nobody; you must pray sincerely to God. Divine grace is the only way for that to happen. Long for God with your whole being, as though your life depended on it! Then you will surely see the results," she said, touching his head in a gesture of blessing.

My Guru In Disguise

Many years later, after Mother's death, I saw that man again. He had become one of the most spiritually awakened souls I was privileged to encounter.

That evening when we returned home, I found Mother alone in her room, sitting by the window, engrossed in her own thoughts. I sat down near her, not saying a word. The room was dark and I could barely see her silhouette.

As I sat looking at her, I began to feel the room being gently illuminated by a source of light that did not appear to be coming from anywhere. I blinked my eyes several times to make sure I was not dreaming. I looked around and saw nothing, and yet, each time I turned towards Mother, the same strange and soft light reappeared.

"How do you feel, Ma?" I asked, not knowing what to say.

"My heart feels like a fish swimming joyously in an ocean of bliss!" she replied, her face beaming with joy.

I spent that Christmas with Mother. For her, any day that had a spiritual significance brought on a mood, which reflected the essence of that particular event. That day, being Christmas, connected her strongly to Christ. I sat on the floor on a woven reed mat placed close to Mother's bed. The room was full of flowers, making the air fragrant with a faint scent of roses. On the altar was a photograph of the Shroud of Turin, her favorite image of Christ. Next to that was another beautiful picture of the Madonna holding the baby Jesus. Mother lit an oil-lamp and placed a few apples and oranges before the pictures.

"This beautiful face belongs to a great soul, a great *yogi* who is a divine being of light," she said, touching the picture to her forehead. "Christo, Christo, Krishna, Christ," she kept repeating to herself, as she rang a tiny bell and waved the lamp and incense before the images. She was performing the ritual of *arti* to symbolically invoke the divine presence.

"All is one, there is no two," she remarked, anointing the images of Christ and Krishna with sandalwood paste. "*Jai* Jesus, *Jai* Jesus, *Jai* Jesus,"

she exclaimed, getting up to adjust the garland around the picture of the Madonna and Child.

I could sense that her mood was very animated. During such times she would speak and words would flow through her spontaneously.

"We have to become one-pointed in our love and devotion to God. We need to open a new vision, a spiritual eye, which will transform the way we perceive everything around us. We must stop clinging to our attachment to temporary things and direct our minds to that all-prevailing spirit, which is the reality behind everything," she explained.

"How do we become one-pointed?" I asked.

"Most of us run after worldly things ninety-nine per cent of the time, while, maybe, one per cent of our thoughts are with God. Then we complain endlessly when things go wrong, blaming God and everything else, instead of learning to look within. A true lover of God devotes ninety-nine per cent of the time to God and one per cent to worldly things. Because they know how to just go with the flow of everything, without resisting, totally surrendering with complete awareness," she said.

"So then, what is the purpose of life?" I asked.

"To love and know God, to discover our true self, to know we are much more than the physical, to understand that we are sustained not only by the material world, but also by the spiritual. What prevents us from truly knowing who we are is our sense of ego. This ego makes us falsely believe that we are the masters, that we are in control and nothing can ever happen to us!" she said.

"What about free will, Ma? Don't we have a choice?" I inquired.

"Of course, we do. We are all given some freedom to choose, otherwise we would be like dummies that have been programmed. However, we are only 'free' up to a point. If I tie a rope around a dog's neck, it will still have a certain amount of freedom within that perimeter. The dog can decide to go left or right, up or down, but within limits. We are all like that. The rope that ties us is our destiny or our *karma*. None of

My Guru In Disguise

us can ever know for sure when we might die, or get a terminal illness, or what might happen to us the very next minute! Therefore, we must make a choice of how to live each moment. We can either take the path that is enlightened, or one that is delusional. That choice depends on each of us," Mother explained.

"What about working towards a goal? Is that wrong?" I asked.

"You have not been listening, Priya. What have I been saying? I'm not talking about how much you strive for something, or how much you have, but what is your *attitude* towards those things. Do everything without any attachment, without hankering for results. The outcome will always take care of itself if done in the right spirit. Know in your heart nothing can ever belong to you, nothing! Everything will be left behind, no matter what; that is certain. Never forget this. If a child had to choose between a beautiful toy and his mother, whom do you think he would choose? The same thing applies to us. First love God, then everything will fall into place," Mother explained, looking directly at me.

"Yet we all tend to always do just the opposite, don't we?" I remarked.

"Yes, that is why we are so miserable," she replied, abruptly ending the conversation.

As the day drew to a close, her mood began to intensify and gradually she began to lose all awareness of the outside world.

That Christmas Day stands out in my memory as something special. Mother opened my eyes and made me feel that the essence of every path is true, no matter what the outer form may appear to be. She made me see that the incentive is not the fruit of action, but that the action of doing is, in itself, the incentive. Love is the key that opens all doors, no matter who we are. That was Mother's special gift to me.

9

The Last Journey

Three years elapsed before I could see Mother again. She now lived mostly in India, occasionally spending a few months with Father and Pebs in London. In the autumn of 1983, Father was scheduled to go to America on a lecture tour and we felt that would be the perfect opportunity for Mother to visit New York. I was looking forward to seeing her again.

In the meantime, I was going through many changes, both internal and external. I felt unsettled, and as far as I could tell, there was no apparent cause. I started to ponder over Mother's words. To truly assimilate what she had said to me, I knew I would have to find inner contentment and peace in my own environment and not in some 'spiritual place'. The crux of the matter was just what Mother had said — to be able to find that space of humour and happiness and play, no matter what the circumstances. I had to learn to apply this to my life in a way that was not just an intellectual concept, but also a part of my life experience. I tried to look at my surroundings from a totally new perspective. What felt exasperating and taxed my patience before, I now tried to experience differently — to see everything as an observer, and not as a victim of circumstances.

New York, to me, was the perfect example of what Mother would call *lila* — gritty, full of juice, ripe to be plucked from the tree of life and to be tasted like a juicy mango fruit. The city hummed and hawed, spewed smoke from its dark belly and changed constantly, always moving, never static, pulsating and throbbing like the blood in my veins; an arena, where the game of life is played out to the fullest. Behind the visible craziness, everything moved through its arteries with a flowing rhythm. Everything was precisely in the right place, interconnecting and linking together like a giant network of continuous movement.

No other city in the world invoked such feelings in me. I began to experience the city from a spiritual point of view — a place that is deemed anything but spiritual. I suddenly understood for the first time there was no place that was more or less spiritual; all was simply a reflection of my own perception. I somehow 'knew' in my heart that everything, every experience, every place, had a universal vibration that flowed within, like a unifying current. Ironically, I had that inner revelation in New York City, when the rest of the world was rushing off to my homeland, India, for spiritual awakening! I realised then what Mother meant when she said, "Change your vision and everything around you will transform instantly."

Pacing up and down the airport lobby at JFK on a brisk autumn afternoon, I waited in anticipation for my parents to arrive. Crowds of passengers streamed through the gates, when I spotted them approaching. Underneath my obvious excitement I felt a twinge of apprehension. I was afraid. I did not know if I had the ability to cope with Mother's spiritual moods, or if I was capable of looking after her day-to-day needs.

All doubt vanished when I saw her. The first thing I noticed was her new, shorter hair. She looked happy and much younger, as she smiled and waved at me coming through the glass doors. I ran to hug her, when I realised that I was much taller than her. For a moment, I felt we had switched roles. She looked rather fragile and in need of protection.

"Ma! Your hair!" I exclaimed with delight. She turned her head, showing off a little. "Your sister chopped it off one day. She said it had grown too straggly. Do you like it?" she asked.

"Oh! I just love it! Looks great on you; suits you well," I replied, touching her hair. Pebs had also coloured her hair, removing all traces of grey and making her look years younger.

Our drive back to my apartment gave us the perfect opportunity to catch up with all the news. Father and I did most of the talking. I noticed Mother looking out of the car window, observing her surroundings with the curiosity of a child as her eyes twinkled with delight.

"We were here so long ago. Everything has changed. Now there are so many new skyscrapers; they seem to be touching the sky! Priya, will you take me to Radio City Music Hall and Rockefeller Centre?" she asked, enthusiastically.

"Yes, of course," I assured her. "We'll paint the town red, as they say here in America."

Father left almost immediately for a cross-country lecture tour, while Mother and I had six weeks to spend together. I helped her unpack and tried to make her feel as comfortable as I possibly could in a typical New York apartment, which was small. I lived in Brooklyn and my apartment had a fabulous view of the Manhattan skyline. It fascinated Mother and she would often stand by the window, gazing at the city.

Very soon, she settled down, thoroughly enjoying the experience. At that time I was working on some freelance projects at home, which meant I could spend six weeks of uninterrupted time with her.

Every morning I planned our outings, doing ordinary and fun things together. I could see that Mother really enjoyed being in the United States. She delighted in the simplest of things, like walking into Woolworth's to buy assorted bags of candies for her disciples' children, wandering through Macy's and Bloomingdale's, and strolling through the park, feeding the squirrels.

I was struck by her sense of fun and non-conformity. She was so

My Guru In Disguise

unpredictable and spontaneous that I was always surprised. She was open and full of curiosity, yet at the same time, completely unattached to things. I knew, for instance, she would end up giving away everything we bought on our shopping sprees. Sometimes I would extract a promise from her not to give away the sweater or the bottle of perfume that I had bought for her, threatening to never get her anything if she did. But she always did and I always made her promise!

One day as promised, I took her to visit some of her favourite places, Radio City Music Hall and Rockefeller Centre. The day was beautiful and a gentle, cool breeze made walking a glorious experience. We decided to get out of the cab several blocks away and stroll down Fifth Avenue. Her inquisitiveness knew no bounds as we glided past the glittering storefronts, feasting our eyes on what I called 'visual nourishment'.

"Isn't this wonderful? Everything is *lila* and we are all a part of that play. How wonderful!" she exclaimed, with delight.

As we walked along, I noticed that she still had the power to make a few heads turn. She moved gracefully and with great ease in her orange silk sari, her shoulders draped in a beautifully embroidered woollen shawl that I had given her on our trip to Kashmir. Her new, short hair curled gently at the nape of her neck, making her look much younger than her sixty years. Although the rigours of spiritual life had taken a severe toll on her physically, I could still see glimpses of her former self that I remembered so well. But now, her face radiated much more than physical beauty. There was something intensely mystical and aloof that was very hard to describe.

We had walked for several blocks when she began to feel tired, and I decided to take the downtown bus. We hopped on the bus and sat by the window seat. She looked at everything with her keen power of observation. From time to time, I could see her getting distracted, slipping back into her inner shell.

That happened to her often, even in public places. Sometimes, seeing or hearing something would move her, triggering in her an internal

response that altered her state of consciousness, making her more introspective. I kept trying to engage her in conversation, in an attempt to prevent her moods from fluctuating too much between her inner and outer worlds. Soon our stop arrived. I held on to Mother's arm, getting ready to dismount.

"Careful honey; watch your step, have a good day darl'in," said the bus driver, who was a friendly and very chatty fellow. He waved, winking at her.

She smiled back. "Oh! Thank you!" she said, looking very amused.

I was tickled by his words. No one in India would ever dream of addressing her so casually. I knew she enjoyed the anonymity and the non-conformity of being outside her own familiar environment.

"I love America. People are not self-conscious and that comes from being open and free spirited. When one is that way, it is so much easier to touch God," she said, as we headed toward Rockefeller Centre.

Prometheus loomed larger than life, dazzling in a sheath of clear gold. "Ma, that is the Greek God, Prometheus. He stole the fire from the heavens and brought it down to earth," I explained, pointing at the statue.

"Ahh!" she sighed, gazing at the gold statue in admiration. "You see, he knew that fire is the light of God, and without that we couldn't survive. What a wonderful thing he did for us all," she remarked, placing her palms together prayerfully.

For Mother, that image was a very potent symbol; an important reminder of the divine power. Little did I know then, that some day that fire, that light of God, would engulf her forever. For her, anything joyous had divine connotation. That made her power of observation unique. She made me realise that every action did not have to be greatly 'significant' to be meaningful; that one could derive delight from anything, however small or insignificant. Seeing and experiencing the world through her eyes taught me a totally new way of responding to the simplest of things.

My Guru In Disguise

We continued to stroll leisurely, making our way towards Radio City Music Hall. Walking into the grand Art Deco lobby, we admired the wonderful architecture of the famous landmark. Radio City brought back happy memories for Mother.

"You know, your father and I came here in 1949. There were many girls who did something called the high jinx! Er...maybe, it was the high kicks! Or something like that," she said, looking at the large poster of the Rockettes.

I laughed loudly, slipping my arm into hers, as we proceeded to find a place to eat.

Most days she preferred to spend at home, reading to me from spiritual texts, explaining the deeper significance behind them. Early one morning, I found Mother standing by the window gazing pensively into the distance. The twin towers of the World Trade Centre and the Empire State Building gleamed majestically in the morning sunlight. The panoramic sweep of Manhattan Island stood tall and erect, enticing the whole world into its arms. Looking at her, a strange feeling of unease arose within me. I couldn't help but feel that this would be her last visit.

"Do you think human beings could create all this without divine intervention?" she asked.

"Somehow, one doesn't quite think of this city as being spiritual; in fact this seems like the last place on earth," I remarked.

"No, no! You must learn to look at everything with insightful eyes. Divine energy is neutral. That power can create galaxies, as well as this city. There is no difference, but only a matter of degree. Don't you remember the ancient belief — whatever is in the macrocosm is also in the microcosm? This is a prime example of that," she said, admiring the view.

After breakfast, Mother and I were sitting together, having our morning tea, when I suddenly felt an urge to brush her hair. She came and sat beside me, looking fresh and rested. As I brushed her hair, I noticed how fine the texture of her hair was. I remembered the time when her thick beautiful tresses framed her face like a lion's mane. That moment

instantly connected me to my childhood, making me feel comforted and soothed. A sense of calm contentment surrounded us both.

"Ma, may I ask you a question?" I asked, seizing the moment. "What do you see and feel when you go into one of your trance states?"

That was not just idle curiosity on my part. I had been experiencing, what I can only describe as a flow of energy moving through my body, making me feel rather lightheaded. Mother was the only person I knew who could help me understand why I felt that way.

"Oh, my God! That is not so easy to explain, I wouldn't even know where to start," she replied, with some hesitation.

"Please Ma, will you try? I do want to know. I feel this is very important for me. I really need to know," I insisted.

"Words can never adequately describe what that is. Sometimes I feel a gentle rocking motion at the base of the spine. That sensation gradually travels upward, remaining at the heart centre before moving to the point in-between the brows. The energy then shoots through the fontanel on top of the head. When that happens, I hear a loud sound like that of a gushing waterfall or a clap of thunder, after which a stream of liquid light pours into every part of my being. I can actually see and feel that light as clearly as I see this room. My whole being gets engulfed by this energy, filling every pore with a new, intelligent, life force..."

"What do you mean by intelligent?" I interrupted.

"This force moves through my body with a will of its own that is beyond my control. I become helpless like a child. Suddenly, everything becomes abundantly clear; I am *not* the one who is in control. There is a higher, super-intelligent, life-sustaining energy, which is responsible for my very existence," she explained.

"How do you know these experiences are not some kind of projection of your mind? How can you be sure that this is not a mental delusion? Maybe, because of extreme stress, the brain reacts this way to shield you from some kind of inner distress?" I asked.

"That is a good point. Sometimes these experiences are so potent

that I cannot contain the force within the limitations of my body. During those times, I feel I am fluctuating between life and death, between sanity and madness," she said.

"If something is an intelligent force, then why do you feel like you're going insane?" I inquired.

"This is certainly not a mental affliction, but a state that takes you beyond the mind, beyond the level of thought patterns, into a state of being fully conscious through every cell, every pore of your being. At times this energy becomes so overpowering, I feel the boundaries of my physical form starting to dissolve, and when that happens, I cannot adequately describe the breathtaking beauty I perceive. Everything is bathed in a sublime lustre, including my own form. All that I see permeates and throbs with an intelligent, fully conscious power, within and without, everywhere. That is when I experience a total absence of separation, where everything becomes a part of me and I am a part of everything. You cannot feel or understand this without personal experience," she said.

"What happens when you return to your normal state?" I asked.

"Well, after going through that experience you can never come back to your so-called 'normal' state, which is like trying to fit into clothes that you have outgrown. Undoubtedly, this can sometimes cause great stress within the mind, which is limited in its perceptions. The right balance has to be found, without which the normal condition of life becomes impossible to sustain. Believe me, Priya, I am not mad; this is not madness. How can one ever become unconscious when every cell of the body becomes fully conscious?" she asked.

"Have you found the right balance?" I inquired.

"Not always. Sometimes I feel as if a large elephant has entered a rickety hut, shaking every inch of my being. When this happens, the physical part of me experiences a violent shake-up. I lose all sense of who I am, what my name is, who my family is; everything gets erased in a flash."

"What happens then?" I ask.

"My own awareness shifts and can penetrate all that I perceive. Like a luminous string linking me to everything. I can actually feel every move, every sensation, and every thought of all that surrounds me. I lose all idea of time and space and just slip into the moment. During those moments, I feel that I am saturated with joy and bliss. That is when I experience love in its purest essence. Oh, what a feeling of complete freedom that exudes! What a sense of exaltation! Then to come back to this level becomes excruciatingly painful. Now I feel as if I am being pitilessly squeezed back into a tiny confined space of skin and bones with all its limitations and drawbacks."

"Is that very hard, very painful for you?" I asked, gently.

"Yes it is," she responded, quietly looking into the distance.

We sat in total silence. My mind boggled, listening to her amazing experiences. I felt an upsurge of tenderness looking at her, because most of the time, her state was so misunderstood.

"How can you balance what is infinite with limited finite means?" she asked, smiling wistfully. "All I can do is totally surrender to God and accept whatever comes my way."

"How do you feel physically? How does your body react to all this?" I inquired, concerned.

"There are times when the body feels like it is being twisted apart. Sometimes the pain gets so unbearable that I tearfully pray to God to take me away," she explained.

"Why does that happen?" I asked.

She paused for a moment. "Sometimes due to ill health or some emotional or mental disturbance the energy is thrown off balance. When that happens, it is an agonising, nerve-shattering, experience, both, for the mind, as well as for the body. At times, I vacillate between ecstasy and agony. I know, only the grace of God protects me and guides me through those moments. That is why I am able to sit here and talk to you," she explained.

My Guru In Disguise

"Do you think you have healing powers because of such experiences?" I asked.

"No, no ! I have no such powers, I am nothing; only God is the supreme healer. Please, get me something to drink Priya, I am a little thirsty," she said abruptly, as if to end our conversation.

Mother disliked references that connected her with any psychic powers. She believed she was nothing more than an instrument and discouraged such conversations.

I refrained from asking her about my own experiences. Somehow, compared to hers, mine now seemed insignificant. There was a part of me that was still apprehensive because I couldn't surrender so completely. I felt I needed to hold back a little, or else I would be like a vehicle without any breaks.

That night I went to bed, pondering over my inner conflicts. Maybe, I needed to find my own way. No one, not even Mother, could give me a magical solution that would put an end to my doubts.

The sound of a passing fire-engine woke me with a jolt. I glanced at the clock and the time was past midnight. My throat felt dry and I made my way into the kitchen to get myself a drink. I saw Mother's silhouette at the kitchen table, holding a cigarette. As she drew in the smoke, her face lit up with a faint orange glow.

"Not again, Ma! You know smoking is bad for you. You will ruin your lungs; just stub that thing out. Okay?" I told her, feeling a little exasperated.

Mother had been on and off her smoking habit for a number of years. She had now developed a smoker's cough that kept getting worse.

"You don't understand. The cigarette forces my mind to remain at this level. Otherwise, I would become unconscious to the world. Nowadays, even during my normal moments, I feel like my brain has been lit and I feel irresistibly drawn to that light. This helps hold my mind down, to keep me grounded," she said, puffing away at the cigarette.

"Okay, just promise me you will not overdo it? Please! " I insisted.

"All right...okay...okay, I won't. Okay?" she replied, smiling.

I sat opposite her with my glass of water. I could see there was no sign of sleep in her eyes.

"It's very late; don't you want to go to bed?" I asked.

"No, I don't feel sleepy. I hardly need any sleep; maybe three to four hours at the most. I really can't sleep longer than that," she said, looking wide awake.

Another fire-engine raced by, this time making a thunderous, groaning, maddening noise. I stuck my fingers in my ears, trying to muffle the sound, but the noise pierced through, jarring my nerves.

"God! I can't stand this...I hate it! This city is driving me nuts!" I snapped with irritation.

I noticed Mother calmly puffing away, smiling slightly to herself.

"Calm down Priya. Don't you know, the Lord of the Universe just drove by your house? He made a loud noise to wake us all up. He is so loving and compassionate, don't you think? He comes all the way in the middle of the night so that we can wake up to his presence. Wake up! Wake up! Wake up!" she said, waving her hands up and down, smiling at me mischievously.

"Really Ma! What next? I'm going to bed; why don't you rest a bit. Tomorrow we'll go to Chinatown and buy your favourite jumbo prawns. What do you say?" I asked.

"Oh! Good!" she said, chuckling like a child.

"You know what? You are a funny one. Goodnight, Sweetie," I said, bending down to kiss her forehead.

Next morning, we went to Chinatown. We walked through the narrow, crowded streets. The smell of raw fish, rotting bananas, deep-fried noodles and frankincense, all assaulted our senses, as we dodged through the jostling crowds.

"I can't believe this is America! This is just like a bazaar in the East!" Mother exclaimed, looking around with great interest.

We entered a Chinese supermarket. Brightly painted boxes and tins

132 *My Guru In Disguise*

lined the shelves. Every conceivable exotic spice, food, fruit and tea, tempted the senses like a skilled seductress, luring her prey. I could feel Mother's excitement mount. The enticement was so great that she went off like a bullet headed for the target.

"Let's try some of this delicious dried fish. We used to have fish like that in Hyderabad. Oh, look — jackfruit! lychees! persimmons! Let's get those sour plums," she said, bursting with enthusiasm and filling the shopping cart with a speed that reminded me of a ten-armed goddess.

"Ma! Ma! Take it easy, please! We can't get everything. I don't have enough money," I whispered desperately under my breath. "Let's take a few things today, then we'll come back for more another time, okay?"

Both Mother and I were bad cooks. Neither one of us ever knew what happened in that mysterious place called 'the kitchen'. I would simply instruct our cook to dish up my favourite dish and somehow, magically, everything would appear on the table.

When I left India and started to live on my own, pangs of hunger and soaring restaurant bills, forced me into the kitchen. However, the fact that we did not have any culinary skills did not mean that we lacked interest in food. Both of us possessed highly developed palates, which made us venture boldly into the world of eclectic cuisines.

Mother decided to cook one of her favourite dishes. We fearlessly attempted to cook jumbo prawns in coconut milk sauce. After we had slogged away for hours, much to our surprise, we did manage to conjure up a pretty decent meal, which we both polished off with great relish!

Although Mother usually preferred to take vegetarian food, occasionally, she enjoyed some fish and chicken. "You must never get too obsessed or rigid about food. Eat what is put before you, in moderation and with relish. To get stuck in rigid eating habits is not a good thing. Then food ceases to be pleasurable and does nothing for the body or the spirit," she would always tell us, when we fussed and fidgeted too much with food.

I kept a vigilant eye on her as one would on a child. I was always

fearful of her trances that could occur suddenly. Sometimes a hot soak in the bath helped relieve her body of some stress. One day when she felt very tired, I decided to give her a bath. I filled the bathtub and poured in some bubble bath. I think she was a bit embarrassed, when I tried to coax her into the bathtub.

"Oh, come on now, Ma. Stop being so coy; we're exactly the same, you and I. There's nothing new here," I said, grinning mischievously.

I remembered as a child, how she would vigorously shampoo my hair, making me want to squirm out of her reach. She would get soap in my eyes, my nose and my ears, which made me scream at the top of my voice.

I scrubbed her back, cleaned in-between her toes, and shampooed her hair, feeling a great sense of triumph at the reversal of roles.

"Stop it, Priya. Remember I am your mother. Stop treating me like a child. This is what happens when one grows old; your own children boss you around," she grumbled.

That day she remained very subdued.

One morning, I decided to take her to visit the Brooklyn Botanical Gardens. I knew she would enjoy that because of her love for plants and flowers. Her eyes gleamed with pleasure. She quickly showered and changed, and was ready to go.

"Come on, hurry up! You are wasting so much time. Let's go; hurry up," she said impatiently, when I paused to quickly tidy up her room.

The sun felt deliciously warm and the clear blue sky was spotless. Walking hand in hand like two kids in pursuit of Oz, we strolled through the gardens at a luxuriously leisured pace. Mother's excitement knew no bounds. Bending down to smell the fragrance of some exotic flower with a strange sounding Latin name, threw her into the arms of ecstasy. Watching her happiness brought a lump to my throat. I think that was one of the happiest moments I had ever spent with her.

I wanted to say, 'I love you Mama,' but remained silent. Our family

was not very expressive. Instead, I put my arms around her and gave her a gentle squeeze. Sensing my mood, she looked up.

"What is it Priya?" she asked, softly.

"Isn't it beautiful here, so peaceful? " I said, looking at the long stretch of rainbow-coloured flowers swaying delicately in the breeze.

"Yes, everything is very beautiful," she whispered. I felt a slight pressure of her fingers around my hand.

We kicked off our shoes and sat barefoot on nature's thick, green rug. The grass felt cool and sensuous under our feet and in-between our toes.

"Nowadays I can't see very well; my eyes hurt when I read or write for a while," she said, taking her glasses out of her handbag. "Your father took me for a check-up, but still, I don't know what is wrong."

"Let me see," I said, taking her glasses and examining them in the light. There was a fine layer of finger grease on the lenses. "No wonder you can't see," I remarked, carefully cleaning her glasses with a tissue.

"There, take a look now," I said, handing her the glasses.

"Oh, yes, that's so much clearer now. Much better," she said, looking a little surprised.

"Will you please clean your glasses from time to time, Ma? You are going to ruin your eyes even more this way," I told her, sternly.

"Yes, yes. I just forget sometimes," she responded, in a meek voice.

That was very typical of her. She had utterly lost her capacity to look after herself and was unable to cope with even the simplest of everyday tasks. That was not because she was indifferent, but because her spiritual life consumed her so completely.

Evening shadows had started to appear by the time we headed home. We wandered through the rose gardens that stretched before us, ranging in shades of deep blood red to delicate white. The air was filled with a sweet fragrance that was very heady. We strolled across a meadow covered with thousands of yellow flowers that swayed in the gentle breeze.

Suddenly Mother and I noticed a young boy. He looked about thirteen-years old and standing fairly close to where we were. He smiled broadly from ear to ear, revealing a perfect set of pearly white teeth that stood out in sharp contrast to his ebony skin. His well-fitted, white turtleneck and white jeans hugged his body like a second skin, and his brand new white Nike's gave him the air of a seasoned cricket player.

"Hi!" he said, grinning widely at Mother and I.

"Hello," I answered tentatively, wondering what he wanted from us.

"Here, take this. I have something for you," he said, smiling at Mother. Slipping his hands into his jean pocket, he pulled out a fistful of what looked like tiny coral balls. He reached out and dropped the little red berries into the palm of her hand.

"Oh, thank you, thank you," Mother responded joyously.

"Want some?" he asked me.

"Er...er...okay," I replied, feeling a bit unsure and surprised.

He dug out more berries from his pockets and gave them to me. Suddenly he turned around and in a flash, vanished from sight somewhere in the park. Mother and I looked around for some time but he was nowhere to be seen.

"How strange! What made that boy do that?" I asked Mother in disbelief, tossing the berries to the ground. I looked at Mother's expression. She was absolutely furious!

"Pick up all those berries, each one of them. Don't leave a single one on the ground," she said, in a stern voice. Seeing me hesitate, she snapped back, her face hot with anger.

"Now! Pick them up now, at once! How dare you throw away a gift that was given with so much love? How dare you? Don't you understand *anything*?" she said angrily.

I tried to retrieve as many as I possibly could. I was surprised and a little confused by her intense reaction. She carefully tied all the berries to the end of her shawl and I slipped mine into my denim shirt pocket. We walked back home in total silence.

My Guru In Disguise

That night Mother explained her angry outburst. "What is the point of meditating, reading one million books, going off on spiritual quests, without really feeling from your heart? God exists in infinite forms and shapes, especially, in that loving gesture, which arose spontaneously from the heart, totally unconditional and with no expectation of any kind. I keep telling you again and again, you must develop a spiritual way of seeing, hearing and feeling, then everything will become clear. That sweet boy was none other than my beloved Krishna!" she said.

As the evening wore on, gradually she slipped away into her inner world—a world I could not enter, where only her beloved and she existed. A place where they sang, danced, loved and played together. Perhaps, that night she shared small coral-coloured berries with him. Mother remained in an ecstatic state for several days after that incident.

On regaining her normal state, Mother seemed to be in an animated mood. She wanted to go and buy presents for her disciples in India. So we decided to do some shopping. In the meantime, I had been tidying her clothes and realised that she needed new underwear. Some of her old things could easily have been donated to the Salvation Army.

"Ma, just look at the state your things are in. I can't stand it! You really must learn to take a little interest in yourself. We're going to get you some new things today. Really, this is too much!" I exclaimed, exasperated.

"Why Priya? Is it really that bad?" she asked, looking a little worried.

"Please Ma! Let's not start..." I replied, impatiently.

"All right, okay? Okay, let's go," she responded quickly, not wishing to start an argument with me.

We took a taxi to 34th Street. Macy's was terribly crowded and we literally had to push our way in. I held on to Mother like an octopus. She had an annoying habit of suddenly strolling off in the opposite direction. We started bra-hunting, making me feel like a hunter-gatherer of the most primitive kind. Amongst thousands of bras, we could't seem to find the right one. Some were too big, others too small, some too lacy,

some too plain, and some too synthetic. Where were the hundred-percent cottons for heavens sake? That was the great dilemma of too many choices. To make matters worse, Mother had forgotten her size. We kept going around in circles, playing blind man's bluff, until we were completely exhausted. I suddenly had a brainwave. I made Mother stand in-between two display racks and moving swiftly behind her, lifted her blouse and groped for her bra tag! At last — 36C.

"That is an old bra; it's a little tight and the elastic digs into my skin," she said, a little startled by my move.

The lines for the fitting rooms were as long as the Great Wall of China. "That's it! I am getting a 38A, that should be loose enough," I exclaimed, rushing off to grab the article in question and then speeding towards the cash register.

Mysteriously we did manage to get everything that we had set out for. I bought Mother a sweater, a bathrobe, some skin cream and a bottle of her favourite perfume.

"Promise, you won't give all this away. Promise, you will use it for yourself. This is my hard-earned money, Ma," I told her.

"Don't be silly, why should I? I am taking presents for everyone, aren't I?" she replied, smiling broadly.

That evening, after dinner, we sat together and she sang songs of Kabir, the great mystical poet:
"He is the mind within my mind.
He is the eye within my eye.
Ah! Could my mind and eyes be one!
Could my love but reach my love?
Could but the fiery heart of my
heart be cooled?
Kabir says, 'When you unite love
with lover, then you have
love's perfection'."
Her voice quivered with emotion. Gone in a flash was the world

My Guru In Disguise

outside and the day's events seemed like imagined shadows. As I watched and listened, I felt her ecstatic mood enveloping me. Her voice had a strange power that moved me and filled my heart, making me simply flow in the moment.

I could never plan anything ahead of time with Mother, so each day unfolded in a spontaneous way. Whenever I found her in an outgoing mood, I would swiftly make plans, otherwise, we would just stay at home. On one such picture-perfect day, I decided to take her to the top of the World Trade Centre.

"You know, one can go all the way to the roof? Would you like to go, Ma? I think you will really enjoy that," I said to her, enthusiastically.

We arrived at the World Trade Centre and got in to the huge elevator. The endless ride seemed to lift us off to some remote spot in space. The place was packed with tourists and schoolchildren, each one wide eyed with excitement and anticipation. At last we reached the rooftop and stepped out into a brilliant autumn day.

A cloudless cobalt blue sky engulfed the island of Manhattan, like a vast dome of glass that sank into the still, azure waters of the Atlantic Ocean. Mother and I walked to the edge and looked down. Everything looked like rows of miniature toys that were lined up together in the playroom of the jolly green giant! Humans moved like worker ants and vehicles moved in slow motion, in what now appeared to be an orderly and silent manner. All we could hear was the faint hum of the life below.

"Wow!" I exclaimed. "What do you think Ma? Isn't this just amazing? Out of this world! So spectacular! Don't you think?"

I went on ranting and raving about this island that I now called 'home'. At that moment I felt like an astronaut who has just discovered the newest planet in our solar system! Seeing everything from a totally new point of view made me see that how we experience everything was merely a matter of perception, of where we stand and how we observe.

Mother was deeply lost in her own thoughts. She gazed into the horizon, each time spotting something and smiling to herself.

"This place is charged with so much energy; do you feel it Priya? Can you feel it?" she exclaimed, joyfully.

We went to the rooftop café and sat down by a large window. We felt we were suspended in space, floating above the earth, viewing the panorama that stretched before us from New Jersey to the Atlantic Ocean. We sat and sipped a cold drink and ate some cheese sandwiches.

"It feels like Mother Lakshmi has now decided to reside in America. Her energy is what makes all this happen. Don't you think?" Mother remarked, her eyes twinkling with happiness.

The Goddess Lakshmi personifies wealth, beauty and abundance, and wherever that energy manifests, all benefits follow. Looking at New York from up here certainly gave me a feeling of being at the door of Utopia!

"But...? Everything is transitory; nothing will remain, and one must never forget that. All this is simply a grand illusion. If we can remember that all things must and will pass, then one can really sit back and enjoy the play," she explained, looking around with great interest.

"Why, when everything is so transitory and temporary, was this grand illusion created? Why are we in a state of delusion? Are we all making big fools of ourselves?" I asked, suddenly feeling pointless.

"As long as the urge to create remains in the Creative Power, this play will continue," she explained.

"But why?" I asked.

"Remember, all creation stems from the interplay of dualities, light, dark, cold, hot, good, bad, male, female, etc. When one is fully God-realised, all duality dissolves into a perfect state of integrated oneness, which is undifferentiated and whole. We have been put on this plane to realise that; to unveil the illusion of separation. Each and every one of us has that capacity for self-discovery. However, until each one realises that, the play of creation will continue," she said.

Mother's explanation reminded me of a marvellous Indian myth about creation. Before the manifest world was created, Vishnu, the creator

My Guru In Disguise

and the preserver of the universe, was absolutely alone, fully absorbed in his own bliss. Suddenly, he felt a great urge to experience that bliss. But to do that, he needed another. So he created Shakti, his creative power, and when they both embraced, the power of love came into play and the manifest world was born. Vishnu was then able to experience his own bliss.

"Whenever I see masses of people gathered together in one place, I am always reminded of that great force of creative energy. Today has been such a day," she reflected.

That night, for some strange reason, sleep escaped me and no matter how hard I tried, I was wide awake. As I lay in bed, tossing and turning, I noticed Mother pacing silently across the hallway, totally absorbed in her own thoughts. My eyes followed her and I wondered what she could see, hear and feel that was beyond this realm. Perhaps sensing my thoughts, she came and sat beside me. I could see her face in the reflected light from the street below. She was in a partial state of trance. She gently stroked my hair and face, running her fingers over my eyes. From time to time, she smiled at something and her lips moved rapidly as though she was speaking to someone else in the room. I strained my ears, trying hard to catch her words, but couldn't. She seemed to be communicating in a strange language, with some unknown entity or entities that were only visible to her.

"Ma, do you want to sleep here with me? Come, rest for a while," I said, trying to draw her attention. Like a child, she slipped into bed and lay beside me, but I could see that her eyes were wide open. Abruptly, she sat up.

"Time to get up, wake up, wake up; you can't sleep now! Wake up! They are all here; they are waiting for us," she said excitedly.

"Who? Who! Where?" I exclaimed, startled by her words.

"Calm down, you will need special insight to see this. They are very advanced souls of light, three of them. I can see them as clearly as I see you. This is a very spiritual moment that can't be wasted sleeping. They

have blessed us by coming here. They have come to guide you, so that one day you too may see the light. My prayers have been answered," she said. Seeing my wide-eyed look, she gently reassured me, touching my arm.

She summoned me to go and freshen up so that we could meditate together. We sat down on the floor and closed our eyes. I could not see or feel anything, but I knew without a doubt that she could. Her whole expression had changed and I knew I was witnessing something extraordinary. Something told me that what I was witnessing was a powerful reality for her, and not a hallucination. Her awareness had moved into a different dimension where such communication became possible.

Next day, her mood was more inward. She sat silently for a long time, her body motionless and eyes closed. Gradually, she opened her eyes, coming back to the present. She decided to read me excerpts from her journal, which she had started in 1959. This journal was like a scrapbook that was filled with inspirational quotes and passages, interspersed with letters addressed to members of the family. Later, when I began to write about Mother, that became one of my most valuable tools. She read a passage from the sayings of Sri Ramakrishna, the great saint of 19th century India, whom she adored.

"Oh, Spirit, teach me to worship Thee as wholeheartedly as a miser idolises money. Let me be as deeply attached to Thee as a drunkard is to wine. May I cling to Thee as stubbornly as one clings to bad habits. Inspire me to crave for Thee, as a worldly man yearns for possessions," she read. "Listen carefully, that prayer is an expression of the intense fire of love that burns in the heart of a great lover of God."

The more I listened to her words, the more I found myself getting drawn into her world, which began to unfold and make perfect sense. I could not help but feel that the world that I had chosen to belong to *was* the insane one, in which we were inescapably trapped, running a rat race for survival. I remembered what a wise friend had once said to me

My Guru In Disguise

when I had expressed my dissatisfaction with the goals I was then pursuing. "Don't you know you have to be a rat to join in the rat race?"

Mother made me understand that there was a unity behind all differences. She was completely open and encompassing in her views. For her all paths contained some truth, and since God, the ultimate reality, was beyond all words and concepts, no written word could fully express that.

"Never tamper with somebody else's faith because everyone is on their own personal journey. Never feel that your way is the only way and that somehow you are superior to anyone. That notion is a sign of ignorance, which stems from a delusion of separation. All differences are a vital part of creation. Do you think even a blade of grass could exist without divine will? Differences are there only to suit different temperaments, but underneath the surface we are all linked; we are all the same," she reminded me.

"Do you know what I miss the most?" she said suddenly. "After my guru passed away, I really missed having a spiritual companion, someone with whom I could share my innermost thoughts and feelings. Oh, nothing matters when I am deeply absorbed within, but I sometimes miss having someone when I come back to this reality."

That confession truly surprised me. I never thought of her as lacking in spiritual company. But I understood what she meant. I think what she missed was the companionship of a friend who was her equal and not a disciple. So whenever such an opportunity arose, she would get visibly animated. I think that is why she enjoyed our conversations so much. Although I was in no way her equal, I was always eager and willing to probe into her world, without treating her as my guru, or as someone who was mentally unstable.

Unfortunately, I only started to truly communicate with Mother during the last six or seven years of her life. Before that, there were too many personal issues that got in the way, making open and objective communication impossible.

As the time approached for Mother to leave New York, I could sense that her mind was somewhere else. Sometimes she would just sit by the window, staring into space. One day in an attempt to distract her, I turned on the television. On the PBS channel, there was a live broadcast of Luciano Pavarotti singing many well-known arias. The moment she heard his incredible voice, tears began to flow down her cheeks, making her completely ecstatic. She started to sink deeper and deeper within herself and remained that way long after the broadcast was over.

My time with Mother seemed to have flown. Father was back from his trip and soon they prepared for their journey back to London. As I packed her suitcase, I felt a little sad. That inner voice kept telling me this would be her last visit to America. In a strange way, I think she also sensed that. Although she did not say anything, I knew she felt sad as the time for her departure approached.

I felt a lump in my throat as I bid them good-bye at the airport. "See you soon, Sweetie. Take good care of yourself, okay?" I said, bending to give her a hug.

"God bless you. Come soon," she replied, touching my head in a gesture of blessing.

We waved at each other. I waited until they were out of sight. Mother walked straight ahead without looking back, leaving me with special memories that would remain long after she was gone. My instinct was right. That was Mother's last visit to America.

My Guru In Disguise

10

My Inner Calling

Mother's departure brought up many conflicting feelings in me that I had not acknowledged earlier. I felt as if I did not belong anywhere, and that nothing held me. I drifted from one day to the next, with no clarity or meaning as to where I was headed. To make matters worse, I could find no specific reason for the strange mood I was in. A part of me felt aloof from everything around me and a nagging feeling persisted in my head. What did my life amount to? I knew that nothing outside myself truly satisfied me, yet I did not know how to fully tap into that source within. All I knew was that I would have to act fast in order to save myself. As I struggled to find answers, I realised that to comprehend my present state, I would have to dig into my past and face everything as squarely and honestly as I could.

I began examining my own feelings and much to my surprise, I discovered, as I dug deeper, that there was a gap within me like a missing link. That link was Mother!

I had to face the fact that when I was growing up, there was a mystic who lived in our house and who was not a mother in the true sense. My own conflict was also partly because I did not know how to integrate my

feelings toward my mother. I did not know how to let go of all my negative emotions and fully embrace the great spiritual lessons I had learnt from her. Somewhere within myself, I was angry and disappointed with her. I felt that in her quest for a spiritual life, she had simply forgotten her role as a mother. What she and Father did with their own relationship was something they had chosen to do and only they could face the outcome of those actions. Yet, for Pebs and me, there were consequences that had a far-reaching effect and over which we had no control. I could not forgive her, especially for leaving Pebs, at such a young age. I felt that an adventurous Father and a mystical Mother was something we had had to adjust to.

In spite of all of Mother's spiritual wisdom, there was a part of her that remained very bruised and wounded. Her own life had left a painful scar on her, making her suffer and struggle like the rest of us. I saw that human side which was fallible, with all its flaws and drawbacks. I think she felt misunderstood, lacking the support that she needed, and most of all, deprived of love. To be viewed as mentally unstable and to be treated at times in a condescending and judgmental manner must have had a deep impact on her. Although she rarely showed her personal feelings, I am certain that somewhere deep within she felt rejected and hurt. That further distanced her from us and the world outside. At times I found her to be so 'other worldly', that she felt as if she did not belong in our less-than-perfect world. She was split between her transcendental and physical states and struggled her whole life to find a way to integrate the two halves of herself, and which I don't think she ever did. Mother herself was well aware of that split and her way of coping was the belief that she had 'given up' the world, in order to pursue her spiritual path. That is the prevalent point of view in India, which has a place in a monastic setting but has no context in the domestic arena.

I sometimes remember the difficulty we had in dealing with Mother's moods. At times she behaved in the most impossible manner. There would be days when she would refuse to eat anything and no matter

how hard we tried to coax her, she would simply not budge. Sometimes, when our persuasion aggravated her, she would fling the plate across the room, making a huge mess. Then there were moments when she would just sit in one position for days on end, without eating or drinking or doing anything else. Many times, out of concern for her health, we would try to bring her back, by giving her something to drink. Sometimes she would respond but there were times when she would get extremely frustrated and angrily hit the person who faced her. Unfortunately, often the blow would land with considerable force on the person at the receiving end. For some reason, contrary to what one might expect, she exuded a powerful physical strength in those moments. At times her behaviour became so erratic and unpredictable that we sometimes thought that she was stark, raving mad.

I think she also felt trapped and helpless, not knowing fully how to cope with the metamorphosing energy that was coursing powerfully and uncontrollably through her body. But most of all, there was the frustration of not being able to communicate with anyone about her inner state. Without a channel that could safely direct that energy into an integrated and harmonious space within, she would, in despair, fall into a state of depression and extreme loneliness.

Those moments were hard to witness, since I knew she was suffering silently inside. No medication or other remedy worked, because the root cause did not stem from a mental disturbance, but was the spontaneous awakening of a subtle and powerful energy. The only other documented case that I am aware of is that of Gopi Krishna. In his book on *Kundalini*, he wrote of his own similar and painful experiences.

Witnessing Mother's condition sometimes filled me with anger, sadness and disappointment, accompanied, of course, by guilt. I was also filled with admiration and a deep reverence for her spiritual life. I found that both points of view were tainted and flawed, because she was not just one way or the other. She was a culmination of everything — the dark and the light, and every other shade in-between; in fact much more human, than otherworldly.

Because Pebs and I were a part of what she 'gave up', our world was profoundly impacted, but in very different ways. For Pebs, her mother was taken away from her because she chose to follow her spiritual calling. For a long time Pebs kept herself removed from anything that reminded her of that. Only after her son was born did she allow herself to slightly open that door.

For me the experience was totally different, because Mother's spiritual side was what connected me to her. I became deeply rooted in my spiritual self. I realised that it was also the cause of my inner crisis. Unlike Mother, who lived on a different plane, disengaged from the world, I wanted to fully experience the world around me, and at the same time, hold on steadfastly to my precious inner world, without losing sight of either. I knew there was nothing in my life that I wanted to 'give up' in order to pursue my spiritual destiny. In fact, that would have been much easier for me, because I was not married and had no children or other family obligations. But somehow that idea never appealed to me and I felt that it was not my destiny.

On the other hand, Pebs and I were very fortunate to have parents who let us follow our own paths and always encouraged us to be true to ourselves. However I chose to live my life, Mother neither approved, nor disapproved; she was simply neutrally supportive. I could never deny that Mother was also an exceptional being, whose life had left a profound impression on mine. I fully acknowledged that. I tried my best to understand her ways with my heart and not my head. I knew I had to do that with more compassion and insight, and without any judgement or guilt. Only then would I be able to move on to the next stage, unburdened and free of the past.

One option for me was to try to find a middle ground — a way that could successfully bridge my spiritual and material life. But that to me felt somewhat like having a foot stuck in each boat, with both boats going in opposite directions. Moreover, I did not like the idea of 'having it all'. That felt overly ambitious and rather excessive. In my mind, there

148

was nothing wrong in not having it all. I wanted to live my life with a greater appreciation for what I had. I felt I was part of a cosmic joke, where I was being cornered into a space with no exit signs.

Once again my creative urge came to my rescue. When I painted, I became focused and free. I soon discovered that I had lost interest in my own driving ambition, which had been like a monkey on my back. I found that I had brainwashed myself into believing that hot pursuit of my goals would make my life worth living. That notion was hard to shake, especially when the world around me believed in quite the opposite. I also found that many times what I thought was my goal, was not what my heart truly desired. I decided not to have an agenda regarding my work. That freed me from the pressure of producing saleable works of art and allowed me to express whatever my heart desired.

Spurred on by those internal struggles, I began to draw and paint with a kind of inner zeal, which at times left me rather exhausted. But that was my only point of refuge, the only ground that felt familiar and stable. I remembered Mother's words, "Whenever you paint or do anything that your heart desires, find the pure joy in that action. The outcome should not be your only motivating force. If your actions are binding, be discriminating and set yourself free." I understood for the first time what she meant. I knew being successful had nothing to do with being who I was, because I could always express what was meaningful to me without being 'a success'. I also realised that, if in my life, success came to me in one form or another, then I would accept that as grace, and if not, I would also accept that as grace. The more accepting I became, the freer I felt. For the first time I truly began to enjoy my art, without caring too much about the results.

I had just turned 35 and during that period I began to feel the need for a spiritual teacher. I wanted to be physically in the presence of someone who could become my guide and someone with whom I could just ' be' rather than 'do'. Although I had learnt so much from Mother and no matter how well we connected on a spiritual level, that primal mother-

child link always came up to cloud my perceptions. When I wrote to Mother about my need for a teacher, she reminded me to be more open about what my concept of a teacher was. A teacher could appear in any form or shape and under many guises, not only to guide us but also to put us through a test, which could at times be rather severe. I again fluctuated between my desire for India and my desire for America. But as time passed, I began to understand that moving physically away from my birthplace did not make me rootless. No matter where I planted a mango tree, that tree remained a mango tree. The problem was that I expected pears! I felt I had to curb my restlessness and learn to surrender and trust the process that was throwing the doors of my inner perceptions wide open. So I knew I had no choice but to be patient and allow things to unfold in their own way.

I needed to see that I was in a wonderful position where I could absorb the very best of both worlds. Growing up in an atmosphere filled with ceremonies and festivals added richness to my life. Those moments were special. I had lived, felt, tasted and touched my roots that constantly renewed my links, without binding me in any way. Thanks to Mother, Pebs and I also grew up with the awareness of many other spiritual traditions besides our own. Mother always taught us to respect every faith, because at the core, the essence of all religions is the same. I accepted that very naturally.

I was dealing with the two conflicting sides of my own nature. I found that although inner and outer worlds were linked, they operated on totally different frequencies, which sometimes were hard to bridge. I knew that I first needed to know who I was, before I could ever hope to know anything outside myself, and that included Mother. From time to time I wrote to Mother explaining my inner state of restlessness. Why was everything taking so long? When would I find that resting place within? I kept on asking her for advice. At times I had a sudden insight that came in a flash, yet I resisted. I knew I had to be prepared to let go of some of the rigid mental definitions of how I saw myself. I was definitely

going through a period of what Mother called the 'ripening' and the 'baking' process that was responsible for my inner oscillation.

Every day I would go to the library, hungrily reading as many spiritual books as I could lay my hands on. They inspired me and gave me the strength to go through my inner changes without feeling that I was losing my mind. Mother's letters helped me, as I tried to grapple with my internal shift. "A mind that becomes elated is also subject to depression. Learn not to identify with either. One doesn't follow the spiritual path simply to seek something, but to realise our divine nature and to live a fully conscious life. Therefore, first strive to truly transform yourself, then automatically the door to peace and happiness will open." Mother's letters always arrived as messages of hope. She instructed me to do certain things that would speed up my progress. I didn't even think that I was progressing, but she assured me that I was. Her letters were sometimes funny, as she was in person. She was a wonderful mimic: I remember shaking with laughter when she acted out some funny part with great accuracy and detail.

In those moments of conflict, I found myself turning to Mother, forgetting all our personal differences. I realised with gratitude that, at least, I had an option. Unlike her, I did have someone who could guide me through my times of inner turmoil. But I also remembered her saying that I had to walk the walk alone. Ironically, I found myself doing just that — feeling alone right in the heart of New York City!

I knew with great certainty that I could no longer continue with my old ways of thinking and doing. I made up my mind to follow my heart no matter what the cost. In some ways I realised I was very much like my mother.

11

A Strange Premonition

Several years had passed before I saw Mother again. Every time I went back to India, I found her getting more and more withdrawn. There were brief moments when we would connect with each other, but very soon she would slip back into her internal world where I just couldn't reach her. Every time I left her, I felt uncertain and sad, not knowing if I would ever see her again.

In the meantime, back in New York, I started to paint again and every day I would spend a few hours with my art. One day I noticed that I was drawing a strange figure draped in a shroud. Father died in April of 1990, exactly four months after I had painted that piece.

When I look back, that year was an year filled with sadness and turmoil, which for the first time unearthed in me feelings of defencelessness and complete lack of control. The hand of destiny had dealt me swift blows, which landed in rapid succession, propelling me out of my former orbit and profoundly shaking my sense of stability. That critical time in my life left me feeling as if I were being severely tested.

Father was in India on his annual visit when suddenly, sipping afternoon tea, while talking with Mother, his heart stopped. I returned to

India to attend to his funeral. Since we had no immediate male family members who, according to Hindu custom, would have performed the death rituals, I, as the eldest of his two children, decided to carry out his last rites. That was highly unusual, because women never perform the death ritual, since the female is always associated with birth; the one who nurtures and sustains life. But I refused to let a total stranger perform the last rites for, what I felt was, the most important of all journeys. So I broke with tradition and did what was normally reserved for a son.

Arriving home late at night, the first thing I saw was Father's body draped in a white shroud. Beside his head was a raised altar, in front of which an oil-lamp burned. There was a vase filled with flowers and incense burning.

I noticed Mother, and what struck me at once was her face. She looked calm and still, but as I approached her, I saw a hint of sadness in her eyes. She touched my head and gently stroked my hair.

"At last, you have come. I was waiting for so long," she said, caressing my face.

"Ma, I didn't get a chance to see him. There was so much I wanted to say..." I broke down, sobbing.

Without a word, she consoled me, running her hands over my back, gently patting me from time to time. We sat in silence, and I could hear her praying softly.

The previous week I had suddenly decided to visit Pebs in London. Two days after my arrival, Pebs received a telephone call informing her that Father had died. She and I left immediately for India on the next available flight. I would have surely missed seeing Father for the last time had I been in New York instead of London.

I was suffering from jet lag after my long trip and felt so exhausted mentally, physically and emotionally that I could no longer keep my eyes open. I excused myself and fell straight into bed.

That night I saw Father twice in a recurring dream. He appeared before me, looking somewhat bewildered and confused.

"Am I really dead?" he asked.

"Yes, Father," I replied.

"Have I really died?" he asked again.

"Yes, Father, you have really died," I replied.

I woke up with a start and tiptoed back to where Father lay. I saw Mother sitting in the dark, her face dimly lit by the light of the oil-lamp. Quietly, I sat down beside her.

In India, the exact moment of death is vitally important because that moment becomes a springboard on which the next level of existence depends. The highest aspiration is to be totally aware of that singular moment when the breath leaves the body and ejects the spirit, the soul, on its evolutionary journey. Therefore, we simply become what we think we are at the exact moment of death. That consciousness is what survives the physical death of the body.

Although, Father felt no pain or discomfort at the moment of his death, he had no time to prepare for his final passing. He died suddenly without being fully conscious and connected to his own awareness — something Mother termed as 'unconscious death'.

Years later, when I decided to write about Mother, I realised I would also have to write something about my father, because they were so intertwined that writing about one without mentioning the other would be impossible. Even though my parents were not compatible in many ways, they connected on a spiritual level. Although each one followed a very different path, they somehow always managed to converge at some mysterious level with each other.

I felt that getting in touch with my own feelings about Father was also important, now that I was faced with his death. I had to begin the process of healing and acknowledging our relationship in a totally different way.

Our father-daughter bond had always been difficult and complex. We could never communicate very well on an emotional level, but did manage to connect on artistic and intellectual levels and would spend

hours sitting together, discussing and designing his latest book or project. As an artist, I enjoyed our interactions very much, and I am sure so did he.

Father was a great 'doer'. He wrote many books on Indian art and philosophy and he loved collecting art and antiques. Our home was filled with fine books, rare objects and antiques. Mother, who loved simplicity, sometimes would humorously call our house 'the museum'. His great curiosity led him to unexplored archaeological sites, where he became part of many pioneering ventures. For him, making a mark was important. He often said, "There is nothing more terrible than being mediocre. Be extraordinary; make a contribution." His own contribution to the field of art and archaeology was substantial. Father had an inquisitive mind and an adventurous spirit. That made him seek out and befriend artists, writers, anthropologists and philosophers of his time. His boundless energy and enthusiasm kept him always on his toes and involved in several projects at once. Observing Father taught me how to appreciate art and understand other cultures, including my own. For that, I will always remain truly grateful.

He was artistic and sensitive; he was quite unlike the typical macho male. Emotionally he was by no means cold and inexpressive, but like many men, he had difficulty expressing his feelings openly. I don't ever remember him hugging me, or verbally using any terms of endearment. His way of showing affection was to buy us things and give us money. Those thoughts and memories of Father made me weep. Mother observed my distress silently and then responded gently.

"Try to understand, Priya, that your father hasn't 'gone' anywhere. He is here. So long as you identify only with his body, you will never understand who he truly is.

"See death as a natural cycle of life and a learning experience. Too much pain, too much grief, or anger, or any other emotion is caused by thoughts that agitate the mind. The mind makes us believe that the death of the body is our final destiny. In reality, death is like a re-birth into a new realm of consciousness."

"Then isn't it natural to feel what I am feeling?" I asked, trying to understand. "Should I suppress these thoughts and impulses?"

"Of course not. You must not suppress any of those feelings. To feel saddened by the loss of someone close is a very normal reaction. We would cease to be human otherwise, but we must always examine: *Why do I feel this way? Why do I believe that this is the end?*

"Non-attachment is the key, Priya. You should never think of that as being indifferent and uncaring; in fact, it is quite the opposite. To truly love someone is to be less clinging, less conditional, less demanding, more giving, and more caring, less possessive. We don't belong to anyone and no one belongs to us, because ultimately we belong only to God. What we miss most when a person dies is interaction with the physical self. The inner essence never dies. Come, let us take a bath, change our clothes and prepare to help your father embark on the next stage of his journey," she said, ending our conversation.

Following the Hindu tradition, I cremated Father's body by the banks of the Yamuna River flowing through Delhi. When I ignited the funeral pyre, I felt a powerful sensation arise within — a feeling that a part of me was also being engulfed by the flames. As the fire devoured his body, I silently prayed for Father. Eventually, all that was left of his mortal remains was a heap of charred, grey dust. I gathered all his ashes into a clay vessel and returned home.

After eleven days of prayer and rituals, Mother, Pebs, Prashad and I left for Haridwar, the holy place of pilgrimage, where the Ganges flows through the Siwalik hills, coming down from the Himalayas on its long journey through the plains. After a six-hour drive in a taxicab, we reached our destination.

The Ganges rises from an ice-bed, 13,800 feet above sea level, deep within the recesses of the Himalayas. From ancient times, the river has been revered as the sacred water that descends from the heavens. The Ganges is a symbol of the Great Mother, who receives all into her fold, carrying each soul towards liberation.

My Guru In Disguise

I was moved as I stood by the bank of the Ganges, which has for centuries been such an integral part of India's spiritual heritage.

On that day when the ashes of my Father merged into that river, I, too, felt connected to the very heart of my ancient roots.

"Goodbye, Father. Be well, be happy, go in peace." With those words, I bid farewell to his earthly remains.

The river engulfed the small clay vessel, which disappeared into the fast-moving current, dissolving into the water, the source of all life.

As immediate surviving members of the family, Mother, Pebs and I performed after-death rituals for the peace and well-being of Father. We bathed in the Ganges, as acts of purification for the body, mind and spirit.

I observed Mother, who was becoming internally absorbed. Touching the Ganges, being surrounded by temples and the sounds of worship, in a place where the main preoccupation of life is spiritual, it all triggered her spiritual mood.

I walked beside her, holding on to her arm in case she tripped or stumbled. We arrived at a narrow, winding street, lined on both sides with small shops and stalls selling everything — from plastic buckets to silk cloth.

Suddenly, Mother paused before a cloth merchant's shop and pointed to an off-white sari with a deep red border.

"Will you please buy that one for me, Priya?" she asked.

"Now? Not now, Ma. This is not the time," I replied, looking a little shocked.

"You must; you have to," she insisted. There was a strange urgency in her eyes.

I had no choice but to buy her the sari, and I could see that this had really pleased her.

"Thank you, thank you, you have made me so happy," she said, smiling.

I held on to her arm as we continued walking, when out of the blue,

a young homeless boy appeared from nowhere and started to tug at Mother's sleeve. He looked raggedy with his tattered clothes that hung loosely from his small, emaciated body. My first impulse was to stop him.

"No! No! Let him be," said Mother, stopping me, her voice filled with determination.

He lifted his tiny, thin arms, and said, "Mother, I have hurt my leg. I have nowhere to go, no one to turn to; only you can help me. Please help me, Mother," he begged. He was clearly in pain.

Mother responded without any hesitation, gently touching the boy's head.

"Give him something," she said, turning to me.

I was wearing a loose white *kurta*, similar to a tunic, with deep pockets on both sides. According to custom, white clothes are worn to a funeral because white symbolises a state of purity. All of my money and change was bunched up with bits of flowers from the rituals, along with some facial tissues. Fidgeting and fumbling, I managed at last to pull out a few rupees. When I reached out to give the boy the money, Mother nudged my arm.

"Give him everything in your hand," she said firmly. "Don't count, don't think; just give."

I gave the boy everything in my hand. He looked at me with shock and disbelief. He had never seen that much money in all his life. Deeply grateful, he lowered himself and touched Mother's feet. She caressed his face tenderly.

"That hurts, doesn't it?" she asked him, touching his injured leg. "You will be fine now."

He gave Mother an enormous grin, his dark eyes sparkling with happiness. Within seconds he disappeared into the crowd. All of a sudden, we were surrounded by throngs of people — old, young, men, women, the sick, the wounded; everyone.

"Mother, Mother, Mother, help us," they shouted together.

My Guru In Disguise

Surrounding us, they pushed each other to get close to her. Such reaction is typical in India, especially in places of pilgrimage where a large section of the very poor manage to survive on the money given by the pilgrims who come to worship. Overwhelmed by the crowd, I tried to pull Mother away, but she refused to budge.

"Give them something," she said, as they all gathered around, touching her hands and her feet, and tugging at her sari.

I handed out whatever I could, and then I suddenly remembered that we had a six-hour journey back to Delhi, which made me stop. I tried to pull Mother away from the crowd.

"Give them everything you have," she repeated forcefully.

"But we need to keep something. We still have to go back home. We are all hungry and tired and we have to find a place to eat," I answered, feeling desperate.

Mother refused to listen.

"Empty out your pockets. Turn them inside out, quickly! Don't hesitate; come on, come on, Priya," she insisted.

I could do nothing but simply give in. I emptied out both my pockets, and within seconds, all the money was gone. I looked at the crowd and asked them to leave, showing them my empty pockets. Mysteriously, they all disappeared as quickly as they had come. Exasperated, I looked at Mother for some understanding.

"Now look, what you made me do! We have no money, we haven't eaten, and to top it all, we have a long drive back home. I don't know. I give up. You take care of this," I said, throwing up my hands in frustration.

"So soon? You give up too quickly, don't you?" Mother asked, walking briskly ahead of me.

I followed her in a huff, while at the same time trying to hold on to her.

"I have some money," Prashad then informed me in a hesitant voice. "I am sure we can manage to eat something."

We walked into a local restaurant, where the owner respectfully

greeted Mother, invited us all in and ushered us to our table. We sat down and had a wonderful meal of steamed rice, lentils, freshly cooked vegetables and hot bread. The man attended to all our needs meticulously and when the time came to pay, he refused to take any money for Mother's portion of the meal!

"God bless you and protect you," Mother said to him, as we were leaving.

"Please come again, Mother," he replied, bowing low before her.

I was a little amazed by the course of events. Mother's absolute faith and total surrender carried her through in a way that was inconceivable to the rest of us. Her simple, childlike nature hid a highly developed soul and there was an invisible force that drew people to her. She emitted an energy that was tangible but could never be logically explained. Perhaps that was the power of spiritual attraction.

We all dozed off, sitting in an air-conditioned car on the drive back home, except for Mother, who sat by the window in the backseat, looking out. The car jolted suddenly, waking me up.

"Tired?" I asked, putting my arms around her.

"A little," she replied.

Quite suddenly, she started to sing softly, "Five minutes more, only five minutes more, let me stay, let me stay in your arms. Oh! I have forgotten the words, I used to sing that song as a young girl." Then she laughed, tilting her head in a manner that reminded me of a child.

"You are so funny," I responded, grinning back at her.

She kept on laughing and humming the same tune over and over again.

Looking back, I think she had a premonition of her own death. Maybe that song was her odd way of letting me know, but I did not think anything of it at the time. Mother often said and did those unusual and peculiar things.

That night at home, she came into my bedroom. "Why don't you sleep in my room from now on? It will be nice," she suggested. "We

My Guru In Disguise

could spend time talking and thinking of God. Just get your blanket and pillow."

I followed her into her bedroom and spread my blanket on the floor.

"No! No, no. Sleep on the bed. You will be much more comfortable there. I am used to sleeping on the floor. I never sleep on the bed. I really prefer the floor," she insisted.

I moved over to the bed. Strangely, I didn't feel sleepy but was totally alert, refreshed and not a bit tired after our long trip. She came and sat by my side and we started talking.

"You remember the young boy we saw today? Well, who do you think he was?" she inquired.

I looked at her, a little perplexed. I wasn't sure what she meant by that.

"He was God himself in the form of that boy. If we only knew how many times He comes to be with us, to play with us. But you see, we have eyes but no vision and, therefore, we can never recognise those special moments. Do you think you can only see God with your eyes closed? No, you must learn to see His light in everything," she said.

"If everything is divine energy, why did you choose that boy specifically?" I asked her curiously.

"The divine power itself is neither general nor specific but is like the sun that shines indiscriminately. Only when we move into the sunlight can we feel its warmth. In that boy, I saw the luminosity of God much more than in others, and that is why I recognised him at once. He was like a shining mirror that reflected the light more vividly," she explained.

"What about all those who commit terrible crimes, who are vicious, mean and unkind?" I asked.

"Yes, that is true. The world is full of such individuals, but when we begin to experience and feel that we are a part of everything and everything is a part of us, we cannot shun anyone, no matter what the circumstance.

"We are like mirrors covered with many layers of dust; that is why

we cannot see our own reflection. The dust is our ignorance and delusion, our sense of separateness from all that surrounds us, nothing more. But polish that mirror and you will see your face. That face is our true reflection and the mirror is our awareness, our consciousness. There is only one way to transform everything and that is through love. In our hearts, we will have to learn to forgive, even if that is very difficult," she said.

I listened very carefully to her words.

"You did a good thing today; you gave away all the money you had," she said.

As the night drew on, I could see that Mother was gradually getting more withdrawn and her attention began to shift within.

"Rest now, Priya. You must be tired," she said, abruptly throwing her pillow on the small mat covering the floor.

Soon the world that we were speaking of was left far behind and she was gone deep within the vast expanse of herself, joyfully experiencing her own internal bliss. As I drifted into sleep, I noticed her lips moving silently in prayer.

The next morning when I was making Mother's bed, I found a photograph of Father as a young man tucked safely under one of her pillows. I realised then that her heart was broken. She wanted to remember him as that simple young man who had captured her heart forty-nine years ago.

After the prescribed period of mourning was over, one night, Mother asked me in a casual manner, "You remember the sari you bought for me in Haridwar?"

"Yes, the off-white one with a deep red border. Why?" I inquired, quizzically.

"When I die, I want you to wrap my body in that sari," she said, matter-of-factly.

"What do you mean? What do you mean...when I die?" I asked in an agitated tone, feeling a sense of unease.

My Guru In Disguise

"Priya, I have something to tell you. Please listen carefully and calmly. The time is fast approaching for me to leave this body. I don't want you to get upset, because then I will not be able to tell you what my last wishes are. You must understand I want you to carry out the last rites for me," she explained, studying my face carefully.

A chill ran down my spine and my eyes instantly filled with tears. I stared back at her in total disbelief! Words failed me. We looked at each other in absolute silence.

"Remember, death is inevitable. There is no escape," she told me, breaking the silence.

"I know that Ma! But why are you saying these things to me now? So soon after Father's death?" I replied, my face flushed with emotion.

"Because that is the truth. Why are you so uncomfortable with the truth?" she asked gently.

"How do you know that? No one can predict his or her own death unless one is thinking of committing suicide?. I don't understand...I don't," I said, pacing up and down the room.

"Come and sit next to me; come, come here," she said, pointing to the mat by her side.

I sat cross-legged on the floor beside her. I could not bear to look at her. I was afraid I might lose all self-control if I did. But I could not help but notice that her face looked drawn and pale against her snowy white hair, which seemed to have suddenly changed colour. Her eyes were distant and I detected a hint of sadness in them.

My mind flashed back to my early childhood. I would spend all afternoon playing with her beautiful thick dark hair, trying to pluck out a few grey ones that peeked in between. As a reward for my efforts, she would give me a penny for each strand that I pulled out.

I could see that Father's sudden death had affected her. Her face could not hide the pain.

"You see Priya, the exact moment of death is a very important moment. I wish to go with my consciousness fully awakened in the

divine presence. You mustn't feel sad. In fact, I feel blessed that I have been given the opportunity to prepare for my journey. I can't tell you exactly when or how, but I know it's not going to be long. You can help me go through that door," she said, running her hand over my back in an attempt to calm me.

"Why? Why now, Ma?" I repeatedly asked her, in disbelief.

"Our bodies are transitory; we shed them like old clothes. Have you ever asked yourself, 'When my body dies, will that be the end of me? What is that 'I' that I constantly identify with?' When we say 'I', we are basically referring to our physical and mental self. But we are more than that — we are also the spirit within which dwells the light of God," she explained.

"What do you want me to do?" I asked her quietly.

"As soon as I am gone, you must wash and anoint my body with sandalwood paste and wrap the body with the sari we bought. Sanctify the room by sprinkling holy Ganges water. Make sure everyone gathers and chants the divine name. Cremate the body as soon as you can; don't keep it for a moment longer than necessary," she said.

"Why is that?" I interrupted.

Normally, the body is kept untouched for three days, because the soul of the departed one takes three days to fully disengage from the body.

"The sooner the spirit disengages from my body the better it will be for me," she said, getting up to retrieve a cotton shawl from her closet. That was a muted yellow shawl, hand-painted with her favorite *mantra*, which was repeated across the surface in delicately scripted red letters.

"Wrap this shawl around my shoulders. This is a special piece with sacred inscriptions," she said, handing me the shawl. "Don't forget to repeat this *mantra* as you go through the whole process. Remember, *mantras* are not just meaningless sounds that repeat themselves. They are powerful syllables with a vibration that creates an energy field, which allows individual consciousness to flow directly towards the divine.

"Don't worry so much. I will be fine. You go back to America

in peace. I will call you long before my final hour; we will see each other again. Don't worry," she reassured me.

That night, I found myself going through all kinds of emotions. The room was dark and I could barely see Mother. I could not grasp the fact that there would come a time when she would no longer be a part of my life. That hit me hard and I felt an immense sense of sadness spread over me. She spoke of her death in a calm and impersonal way, almost as though she was a spectator who was a witness. I think, by speaking of her death she not only prepared me, but also herself.

I knew that leaving Mother this time would be difficult. I found myself worrying over every little thing. I was worried because I was so far away, and so was Pebs. Tears kept welling up in my eyes, as I tried hard not to disturb Mother with the sound of my weeping. Everyone whom I loved and grown up with was gone, like a faded dream, making me feel insular and haunting my soul like phantoms from the past. To face the loss of Mother so soon after losing Father ground my endurance to dust.

I looked at her face in the darkness. As my eyes strained to see her expression, I noticed a soft glow surround her, lighting her face very gently. In a few more weeks she would turn sixty-seven.

"I know you're feeling sad, but I want you to remember, I will always be there when you need me. Every other link breaks except the spiritual one," she said gently.

Next morning, everything felt different; she looked fresh and happy. Her face looked very different from that of the previous night. She positively glowed with an inner radiance that was visible for all to see. Her skin was wrinkle-free, almost like a child's, and there was a hint of pink on her cheeks. In fact, she looked better than she had done for very long time. Her eyes were alert and sharp; and her white hair made her look like a wise hermit. She sat on a low seat, talking to some women who had come to visit her. They too remarked on how well she looked.

Once again, I found that these women had come back to Mother

with their support and sympathy. I was grateful for their presence. Perhaps they linked me to my childhood, which was comforting, especially now, when a vital connection to my past had just been severed. They were preparing to sing *kirtan*, music that is an ecstatic form of divine remembrance, as they had done in the past.

The most vivid memory of my childhood was that of Mother and the women singing *kirtan*. I remembered coming home from school to sounds of music that drifted from Mother's end of the house.

They placed a large rug on the floor and set out all the musical instruments, like the drum and cymbals, arranging them in front of each player. Mother always played the harmonium, a small keyboard instrument.

That day I decided to join them. Feeling a little hesitant, I stood by the door and looked in.

"Why don't you join us, Priya? divine name will be flowing here today in torrents. Come, come and sit next to me," Mother beckoned, pointing to the floor-mat next to her.

I sat down beside her. The women looked at me, greatly amused. In their minds, I now lived in America where I led a completely different kind of life. To see me seated cross-legged on the floor, singing *kirtans* was a bit strange for them.

"Once you taste the nectar of the divine name, you will get hooked for life. Are you prepared for that?" Mother asked me in a mischievous tone of voice, as she fine-tuned and adjusted the keys on the harmonium.

Everyone burst out laughing, and I felt a little awkward, as if I had intruded into their very special world. A hushed silence filled the room as Mother began to sing songs of her favourite mystical poets in her clear, beautiful voice. I was instantly transported back to my childhood, and all the years of being apart simply melted away like magic.

"Oh Friends
dyed deep am I
in the colour of Him.

One I knew,
one I see,
one I serve.
Krishna is the first,
Krishna is the last,
Krishna is the outward,
Krishna is the inward.
And He is the Beloved
and none other do I know.
Krishna is He who is all.
Thou, O Lord, Thou art my all."
She continued:
"I see with eyes open
and smile and behold
His beauty everywhere.
I utter His name and
whatever I see reminds
me of Him, and whatever
I do becomes His worship.
Wherever I go I move
around Him. I am only
the instrument. When
I lie down I lie at
His feet.
He is the only one I
adore and none other."

Mother was completely lost in another world, with hardly any awareness of her surroundings. She sang with her whole heart and soul, flowing with divine love, which carried her away on a wave of deep spiritual emotion.

"The alleys are closed for me,
how can I walk to join Krishna?

The road is rugged and slick
and my unsteady feet
falter again and again,
as I figure my pace
with judgement and care.
I can hardly climb the stages
to the palace of my love,
long, long away.
My heart proceeds by jolts.
Mile after mile, the road is guarded
as brigands watch.
O God, what made you plant my village
so terribly afar?"

Tears of love and joy flowed from her eyes. Many times, the mere mention of Krishna made her swoon and she slipped into an ecstatic mood for days. The music ended with chanting and we all joined in the chorus. There was not a single dry eye in the room. To my utter surprise, I realised we had been singing and chanting for two hours! The sense of time had simply vanished.

After the music ended, the women placed offerings of flowers, fruits and different kinds of food before the altar in Mother's room. This was a beautifully decorated little temple, with all the different deities decked in silks and garlands of flowers. The room was engulfed in the fragrance of jasmine, rose and sandalwood incense. As the evening wore on and all rituals and ceremonies concluded, we sat down to a meal of the offered food. Mother never ate any food that was not consecrated and blessed.

I observed the women as they fed Mother with their own hands, as one would a child. Mother reciprocated by feeding them back. They laughed and joked together, telling each other all kinds of stories, like old friends. The love and affection they felt for each other was obvious.

"Mother, remember the time when she had long hair? And you took a pair of scissors and chopped it off?" said one woman, pointing to

the other. "Do you know what her family said? 'What do you all do when you go to that house? Frankly, all of you are quite mad'."

They all roared with laughter.

"I think that hairstyle makes her look so much better, don't you?" Mother remarked playfully, turning to the woman in question. "Mad? Of course, we are mad! Yes, we are all mad — some are mad for money, some for sex, others for name and fame; we are mad for God!"

Watching them together was a wonderful experience. There was so much joy and love, with no superficial barrier between them. I think because of this spontaneity they could reach that spiritual core within themselves with such ease.

That evening Mother and I had our dinner together. From time to time, she placed portions of her food on my plate.

"What's the matter? Aren't you hungry?" she remarked, looking at my barely touched meal.

"I don't feel very hungry tonight," I replied, listlessly toying with my food.

"Come on, you must eat something. Try this," she said, putting some sliced potatoes on my plate.

Whenever Mother shared her food with someone, they always felt they had received something special. That evening I also felt as if I had received more than just food. Not only did I feel physically nourished, but I also experienced a sensation of internal elation, which surprised me.

Mother's mood shifted intensely that night. I sat silently by her. Suddenly she touched the middle of my forehead with her right forefinger. At once, I felt a strange but pleasant sensation arising in my spine and moving straight up to my head. I experienced a feeling of lightness, where I felt myself leaving my body and floating into space. I became aware of a beautiful light that surrounded me. I could see Mother clearly. She too, was surrounded by a luminous glow. I did not seem to have a physical body. I was more like an abstract shape with a diffused outline.

I felt like a bird effortlessly riding a hot air current. There was no sense of time and space. I was only aware of the moment. Everything around me seemed not so solid, and I found I was able to move through things with great ease. As I floated effortlessly from point to point, I felt happy and free.

Suddenly, everything vanished from my sight. I heard a loud piercing sound, something like the sound of a supersonic jet plane encircling me, propelling me across what I perceived as deep space. I could see thousands of stars covering the dense darkness of night. I seemed to be moving through clusters of glowing points that carried me into a huge wave of liquid silver.

Soon I found myself standing before a brilliant mass of dazzling light, moving in slow motion. As I looked closely, I noticed that the mass was made up of tiny particles that moved in a swirling pattern, creating a large oval. Each spark seemed to possess an inherent intelligence, which operated on a designated path. Every atom throbbed and pulsed with a life force that was generated by a powerhouse of unfathomable energy.

I suddenly got an uncontrollable urge to jump into the centre, but no matter how hard I tried, I simply could not move. An inner voice told me that this was not the right time. At once, I thought of my physical body and in the blink of an eye, I was back. I felt restricted and confined, as if weighed down by gravity and my arms and feet were stiff and numb.

I was absolutely certain my experience was not a dream or some kind of mental hallucination. Everything was much more vivid than anything I had ever experienced. I had no perception of time when I opened my eyes. Hours or a few seconds may have elapsed, I just don't know.

"Ma," I whispered. "I had the strangest experience. I felt separated from my body. The light, the light was beyond words." I was no longer able to articulate.

"That's very good. I know you got a small glimpse of reality behind

this veil of life. But don't get carried away with all those vivid, visual sensations. They will occur frequently as you grow spiritually," she said, with a knowing look in her eyes.

We did not sleep that night. I intuitively knew I would have to pay attention to everything she said, because at some point that would play a pivotal role in my life.

"Let me tell you a story. Perhaps you already know...?" she said.

"Doesn't matter, tell me anyway," I interrupted eagerly.

"Once a pregnant lioness roamed the forest in search of prey. Soon she came upon a herd of sheep and jumped to attack her prey. But she missed and fell to the ground. After giving birth to a cub, she died. The sheep raised the cub. They taught the cub to eat grass and to bleat like they did. Soon the little lion started to identify with the sheep.

"One day another lion was passing by and saw this strange sight. He could not believe his eyes! As he approached, the sheep bolted and so did the sheep-lion! The lion followed and finding an opportunity to corner the sheep-lion, he shook the enormous animal vigorously. 'What are you doing? Don't you know you are just like me? You are a lion, not a sheep?' The sheep-lion refused to accept that. 'No! No! No!' he cried, bleating like a sheep, cowering with fright. 'You and I both look alike; if you don't believe me, come with me to the river and look at yourself,' said the lion, dragging the sheep-lion to the nearby river.

"They both stood together and stared at their own reflections. The sheep-lion could not believe his eyes! He looked nothing like the sheep with whom he had spent his whole life. In fact, he actually resembled his lion-brother! The lion taught him how to roar and behave like a lion. Soon the sheep-lion realised his folly and started to roar without fear. Recognising his own true nature, he left the flock of sheep forever.

"We are all like the sheep-lion; we have forgotten our real nature," Mother explained, gazing at me directly.

"That is such a wonderful story. Do you think I will ever know my true self?" I asked.

"Why not? Call God with great longing in your heart; He will show you the mirror. There is tremendous power in a heart-felt prayer. I love this song, listen...." she said, softly clearing her voice:

"Thou art my all in all.
O Lord! The life of my life, the essence of essence;
in the three worlds I have none else but Thee to call my own.
Thou art my peace, my joy, my hope;
thou my support, my wealth, my glory;
thou art my wisdom and my strength.
Thou art my home, my place of rest;
my dearest friend, my next of kin;
my present and my future, thou;
my heaven and my salvation.
Thou art my scriptures, my commandments;
thou art my ever gracious guru;
thou the spring of my boundless bliss.
Thou art the way, and thou the goal;
thou the adorable one,
O Lord!
Thou art the mother, tender-hearted;
thou the chastising father;
thou the creator and the protector;
thou the helmsman who dost steer
my craft across the sea of life."

"One sleeps every day, but what we did last night was wonderful, was it not?" she remarked, as we watched the dawn break. Her face beamed with happiness.

"Yes Ma, that was wonderful," I answered.

"Go and take your bath. Freshen up, then we can have breakfast together," she said, patting my back.

When I returned, the room was packed with women. I quietly slipped in and took a seat on the floor. Mother was speaking to one of the women.

"What is the matter with you? Why has your heart not softened as yet? Tears! Tears of joy must flow at the sound of the divine name. Until that happens, the door to the heart remains locked," she said to the woman.

She then picked up a thin bamboo stick that she always kept beside her bed, and in a flash, gave the woman a swift whack across her back! Everyone knew that was Mother's strange way of internally unlocking something within someone. The poor woman took her 'loss of face' moment in a spirit of humility and devotion. Everyone started to laugh loudly as she sat there looking rather sheepish.

"Priya, have some fruit," Mother said, reaching for a large bowl of freshly cut fruit before her. "You see, Priya now lives in America. They have to cook, clean, do everything. That makes everyone very independent, which is very good,"she said, laughing.

That evening, I was surprised to see that Mother had emptied out her room. Everything, except her bed, had been removed and the room was totally bare except for a thin mat laid on the floor. A few of her favourite books, some journals and diaries lined the wall behind her bed. There was an oil-lamp, and an incense holder had been put where the altar was.

"What happened?" I exclaimed, looking at the bare room.

"Well.... I decided that you should have some of these images. I want you also to have my prayer shawl and my prayer beads," she said.

Her closet still held all her personal belongings. I noticed all her sketch books and paint boxes were neatly kept on the bottom shelf. I felt humbled by her gesture, but at the same time, I was a bit hesitant. I did not know the right rituals and ceremonies associated with those images. They were not antiques that could be kept as decorative pieces.

"God is only interested in the heart of the devotee. What does it matter if you can't follow the scriptures or the rituals precisely? Place a flower and light a candle, but do it with love in your heart. That is all," she said, as if reading my mind.

"Don't you want to keep the images a little longer? I can always take them later," I asked, tentatively.

"No....no! What's the use? I am in such a different state now. A level of consciousness, where there is no form or shape or attribute; everything vanishes! In that state the need for all external forms, even meditation becomes obsolete. Moreover, I think the time has come for you to have some of these things," she said, handing me her shawl.

There was a beauty to the bare simplicity of her room. To see everything stripped down to the barest minimum moved me.

Mother's birthday arrived on a clear blue, very hot, fifth day of May. Pebs and I decided to do something special. We bought her new clothes and laid out a feast of all her favourite foods. We made her wear a new hand-woven cotton sari, wrapping a dusty orange muslin shawl around her shoulders. She looked happy, showing child-like enthusiasm. We kept everything as simple as possible, not only because of Father's recent death, but also, because Mother disliked any ostentatious display of rituals surrounding her.

Soon the house was packed with people. The women arrived with gifts, food, flowers, and different kinds of sweets. They garlanded her and fed her, anointing her with dabs of sandalwood paste and saffron. The room was filled with a beautiful fragrance of rosewater that was sprinkled all around. They planned to spend the day singing and chanting with Mother. Mother's face radiated an inner glow that was quite beautiful.

That evening a friend of Pebs arrived from London. After dinner, we decided to play a board-game with Mother. She enjoyed that immensely and played the game with great fervour. Each time she lost, we roared with laughter, looking at her surprised expression.

"I don't know how that happened? No! No! Let's start again!" she exclaimed, her eyes sparkling with mischief.

I sat with her long past midnight and she read me passages from the *Bhagavad Gita*. We talked of true renunciation and of work done in the

spirit of detachment, but not indifference and done in a spirit of 'desireless action'. It meant 'to act without the need for any reward or gain'.

"Always remember, this world belongs neither to you nor me. Everything belongs only to God. Live in the world with the attitude that all those you call your own — your husband, wife, father, mother, children, friends, relatives — all belong to God. They are not yours to possess. When you love them and take care of them, think you are serving the divine in many different forms," she said.

"I know Ma, I know," I replied softly. She looked so delicate and frail as she spoke, yet her eyes reflected a strength that was extraordinary.

Gradually the time approached for me to leave. I felt a great sense of unease, tinged with a feeling of sadness, more so than usual. I caught myself staring at Mother, trying to capture something of her in my mind's eye. At night I was gripped by feelings of dread and panic that made me feel restless and jittery. She sensed my mood and tried to soothe and comfort me. She sat by my side and touched my head, repeating a *mantra* softly under her breath.

Pebs left for London, and my flight departed the next day at midnight. I was all packed and ready to leave. I entered Mother's room to bid her goodbye. She was sitting on the floor, on a thin palm-leaf mat. I knelt before her, but soon realised that she had gone into a trance. I don't think she was fully aware of my presence.

"Ma," I whispered, "I have to go. I have made all arrangements. Please don't worry. Call me if you need anything. Promise me, you will take care of yourself. Promise me. I will come as often as I can…Ma? Can you hear me? Ma?"

Slowly she opened her eyes and looked straight at me. I leaned over and gently touched her hand. I detected a faint hint of a smile on her lips. She placed both her hands on my head in a gesture of blessing.

I could feel my heart breaking.

"Go Priya, go in peace, God bless you and keep you safe," she said, closing her eyes.

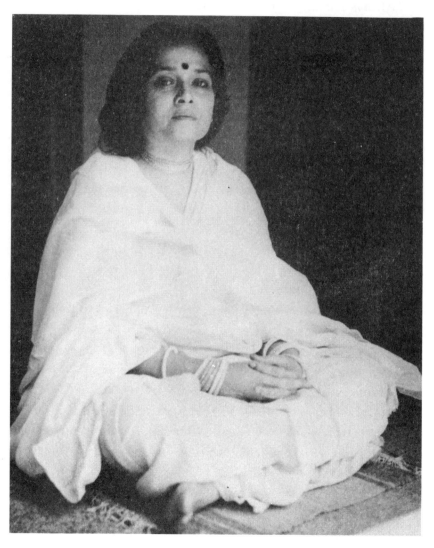

Mother in her mid-forties

12

The Last Moments of Life

The sound of a car alarm from the street below startled me from deep sleep. For a second, I was not sure where I was. I opened my eyes, half expecting to see Mother, but soon realised that I was back in New York. I dragged myself out of bed. My mouth felt dry, my head pounded and I suffered from awful jet lag.

Leaving Mother this time had been very hard. My heart sank when the plane lifted off the runway and the lights of New Delhi receded, like stars disappearing into the dark space of the night. Somewhere within that was Mother, probably sitting in the same position, journeying into that vast seamless world within. I felt such a strong sensation of being ripped apart that I could no longer hold back my tears. I simply surrendered. I closed my eyes, and prayed for her well-being and safety. Little did I know that it was to be the last time I would see her at home.

Externally, I settled back into my New York life, but something within was changing. I found myself struggling to cope with aspects of my life that were not directly linked to my spiritual self. I felt trapped like a prisoner in a cage, of which, perhaps I was the sole architect. Everything that held my attention before had become utterly meaningless

and tedious. I tried desperately to find a balance within myself, something that could bring my inner and outer life into sync. I was looking for some clues that could ease my inner storm. I found my brain churning with questions for which I could find no answers. I wanted to know why I was here? Who was that 'I' ? Was I only somebody's child, somebody's friend, somebody's family? All of that was undeniably true, yet everything seemed so intangible and transient. Where did I belong? Where was my home? I no longer fitted. I was like a square peg in a round hole. I just did not know. In a small way, I began to experience what Mother must have felt. To lose her now, when I needed her most was hard to comprehend.

I kept imagining how I would face her death. What would her last moments be like? I thought of different scenarios and played them through my mind. At times I tried not to think of those things, telling myself to let go, and to just let destiny unfold. Sometimes the feeling of love carried the weight of pain so intensely that I felt to run away would be easier, to be without deep ties to anyone or anything.

I remembered the time when, as a teenager, I felt a sense of enviable longing, seeing the *yogis* and ascetics who would come to visit my parents. How wonderful their life must be, I thought. They were free as the wind with no possessions, no family, nothing to hold them to the drudgery of day-to-day living. I would daydream wistfully of remote mountains and mysterious valleys, where nothing could ever touch you and pain and fear become your slave, where you revel in the bliss of true self-knowledge. I felt confined, restricted and closed in, within a family structure that played havoc with my fragile emotions. There was a weight that pulled me down and I felt burdened by my possessions and everything else around me.

I recall telling Mother that one day I, too, would lead the life of an ascetic, because I was fed-up with the dull routine of the usual conventional life. Mother's response to that was, "Careful Priya, in your quest to find freedom, don't get attached to your begging bowl." Most *yogis* and monks rely on the charity of others, and always carry a

My Guru In Disguise

begging bowl. In other words, what Mother meant was that I had to learn to 'be in the world but not of it'. There was no running away; I would have to face my mirror and see myself from exactly where I stood.

I felt edgy every time the phone rang. One evening, my worst fear was confirmed. Pebs called from London, her voice was hushed. "I just got the news, Mummy has been rushed to the hospital. She was in a terrible accident and most of her body has been badly burnt."

"Oh! My God! How? What was everyone doing? How did that happen?" I could hear myself asking her in a loud voice. My palms felt sweaty and my heart pounded.

Pebs explained that at that point, no one knew how serious the accident was. I called the hospital and got conflicting reports from her devotees. Sometimes they said that she was not doing badly, at other times, I was told the reverse. That uncertainty frayed my nerves and made me very anxious.

The time between my phone ringing in New York and the moment when I stepped into Mother's hospital room, felt like an eternity. My frantic rush to JFK, sitting in the cab, everything felt unreal and strange! I had dreadful visions of extreme agony, of unbearable pain, and helplessness. I felt sadness, tinged with anger. *How did that happen? Why wasn't she more careful? Why? Why? Oh! God! Please let her live. I want to see her alive. Don't die now Mother, wait...wait for me,* I prayed.

By the time I boarded the plane I was exhausted. My body ached, and my limbs felt sluggish. My eyes were bloodshot with emotions and lack of sleep; my appetite was gone and my thirst increased. Never in my life had I felt despair so intensely.

I kept imagining what I would do if Mother became incapacitated and confined to a wheel-chair. She would need a full-time nurse to take care of her. How could I possibly leave her alone at a time when she would need us the most? Everything had happened so fast. Within two months of leaving Mother, I was returning home under such tragic circumstances. Although we had spoken of death and dying, my mind

refused to accept it. I wanted her to live. At the same time, I could not help feeling a nagging sense of doubt — suppose she were to become an invalid? Knowing her, I knew she would choose death over being half alive.

Yet, no matter what I wished for, I could do nothing and I could not shake off the feeling of helplessness, hopelessness and total desperation.

Over the last few months, things had happened so rapidly that I knew I had come to a turning point at which, whatever the cost, I would have to embrace a new dimension of experience and a new mode of action, or simply disintegrate. I kept reminding myself that all trials and tribulations teach us to suffer life more truly — that is a slow, involuntary way of learning to yield, to surrender to a reality that is beyond our control. I remembered Mother's words, "Every man must be his own path-finder." Although, at this moment in time, I felt confined and storm-driven in a vessel that was pilotless. I knew that one day I would tread the same path as she. But how could I find my way if she left me now?

Every minute ticked in my brain. I moved at an excruciatingly slow pace, going through immigration and customs.

"Anything to declare?" The customs officer asked, stopping me as I tried to run past him.

"My Mother is in a serious condition in the hospital; please let me go. I have absolutely nothing," I replied, feeling desperate. He looked at my face and let me go.

I spotted Prashad, his face looked drawn and worried. We got into the car in silence.

"How did this happen?" I asked, remembering the burn marks on her arms. My heart skipped a beat as I braced myself for the worst.

He told me that he was not in the house when the fire broke out, but Meena was. By the time he arrived at the house, Mother was already badly burned and they had rushed her to the hospital. At first, the doctors had not realised how serious Mother's injury was, because the upper half of her body, her arms and her face, looked perfectly normal. Moreover,

there were no visible signs of distress. Mother had walked in on her own, without uttering a single sound or showing any indication of pain!

"How did the fire start? Was it a cigarette?" I inquired.

His voice quivered as he explained. As usual, Mother had lit an oil-lamp before the altar. But maybe this time, she stood a little too close to the flame, when she drifted into a trance. Mother's trance had been so deep that she had no idea that her clothes were on fire, until the flames came close to her face.

As I listened, I began to feel very angry. Why did they leave her alone? What was Meena doing? They were supposed to have taken care of her; where were they? All these thoughts rushed through my mind. But as my anger subsided, I realised there was no one to blame. This was a terrible accident that was beyond anybody's control.

Yet, I could not help, but be haunted by a nagging doubt. Did she intentionally do that to herself? Had everything around her become so unbearable that she could no longer endure being in the world? I could never be sure, and I hoped I was wrong. I knew nothing would ever be the same, no matter what the outcome. From that moment, everything that linked me to my roots — my mother, my home, my family — everything would be different. I could never again experience my links with the familiarity of the past. As I sat staring out of the speeding car, my whole world turned upside down.

The familiar white building of the hospital came into view. My mind ran faster than my legs could carry me. As soon as the car drew to a halt, I jumped out and ran towards Mother's room. I found myself standing at her door, just past midnight.

A few women were keeping vigil in the visitors' waiting area. Their faces looked anxious and sad. They hugged me lovingly and I could feel their warmth and support. Their concern touched me. But I instantly knew that Mother's condition was serious, confirming my worst fears.

The smell of antiseptic mixed with roses hit me when I entered the hospital room. A gushing sensation of tenderness mingled with sadness

welled up within me the moment I saw Mother. Her whole body was covered with a white sheet, except for her hands, which rested across her heart. Her face was pale and she looked frail and thin. There were tubes stuck into every part of her body, which made her look like a puppet on strings. I moved quietly to her bedside and touched her hand gently. Her eyes were closed, yet somehow, I knew she was not asleep.

Pebs arrived from London, looking tired and anxious. We stood on either side of the bed, stroking her hair, her arms and her hands, and carefully avoiding the tubes that surrounded her. I tried hard to hold back my tears. I did not want her to see me cry. This was totally different from what I had imagined. There were no agonising screams of extreme pain; not even a moan. Her expression was calm and still, with no signs of anguish. Although she had been sedated and given painkillers, nothing could have taken away the extreme discomfort her body must have been going through, without drugging her unconscious. I knew when I touched her that she was fully conscious and aware of everything around her. Slowly, she opened her eyes. I will never forget the expression of sadness they emitted.

"I am sorry. So sorry, for the trouble I have caused. Please forgive me," she whispered.

"There is nothing to forgive Ma. Please don't worry," Pebs and I responded simultaneously, touching her face.

She looked at us for a minute, then closed her eyes. Looking at her brave face and her frail body moved me so deeply that I had to leave the room.

I escaped to the bathroom and cried. I cannot remember weeping that way before. The sensation arose from the depths of my soul, tearing me apart as tears gushed down my cheeks, stinging my eyes and making them burn. I felt that I had reached the lowest point of my life with no recourse. The fire that had engulfed her was now consuming my heart, my soul and my mind.

I spoke to the supervising nurse about spending the night

with Mother. Pebs and I did not want her to be left alone. Eventually, a temporary cot was moved into the room and arrangements made for us to be with her for as long as she remained in the hospital. Pebs and I took turns, sitting by her bedside, watching over her. I pulled up a chair next to her bed and spent the night just holding her hand. The room was dark except for a dim nightlight and the only sound was that of an air-conditioner humming. The room was fairly large, and her bedside table had been temporarily converted into a shrine, with a few pictures of her favourite deities. There was also a vase filled with fragrant red roses that had been put there by one of the women.

The night passed and I began to drift into an uneasy kind of sleep. A faint glow of early dawn filtered through the window, gently erasing the shadows of the night. I felt a slight movement as Mother's fingers touched the palm of my hand. I woke up with a start. I noticed she was looking at me.

I leaned over and whispered in her ear, "I am here now, Ma. Don't worry. I'll take care of you. I'll be your strength; you will be fine and you will go home soon. Don't worry, just get better. Okay? We are all here now."

I detected a hint of a smile, but her eyes spoke volumes. I could feel how much she appreciated our presence.

"Does it hurt too much?" I asked.

"A little," she replied, shaking her head ever so slightly.

A team of doctors arrived along with a nurse. Soon the room buzzed with activity. They surrounded Mother, poking, prodding and examining her.

"Hello! How are you this morning?" asked the chief physician in a loud voice, in an attempt to attract Mother's attention.

"I am fine, Doctor," she replied, softly.

"Ah! I see your two children are here. That's good, very good," he said, smiling. She smiled back at him weakly, as he patted her gently on the hand.

After what seemed like a secret conference, they left the room. Pebs and I followed them out.

The chief physician came up to us. "We need to talk," he said. "I hope you realise your Mother is in a very critical state. Her burns are very severe. Her back is badly burnt and so are her legs. I don't know how her hands, face, feet and chest were spared. We could move her to another hospital, which has a specialised burn unit, or get a team of specialists to come here. That would be much more expensive."

"I don't care about the costs. All I want is for her to get better. What are her chances of recovery, Doctor?" I asked.

"Well...? We hope she responds to treatment but one can never be sure. You see, a lot of skin grafting will have to be done. Unfortunately she doesn't have too much healthy skin left. She will also need intense physical therapy and a full-time nurse to take care of her. Her recovery will take a long time. But for now, we cannot get her into surgery; she is still too weak. Her body has suffered a terrible trauma...." his voice trailed off, as he explained cautiously.

"Will she live, Doctor?" I inquired.

"All depends on how well she holds up. Also, we don't know how well she will heal. Sometimes there are complications. When the wounds start to dry out, the skin begins to stretch and that can be extremely painful. Sometimes in severe cases, such as this, there is a possibility of infection. We will have to wait and see, one day at a time," he explained.

I was suddenly gripped with extreme apprehension and uncertainty. Mother would have to remain in the hospital for a long time and I would have to make arrangements to take care of all her practical needs. No matter what conclusions I came to, I found myself standing in the same uncertain spot. I decided to go home for a few hours, to shower and change and to gather my thoughts.

Returning home under these tragic circumstances felt very strange. The house felt depressing, uninviting and empty. Mother's room felt stark and bare. I realised then that her sparsely furnished room had

My Guru In Disguise

prevented the fire from spreading. The room was clean, with no trace of the fire and everything looked just the same.

I showered and changed as fast as I could. I preferred to be in the hospital than to remain in the house. I forced myself to eat some breakfast and hurried back to Mother.

Throughout the day there was a steady stream of visitors. I tried to shield Mother and no one was allowed to stay for too long. Pebs and I took turns sitting by her bed, watching over her like two hawks. Everyone who came felt anguished on seeing her in that painful condition, and her pain became as potent to them as though they were of the same blood.

The nurse came in every hour with a dish filled with multi-coloured pills, which took Mother a painfully long time to swallow. She could hardly swallow any food and could only tolerate a little liquid, one teaspoon at a time. Her main source of nutrition was through an intravenous injection that was stuck in her vein. A mattress filled with water was placed under her to ease her discomfort as much as possible. In her condition, I don't think anything could have relieved her of the agony she must have felt. Every night Pebs, the women and I, would take turns to sit with her.

One night when I was sitting beside her, she whispered, "Please, don't let them move me from here. Please let me be in peace."

"Don't worry, Ma, I won't let them. Don't worry, no one will move you anywhere," I replied, gently reassuring her.

In an attempt to give her some relief, I started to stroke her hair and to chant her favorite *mantra*, softly under my breath.

"Yes...that is all I need," she said.

As I repeated the words, I could feel a power surging through me. There was an energy surrounding Mother that I could feel, but could not adequately describe. The closest description would be that I felt as if I had been transported to a space that was humming at a different frequency. I felt the air had become rarified and that an invisible,

impenetrable barrier repelled all negative energies. Mother and I were magically lifted out of our present state into a realm of total peace. Soon she drifted into a calm, deep sleep.

Each day, for me, felt like a lifetime and there was not a moment of relief. A team of burn experts arrived. They, too, were surprised to see Mother's calm reaction. Each week they came in to change her dressings and to clean her wounds. That was the only time I heard her crying out in pain.

"Oh! God. Ahaa...oh! God...take me! Take me," she cried.

Her voice pierced my heart like a sharp knife. All I could do was wait helplessly outside. Ironically Pebs who had always been perceived as the 'soft one', turned out to be much stronger than I, and was coping rather well under the pressure.

One morning, Mother's cries seemed more painful than usual and I could not resist the impulse to peer in. I can never forget the excruciating sight I saw. Mother had been turned on to her side and stripped completely naked. Bloody red chunks of raw flesh hung loose from her body, making her bones quite visible. Parts of her skin were so shrivelled and charred that the body ceased to look like anything human. Her flesh had turned blue-black, with blood clots stuck to the surface of her skin. Her body reminded me of a mutilated carcass from the slaughterhouse.

The sight was so disturbing and terrifying that I felt myself getting sick to my stomach. My head began to swim and there was a sharp ringing in my ears. I could feel myself slowly collapse. No matter how hard I tried to remain standing, my legs felt like jelly, giving me no support. I have a vague memory of being made to lie down and given a mild sedative. When I woke up, evening had already set in.

I was so stressed by the day's events that I decided to walk home, which was about twenty minutes away. The air was still hot, but not as hot as during the day, which had been like an oven. I planned a slight detour and decided to walk through a beautifully landscaped park that surrounded the tomb of the Afghan Sultan, Ibrahim Lodi.

My Guru In Disguise

My heart felt heavy and each step was an effort. The thought that kept repeating in my mind was, 'Why? Why did this happen? Why to a person like Mother?' I had always believed she was protected by her intense faith in God. Why then did she have to suffer this brutal and tragic fate? I groped for answers that eluded me.

Mother's beautiful face appeared before me. I remembered sitting on her lap as a child — how lovely, how perfect, she was then. I felt a lump rise up in my throat as those vivid memories came floating into my mind. I looked up at the sky to stop my tears from falling, when I noticed that a patch of the blue sky had suddenly turned bright green! I gasped in surprise, realising that the cloud was hundreds of migrating green parrots. Mother loved birds, especially parrots. She had two pet parrots that would respond to her voice. Whenever she set them free, they came back and nested on the roof of our house, creating a large colony. We loved looking at them from our window as they sat in pairs, cuddling and pecking each other. Seeing them now gave me such a sense of joy, like a ray of hope and comfort in the midst of the despair I was feeling.

I was compulsively drawn to Mother's room, which felt peaceful and cool. A part of me thought, irrationally, that everything would somehow fall into place. I decided I needed to calm myself, to try to let go of all the questions my mind was churning up. I sat on the floor and closed my eyes. Soon I began to feel less confused and much calmer. I spent the evening browsing through Mother's books, all of which dealt with spiritual subjects. While thumbing through the pages, I found a scrap of paper with a scribble. Mother had the habit of writing things that inspired her on scraps of paper, often using them as bookmarks. She wrote:

"I am a spark from the infinite
I am not flesh and bones, I am light.
I am an immortal child of God
living for a little while in the
cavernous shell of this body. I am

here to behold the tragedies and
comedies of this changeable life,
with an attitude of
unchangeable happiness."

Each day Mother's condition kept worsening. There were moments when I convinced myself that she was getting better, but clearly that was not the case. All I could do was pray.

A young man who was devoted to Mother came to visit her often. One afternoon when we were sitting outside in the corridor, he reassured me that Mother would be fine.

"Don't worry," he said, "*Maji* explained that her guru had appeared to her and told her that everything would be fine in thirty days."

That gave me some consolation. I thought, perhaps, Mother had a premonition. I asked her the critical question, "Ma, tell me, are you really going to be well in thirty days? Will you feel strong enough to go home?"

"Yes, I will be fine. I will be home," she replied, gently patting my hands.

I wasted no time. Next morning, I set out to find a good, full-time nurse and to work out all the practical details of taking her back home. I told the doctors to do everything they possibly could but refrain from doing anything that was over-ambitious. I knew Mother would not like to be so completely violated and she did not want to be sedated into unconsciousness. That was her choice. No matter what the cost, I was determined to uphold her wishes above everything.

Every day the women arrived with flowers and freshly squeezed fruit juices, since she could no longer swallow any solid food. They would sometimes spend hours, gently stroking her head and massaging her feet. They took turns reading from the scriptures or singing her some of her favourite devotional songs. I noticed that it made Mother happy. She listened to everything attentively, trying from time to time to clap her hands softly.

I observed one man who would come and read to her. He had a

My Guru In Disguise

beautiful voice, which made the reading very moving. Sometimes I saw Mother's expression change and tears of joy would trickle down from the corner of her eyes. He read passages from the life of Chaitanya, the great saint and mystic of medieval India, whose life had been the apex of divine love that stemmed from intense devotion. Mother connected deeply with Chaitanya and always loved to listen to anything that was linked to the saint's life. One day listening to him sent Mother into a trance. She remained that way until the doctors and nurses arrived to treat her. The intrusion jolted her painfully out of her deep mood. I could not blame the doctors because they did what they had to do. Moreover, they were not fully aware of Mother's powerful internal life. They did everything possible to stabilise her. Both her arms were jabbed repeatedly to connect her to life-supporting tubes and now they had reached a point where they were swollen and bruised. On top of everything else, the doctors could not find another vein to inject. So they hooked tubes to her feet. All her normal bodily functions slowly began to cease, and they tried to force-feed her by pushing a tube down her throat. Steadily, she grew weaker and her lungs began to collapse, getting filled with fluid. The medical staff tried to pump the liquid out. They put tubes up her nose and hooked her up to an oxygen cylinder. To me, all of those valiant efforts seemed tortuous and extremely painful. I was torn between my love for Mother and my desire to see her alive. At the same time, seeing her suffer was unbearable. I remembered what she had said to me one night when she still had a little energy left.

"Please, tell them to stop. Please, just let me go now Priya. Don't hold me. Just let me go," she had whispered, pleading.

My attachment to her was so strong that I hung on to her internally, refusing to let go. I justified those feelings by telling myself that we had to do everything in our power to make her well. I refused to accept the fact that she might not live. The doctors wanted to sedate her heavily. This implied that she would lose all ability to remain conscious. I knew how important it was for her. Everything she held sacred would be

undermined, if she were to die without regaining consciousness and I could never forgive myself if I allowed that to happen.

While I struggled with such internal conflicts, her condition began to decline. One day, as I sat by her bedside, the doctors busy with their daily routine, pushing tubes up her nose and down her throat, she suddenly opened her eyes and stared straight at me. Her eyes had such a tormented look of total distress that I decided to let her be in peace. I could no longer care about the consequences. Pebs and I decided that to continue with this mode of treatment was futile. So I instructed the doctors to stop and to remove the tube from her mouth.

By now, we knew she had reached a point of no return. All I wanted was for her to be made as comfortable as possible, without tormenting her body. That evening as I sat stroking her hair, she looked so frail and vulnerable that I was filled with an upsurge of love. Seeing her reduced to such a state of helplessness, where circumstances had forced her to surrender so completely, was heart-breaking to witness. Perhaps the tragedy that she faced now was at the spiritual level — the ultimate sacrifice. I knew that love was the only thing that could survive beyond death. All other emotions and conflicts had become utterly meaningless.

"Go, Mother. Go in peace, and take with you all the love I have," I whispered softly in her ear. I knew that if I truly loved her, I would have to let her go.

Pebs and I tried our best to make her feel as restful as possible, bracing ourselves for the inevitable. The two women who had been constantly by her side ever since the accident, arrived to spend the night with Mother. They sat by her bedside, chanting softly and lovingly touching her bruised arms. One of them was the same woman who had had difficulty in expressing her feelings. Her tears flowed profusely as she rocked Mother gently in her arms, like a little infant.

The attitude of the doctors had also changed. They were less aggressive in their approach. One day the physician in charge informed

me in a serious tone of voice, "We have done everything possible, but too many complications have set in. I don't think there is anything more we can do, except to make her as comfortable as possible. I am sorry, so sorry. She has been a remarkable patient. Every time I asked her how she was, she always smiled and said she was fine. I will never forget her." He came up and patted me on the shoulder in a gesture of comfort and sympathy. I noticed his eyes were glistening with tears.

Mother's life was slowly drawing to an end. Her lungs were filling up with liquid and she was breathing with great difficulty. The doctors tried in vain to drain the fluid from her lungs. All through that ordeal, Mother was fully conscious of everything. She would open her eyes from time to time and gaze at something with a strange intensity. I slipped my arm behind her neck and held her head close to my heart. There was no feeling of sadness, no sense of despair, not even tears. What remained was only love. I held a small teaspoon to her lips to give her three sips of holy Ganges water, reciting her favourite *mantra* under my breath. I knew that was what she would have wanted. I adjusted the pillow and slowly lowered her head on the pillow, gently touching her face and her bruised arms.

The nurse came in with Mother's daily medication. I intervened, preventing her from disturbing Mother. I firmly put my foot down and refused to allow her to even touch Mother. I knew she could not be touched at that critical moment. For an instant, Mother opened her eyes and looked at us, but soon her eyelids flickered and her gaze shifted as she slowly closed her eyes. Her face was calm and peaceful, reminding me of a child who slept. No one was aware that Mother was gone, until moments later, when we realised that she had stopped breathing.

As her destiny carried her into another realm, I remembered that exactly thirty days had passed since she had seen her fateful vision. I had misunderstood what she had meant by going home.

She would be fine now that she was home — not a place defined by

four walls, but a journey's end — a point of rest and peace, of freedom and joy.

Gone forever was the cage that held a spirit that could never be contained.

13

The Silent Departure

As the sun appeared, unveiling a cloudless blue sky, we took Mother's mortal remains home. I made sure that everything was exactly what she had wished for. Pebs and I washed Mother's body, carefully avoiding the injured areas. We anointed her body with special oils and sandalwood paste, wrapping the silk cloth around her and covering her shoulders with her favourite shawl. Her room was empty, except for a low *divan* on which her body was placed. The altar was decorated with roses, tuberoses and marigolds. Lamps were lit and incense burned; holy water was sprinkled to sanctify the space.

Soon the word got around and the house was filled with women and their families. They arrived with garlands and flowers and placed them on her, transforming her body into a pile of brilliant colours. Sunlight streamed through the windows, casting a vivid golden glow and flooding the room with a soft translucence.

Men and women, young and old, whose lives had been profoundly affected and touched by her presence, surrounded Mother. One by one, they came up to her body and touched her feet. As they bid their private farewells, they silently wept tears of irreversible personal loss. In her, they had found their guru, their family and their friend.

I prepared to perform Mother's last rites. According to tradition, I had to cleanse my body, mind and spirit. I clipped my nails and cut a lock of my hair (normally a son would shave his head). I bathed and changed into fresh white clothes. I fasted on a diet of fruit, drinking only juice and water. Mentally I had to prepare myself by putting my personal grief aside and making myself the bridge that assisted Mother to cross. over to the other side. I stopped all superfluous conversations, concentrating solely on things that were of spiritual nature.

Verses from the *Bagavad Gita* were recited and we gathered around her for the last time. With the assistance of Prashad and two other men, I moved Mother's body onto a funeral bier. We lifted the bier on our shoulders to carry her to the funeral carriage. As I carried Mother's lifeless body, I felt a part of me dying.

We arrived at the banks of the Yamuna River that flowed through Delhi. The river shimmered and a gentle breeze moved over the surface, creating ripples that softly caressed the shore. Flocks of seagulls glided down, trying to catch fish. I chose a spot that was secluded and where the river flowed against the edge of the platform. This seemed to me the ideal spot for lighting the funeral pyre.

I got ready to perform the last rite of cremation, called *antyeshtti*, which means 'the last sacrifice'. To ascend into the realm of the spirit, the body has to be sacrificed. The cremation ground where bodies turned to ash is a sacred place, because that is a visible reminder of the transient nature of life. I did not feel a sense of unease or fear, witnessing the other funeral pyres that were burning the mortal remains of someone else's loved one. In fact, that connected me in a very special way to those who were left behind.

Mother's body was placed on a bed of firewood and the area was cleaned and sanctified. The priest began to recite verses in Sanskrit, the ancient language of our ancestors, while preparing the pyre to be lit. He handed me a flaming torch made from sacred *kusha* grass. According to custom, I circumambulated the pyre three times, going counter-clockwise,

which is symbolic of going back to one's original place of rest. The flame is lit in the mouth of the corpse, symbolising the end of physical sustenance that supports life. I felt my hands shake when I ignited the mortal remains of Mother, the bestower of my own life. I found it so very ironic — here I was igniting a fire, the effects of which we had tried so hard to combat. Yet now, I had become the torch-bearer of that flame which would reduce her mortal remains to ash.

The flames flickered slowly at first, before transforming into a raging fire in a matter of seconds. The heat scorched my face and the hot sand under my bare feet made them burn. A shower of flower petals and frankincense bathed the pyre, as all those who were present offered Mother their last obeisance. The flames quickly devoured Mother's small, delicate, half-ravaged body. The fire sizzled and sparks flew out like points of molten light that surrounded her in its luminous embrace. Experiencing that made me realise death was merely a state of transition between the life of the body and the life of the spirit. Death was not something that was morbid but rather a rite of passage that carried the spirit on its evolutionary journey.

Suddenly, the weather began to change. Thick, rolling, grey clouds appeared on the horizon, the wind picked up and a light rain started to fall. The tide rose and the river began to swell. The water splashed against the platform surrounding the pyre, gently swirling around my feet and cooling them instantly. Feeling the drops of rain on my face was soothing, but something also unlocked within me. I became overwhelmed by feelings of forever losing Mother and never seeing her again. A sense of despondency started to spread over me and I went down on my knees, internally crying out for her. Suddenly out of nowhere, a beautiful white bird swooped down, right over my head, singing a most joyous song. The bird hovered over me, flapping its wings so close to my head that I could almost feel its touch. That moment was magical and mysterious. I felt I was given a sign — a sign that I could never lose the spirit that was Mother. What I was losing was only her body. She had gone into a

sphere of joy and peace, where she was free and happy like the bird that flew over my head.

The rolling clouds, the coolness of the river beneath my feet, the leaping flames that rushed heavenwards, the drops of rain that soothed like a healing hand, the white bird's song, all in that moment became a reflection of Mother. All was a reflection of that spotless mirror she spoke of, where the essence of her true form shone perfectly through. The whole scene felt surreal like a vivid dream, staged by an unseen hand. Many years later, inspired by those events, I dedicated a painting entitled, 'The Messenger of Love', to the memory of Mother.

I gathered up Mother's ashes in a simple clay urn. The fire had consumed everything. Nothing remained, not even the fragments of bone. What was left was a powder of ashen dust. I returned home with Mother's ashes and placed the urn outside in the small courtyard under a tree. My body was covered with ash and my white clothes had patches of grey. My nose, hair and eyes felt gritty and the smell of smoke surrounded me. That did not repel me. How could I feel repulsion now, when the final element of her physical form covered me? Mother now came to me in many guises, including ash.

I showered and changed, then decided to spend the afternoon in Mother's room, to be alone with my thoughts. I spread her straw mat on the floor and immediately fell asleep. I remember nothing except a dream that I had of her. I saw her surrounded by beings of light. They seemed to be helping her make that transition from death into the realm of the spirit. I sensed a tremendous amount of love around her. She looked a little shaken, but very happy. She appeared to me, as she had been when she was young.

"Look Priya, look, I am fine," she said, joyously.

When I finally woke up at two in the morning, the room was dark and the house quiet. I stared into the darkness, remembering Mother. Alone in the silence of her room, I realised that I was now motherless. I felt a void in my heart. I silently watched the dawn approach, cutting

My Guru In Disguise

through the darkness with rays of light. Everything looked just the same, yet for me, something had changed drastically. I began to realise that my so-called reality depended upon my perception and experience, and the moment that shifted, everything changed.

That morning a steady flow of visitors began to arrive. A simple altar was arranged with a photograph of Mother in her mid-forties. A garland of roses and fragrant jasmine were placed around the picture frame. Lamps were lit and incense burned, transforming the house into a sacred place of worship. Verses from the *Bhagavad Gita* were recited and hymns from the scriptures sung. According to tradition, cremation is for the body and the last rite is for the transition of the spirit. The priest guided me and I performed the last rite. I recited prayers for Mother's safe passage and for the well-being of my ancestors, for the well-being of all departed souls and for everyone who had lost a mother and ultimately, a prayer for Mother Earth, the sustainer of us all. I found the rituals and prayers had a very healing and a comforting effect on me. I realised that I was not alone in my grief; rather, I was a part of the whole human family, experiencing the same sense of loss.

There was an eerie feeling of *deja vu* when I returned once more to Haridwar to immerse Mother's ashes. I felt much calmer now than I had during Father's time. I gently lowered the urn into the gushing river. Pushed by the swirling current, the fragile vessel swiftly disappeared from sight. The mighty Ganges carried away the last remains of Mother, where separation could no longer divide, where her boundless self bounced over the waves of timelessness. The physical ties that linked me to my roots were finally severed forever.

Pebs and I concluded the ritual by bathing in the cool waters of the Ganges. The water engulfed me with a feeling of immense freedom, a sensation of suddenly being cut loose and free. At the same time I felt absolutely no sense of elation. Instead, I felt I was being unexpectedly thrown off a steep cliff, with no perception of where I would land. Being cut off from my past and the ties that anchored me, made me feel like a

I perform Mother's last rites by the Ganges in Haridwar

kite floating in space. Even though the string was still attached, there was no óne holding the string, which made the kite move wherever the wind blew. I knew that the time had come for me to embark on a new journey. That journey would carry me into the unknown depths of my very being and in that inner space I would have to learn to surrender, to accept, without constant resistance to the path of my own destiny.

I remembered what Mother had said about giving. This time I gave freely to the poor and the destitute, and I emptied my pockets without a single thought. Mother would have wanted that. *I know you are watching Mother; I hope you are happy and at peace; I did my best to carry out your last wish*, I said to her silently. That evening, as the sun began to set and the shadows of dusk cloaked the light of day, a chapter ended in all our lives.

Returning home, I felt empty handed, as though I had left something precious behind. That night as I lay in her room, I realised one could never lose someone who is precious. They always manage to live somewhere in your heart.

The next day I began emptying out her closet. All her clothes still held her fragrance. I could not believe that she was gone. I gave most of her things to each of the women. They wanted something that had personally belonged to Mother. I was surprised to see that she had so few personal possessions. "Can a bird take flight with a carcass on its back? Possessions are like carcasses on our backs," she would say. For myself, I kept her journals, diaries, a few sketchbooks and some drawings. I also kept the thin bamboo stick that she always had beside her.

The women came to pay a visit every day, bringing offerings of Mother's favourite foods and flowers. They sang songs of devotion and reminisced on the moments that we had all spent together. Each one carried a cherished memory that had in some way profoundly affected and transformed their lives. For the first time, I began to see Mother through their eyes. I realised that she was not only our mother, who we took so much for granted. She was also a rare human being, whose life

had impacted the lives of those who came to her and whom she enabled to embark on that mysterious and amazing journey within.

I began to look forward to their visits. They connected me to the sights and sounds of Mother, without which, the house became an empty and barren place. Soon the time came for me to leave India. That last evening, we sat in Mother's room, sharing stories that linked us to her and made us feel her presence. I felt sad when we said good-bye. After all, I had known some of them since I was a child. I had seen them evolve and change, blossoming in the presence of Mother, becoming special human beings whom I had the privilege of knowing. I knew this would probably be the last time we would be together. From that moment on, we would carry our special memories that would always link us in a unique way.

That night I sat wistfully reminiscing when suddenly, I was startled by the sound of something hitting against the windowpane. I discovered a little grasshopper had flown into the room and was sitting on Mother's picture-frame. The insect flew around the room and landed on the mattress, facing me directly. I was fascinated by the tiny creature, which had the wisest expression and the most penetrating gaze. Sitting motionless, its large eyes stared into space. I had never really watched a grasshopper that closely before. In a flash, Mother's words came to me, "Look at a grasshopper, if you want to see the face of God."

"Why a grasshopper?" I had asked.

"Why not?" was her answer.

I left what had once been my home, without a single backward glance. I felt an urgent need to leave quickly, without lingering or last nostalgic looks. I knew that I could no longer be separated from Mother because she was now in my heart and not within the four walls that I once called home.

My Guru In Disguise

14

The Irreversible End

I returned to New York. This time the stark reality of never seeing Mother again hit me. Tears filled my eyes, instantly taking me back to the time when she had left home and I had gone to the library, hoping to find a secluded place, where I could hide my tears. That moment felt exactly the same to me. But this time her death made everything irreversibly final.

I tried to settle back into my life in New York, but for the first time I found myself completely out of sync, as if in a mysterious dream world, which no longer had any connection to my inner reality. I became more and more reclusive and contemplative, needing my periods of solitude, which were difficult to find in a city like New York. I intuitively knew that my moods were not just linked to my grieving, but were symptoms of the internal change I was going through.

Perhaps losing Mother was the final push I needed to fully awaken to my inner life. However, I also found that somewhere within me was a pain that I could not bear to touch. Not only the pain of her loss, but also, what felt like old 'fossilised pain'. No matter how hard I tried to resolve those issues, there was something within me that had always felt left out

of the orbit of Mother's inner life. In an attempt to shield myself from my own pain, I began to remove all traces of Mother. I put all her personal belongings and photographs in a box, storing everything out of sight. Outwardly I tried to behave as normally as I could, but inwardly a storm was raging. Unable to fully express that to anyone, I began to feel more and more alone.

Some friends, in a well-meaning attempt, tried to engage me in various social activities hoping I would "snap out of it". I felt a strain keeping up with the act. At times it became so excruciatingly unbearable that a part of me wanted to escape. My inner turmoil manifested itself in very strange ways. I found myself suddenly bursting into tears when watching TV or a film, or sometimes, much to my embarrassment, sitting with friends in a crowded restaurant, having a meal. Before that time I had always harboured an image of myself, as someone who was strong and independent. But my odd new behaviour shattered all my notions of how I saw myself. I was forced to accept the vulnerability of my own nature.

Three years passed before I found the courage to again look at things associated with Mother. I began to unpack the boxes and found old photographs, some letters and several drawings. I glanced through her journals and diaries, searching for a sign, something that would reassure me of her spiritual presence. As I sat looking through one of her journals, a note she had scribbled fell out:

Priya darling,
Do let me know when you miss me? I will always come to seek you.
Everything is fine. Love with blessings and joy

<div align="right">Ma</div>

I could only smile through my tears. I would have to let go of my pain to be able to feel the spirit of her true form. I knew then that nothing

could separate us. I felt her watching over me, protecting and guiding me all the way. Sadness lifted off me and a feeling of love swelled in my heart. That evening I listened to a tape recording of her singing those familiar songs of my childhood. Her voice filled the room, making me feel her presence. Then my heart cried out for Mother, because now I could truly experience her pain, her loss, and her isolation. My own feelings of isolation and loss allowed me to embrace hers, and the lessons of my life were teaching me to accept her without judgement. I realised that the spiritual life that was unfolding within me connected me to her in a profound way, more than I had ever thought possible.

I seemed to miss her most when daylight faded and dusk fell, casting long shadows, silently ushering in the night. That was the time when she would sing songs of devotion. Most evenings, I spent time reading her journals. I found a letter in one of the journals addressed to Pebs and me written in 1959. She wrote:

Dear Ones,
You both know, I am sure, who was Buddha. When the Blessed One began his sermon, rapture thrilled through the entire universe. Buddha, the Enlightened One, looked equally with a kind heart on all living beings, all those who knew him called him 'Father'. He was one of the greatest combination of heart and brain that ever existed. His life was an example of unselfish action, an ideal *karmayogi*, the one who acted without ulterior motive. "Happy is the one who has overcome all selfishness, happy is the one who has attained inner peace, and happy is the one who has found the ultimate truth," said Buddha. Remember and learn from this always. When you both grow up, from day to day, you will see and learn from life, from your own and from others. Don't ever forget my dears, life is made of joy and sorrow and you must always know how to accept them both with equal understanding.

The truth is best as it is. No one can alter it, neither can anyone improve it. Have faith in the truth and live it. Now you will ask, what is this mysterious truth? To know that you are infinite is the truth. To find that you must always begin with yourself. Learn moderation in speech, control of mind and tranquillity in action. Be humble. The one who has no 'I' and 'me' and 'mine', grieves not for that which is unattainable. Never take delight in quarrelsome disputes or engage in controversies to show superiority of intellect or talent. Remain calm and composed with no hostile feelings in your heart towards anyone. Never abandon the disposition of charity for all beings. If a man or a woman is old, regard him or her as your father or your mother; if young, as your brother or sister; if very young, as your child. Live in this world like a beautiful lotus unsoiled by the mud in which it grows.

No one can become a true ascetic by a shaven head alone. An undisciplined mind; that utters lies, that is full of desire and greed, lives a life of falsehood. Nor does silence make a sage. Like Buddha, follow the middle path. Be wise, learn to grasp a pair of scales and keep perfect balance. Let your actions speak louder than words. Exhibit true superiority by virtuous conduct. Meditate deeply on the vanity of earthly things and understand the fickleness of an ignorant life. Ignorance causes the ruin of the world. Envy and selfishness break human ties and hatred is the most violent of all fevers. When the ignorant reproaches the wise, he or she is like the one who looks up and spits at heaven; this soils not the heaven, but comes back to soil the self. Never deceive nor despise another. Never lash out with anger or resentment, or wish to harm another. Be free. Be free from pride, vanity and ego. Have faith and wisdom and you will be respected everywhere, in every land. Teachers can only teach, but you and you alone will have to make an effort towards self-transformation.

My Guru In Disguise

Overcome all unruly cravings. Learn moderation. Health is the highest gain; don't ruin it for the sake of vanity by starving yourself to be thin and taking dangerous drugs to achieve it. In the *Bhagavad Gita*, Lord Krishna tells Arjuna: "A harmony in eating and resting, in sleeping and wakefulness, in whatever the action, brings freedom from all pain." A harmonious mind finds a place of rest in the spirit within, where all restless desires disappear in the vast ocean of joy and truth, where the mind becomes steady and fully content and the greatest of upheavals can no longer disturb it. Contentment is the greatest wealth. Victory breeds hatred; the defeated live in pain. Happily, the peaceful live with the wisdom of giving up both victory and defeat. Buddha said it is not life, wealth and power that enslave men, but clinging and craving for more and more. The one who sticks to wealth, better cast it away than to be poisoned by it. But the one who is not bound to wealth or power, who uses it rightly, will be a blessing to his fellow-beings. Always inspect your thoughts before you act, for as we sow, so shall we reap. Seek the welfare of others and bring back those who have gone astray and enlighten them who live in the night of error. Whatever may be the cause of your suffering, never wound another, be gentle, show kindness. The one who wilfully harms life becomes an outcast. Benevolence towards all beings is the very heart of true religion. Cherish in your heart boundless love and compassion to all that lives.

Love to all.

Fascinated, I leafed through the pages. A passage on desire caught my eye. She wrote:

All creation arose from the desire of the cosmic mind to create.

Desire, therefore, is the fuel behind the manifested universe.

Everything we perceive from the very simple to the very complex arose from desire. However, that is very different to ego-based desire, which is only motivated by selfish fulfilment. Ego-based desire is the root cause of all suffering. Therefore constant feeding of desires is not the key to happiness, but renunciation and discrimination provide the answer. That simply means giving up the lesser for the greater, and, the uncertain for the certain. Meditate in solitude and try to perceive the fleeting nature of the world. Gradually discrimination will awaken to remind us to be effortless in our quest and to finally dwell in a state of unchanging oneness.

Reading Mother's words inspired me to re-think the course of my life. I realised that my career as a designer was not what I wanted for the rest of my life. I knew I had no choice, because if I continued with my present lifestyle, I would simply collapse under the demands and strains. I felt I could no longer sit safely on the edge with my feet planted on dry ground. I would have to take a risk and jump into the unknown, even if I couldn't swim. I needed to trust that I would be carried across the turbulent water, and that I simply had to allow everything to unfold without feeling fearful. I recalled what Mother had said: "Fear cripples the flight of the spirit; the one who is internally awake, knows no fear." At that moment, reasoning became powerless against the gentle tug of my heart, which was prompting me to take that leap.

Mother's sudden death had made me see that life is strange and full of surprises. No matter what I planned, the force of unforeseen circumstances had dragged me away from my predictable and familiar world into a world of ambiguity, of 'not knowing'. Perhaps those were the moments that made me face myself without the mask of my outer façade. I realised, in order for me to grow, I had to learn not to 're-act' but to 'act'.

Eventually I did leave the city and my old life, spending a few years

in New Mexico. During that period, I also felt an inner compulsion to write about Mother. I wanted to probe my feelings in order to heal the pain of her death. I unpacked my old journals and started to read what I had written over the years. I found in doing so that I was uncovering feelings I had not consciously examined before. I found that writing about Mother had a liberating effect on me, releasing me from my inner contraction regarding her life and her death. I disappeared into my study and scribbled away for hours. When a few of my close friends read what I had written, they urged me to write a book. Unfortunately, unforeseen circumstances forced me to move and my writing was interrupted for some time. I then moved back East, to up-state New York. I wanted to be closer to the city and my friends. My new life there became more fluid and less structured. I painted and wrote and did things that made me feel free and happy.

One day, after I had moved back to the east coast and was in the middle of renovating my new house, I heard the shocking news that the World Trade Centre twin towers had been attacked. The destruction of the twin towers saddened me deeply. That event not only left a scar in the very heart of my soul, but also tragically, ended the lives of so many of our joint human family. But for me personally, the physical landmark of that beautiful day that I had spent with Mother was erased. Her words haunted me, reminding me how prophetic her vision had been. I saw in that act the madness of war and the futility of hate.

The loss of Mother and others who were close to me had opened my heart in such a way that I could identify with the pain and loss of another human being. I could feel another's tears because of my own. Why did I think that my pain was greater? Why was the pain of another human being less important than mine? I was not an exception, nor was I singled out to be the unique target of some cruel, unseen hand. All of humanity suffered. That was the nature of life, the human condition. For the first time I understood from my heart and not just my head. I realised that if I had the blessings and the good fortune to experience love, joy,

contentment and peace in my life, then I also had to be prepared to face loss, sorrow and extreme discontent. One could not live without experiencing and understanding both. Life was a play of opposites, constantly tugging at the seams of our existence.

I found that I could no longer shun everything that hurt, or look for that elusive something that would keep me entertained in a state of spiritual forgetfulness. That was no longer an option for me. I knew that what lay beneath the surface were trials, tribulations and challenges, waiting to erupt and seep into the crevasses and caverns of life that we try so hard to protect. Mother's life of total faith and surrender came to mind, reminding me that I needed to rely completely on the wisdom of a higher power and to have absolute faith that I would be guided. I discovered that whenever I acted consciously, with full awareness, I unlocked something within, which allowed me to move effortlessly, with a fluidity that lifted me and took me exactly where I was supposed to be. There were times when I felt like an onlooker watching, without clinging, without judging, without hankering after results. I was learning just to 'be'. What meditation and spiritual practices could not teach me, the wound in my heart did. Everything opened my eyes and my heart to that 'oneness', that Mother so often spoke of. No matter what race, what colour, what culture, or what country we came from, we cried the same tears, felt the same pain. We also felt joy, peace, and the most unifying of all experiences, love. I wished I could thank Mother now, to acknowledge her presence in my life. But perhaps just by opening myself to feel that there is a common thread that connects us all is more in keeping with her vision.

That conscious realisation infused me with a strength I did not know I possessed, a strength so powerful that I no longer had space to accommodate my rage, my sorrow, my hurt. I knew then, that I had somehow weathered the storm, and that there was still a part of me, which was left intact and whole. That was my moment of rebirth, my moment of awakening. Something soared within my soul and I knew for

My Guru In Disguise

sure that I was not a prisoner within my body, not bound by my grief, nor my emotions, nor my rage; in fact not bound in any way. I was completely and utterly free.

With the passage of time, parts of me that had been dormant since childhood slowly started to stir. Those parts wanted to emerge, to be seen, to be heard, to be felt, to be loved, to be held, to be free. I understood with great clarity that to experience the totality of my spirit, all the different layers — the physical, the emotional, the mental, and the spiritual — had to come together like a dance where every step counted. Ultimately, there could be no separation, because each episode was a spiritual lesson, essential and integral to my whole being. I was discovering like an explorer a divine presence within, a part of me that was now emerging like the first crimson rays of a new dawn.

My mother, my guru, my spiritual friend, all in one, I miss you. You taught me not to cling, not to identify only with the body. I know that to be true. Now that you are no more, I know I can love the spirit much more than the body. But I also understand that your physical presence was important to me, that 'you' who incarnated in that body and became my physical Mother. The one who made 'me' possible by giving me the gift of life. I owe you a debt of gratitude for showing me the invaluable path towards discovering myself and leading me to my own light. To me, you will always be like a beautiful temple surrounding a perfect image. To me, that is how you will always be. Not the perfect mother, not perfect in many ways, but a perfect 'being' who was completely 'human'. I know I will surely see you when my body dies. I know I will experience you again as light. But as long as I live in this body, I will miss your voice and your touch. Both in the joy of your presence, and now, in the silence of your departure, I am left wounded. But in that heartbreak lies the seed of my happiness. Etched in my heart you will always remain, no matter what. Your blood is my blood; your flesh is my flesh.